The author wishes to thank the late Margaret Sutton, for inspiring me to create a mystery heroine; Hannah Dobryn, for naming me literary executor of her Katy Green mysteries; Pat Childs, for taking Katy to audio; Meredith Phillips, for bringing Katy into print; and Kathy Frankovic, for helping me to bring Katy into our lives.

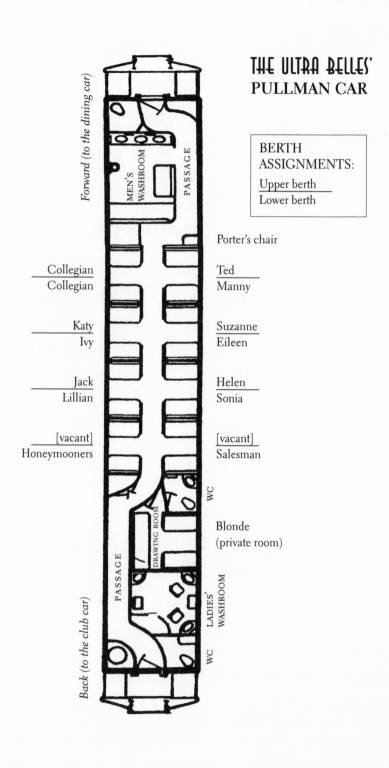

THE ULTRA BELLES'
PULLMAN CAR

Forward (to the dining car)

MEN'S WASHROOM

PASSAGE

BERTH
ASSIGNMENTS:
Upper berth
Lower berth

Porter's chair

Collegian
Collegian

Ted
Manny

Katy
Ivy

Suzanne
Eileen

Jack
Lillian

Helen
Sonia

[vacant]
Honeymooners

[vacant]
Salesman

WC

Blonde
(private room)

DRAWING ROOM

PASSAGE

LADIES' WASHROOM

WC

WC

Back (to the club car)

Raves for the

TOO DEAD TO SWING

Audio-play

2001 Audie Award
and Listen Up Award Winner
www.toodeadtoswing.com

"The swing-era atmosphere is deftly evoked through language and cultural references, as well as through lively swing music.... The first of a proposed series featuring thoughtful, engaging amateur detective-musician Katy Green, this production vividly captures the camaraderie, shenanigans, and catfights of the 'all-girl band.'"
—*Booklist* (STARRED REVIEW)

"Glatzer's novel captures the period and the train and bandstand backgrounds flawlessly and delivers a surprising but scrupulously clued puzzle."
—Jon L. Breen, *Ellery Queen Mystery Magazine*

"Set just before the war in 1940, this musical mystery is the cat's meow.... Glatzer's period details are spot on."
—*Los Angeles Times*

"...this marvelously entertaining audio dramatization will appeal to fans of noir mysteries, old-time radio plays, and 1940s swing music."
—*Publishers Weekly*

"It has all the markings of a BBC radio show, only it's made in America."
—*Murder: Past Tense*

TOO DEAD TO SWING

MYSTERY FICTION BY HAL GLATZER

Kamehameha County

The Trapdoor

Massively Parallel Murder

Too Dead to Swing

A Katy Green Mystery

by
HAL GLATZER

PERSEVERANCE PRESS / JOHN DANIEL & COMPANY · 2002

"Walking on Eggshells," "Yours Till Dawn," and "Remember To Forget"
copyright © Hal Glatzer; used by permission of Audio-Playwrights.

A Perseverance Press Book
Published by John Daniel & Company
A division of Daniel & Daniel, Publishers, Inc.
Post Office Box 21922
Santa Barbara, California 93121
www.danielpublishing.com/perseverance

10 9 8 7 6 5 4 3 2 1

Book design by Eric Larson, Studio E Books, Santa Barbara
www.studio-e-books.com

LIBRARY OF CONGRESS CATALOGING-IN-PUBLICATION DATA
Glatzer, Hal.
 Too dead to swing : a Katy Green mystery / by Hal Glatzer.
 p. cm.
 ISBN 1-880284-53-7 (pbk. : alk. paper)
 1. Women musicians—Fiction. 2. Swing (Music)—Fiction. 3. California—Fiction.
I. Title.
 PS3607.L38 T66 2002
 813'.54—dc21 2001004863

(AST OF (HARACTERS

KATY GREEN, a working musician, adept on both violin and alto saxophone. Katy joins the Ultra Belles—an all-female swing band—on tour in California, only to discover that somebody is out for blood.

TED NYWATT, a songwriter who has organized the Ultra Belles to showcase his songs. Ted's a notorious Casanova (even Katy is an ex) but his latest sweetheart is nothing but trouble.

EILEEN WHEELER, the Ultra Belles' singer. Eileen is pretty, and talented, and rich...and very unhappily married.

JACK ("Don't call me Jacqueline!") MOREL, guitar. She's plain-spoken and staunchly left-of-center, so nobody in the band is "neutral" toward Jack.

LILLIAN VERNAKIS, trumpet. For her own safety, Katy has to figure out if Lillian is merely scatterbrained—or actually insane.

IVY POWELL, bass. Ivy is salty and feisty and razor-sharp, but the next fight she picks could be her last.

SONIA BLISS, drums.

HELEN BLISS, clarinet. The Bliss Sisters were a famous sister-act in the heyday of vaudeville; now they resent having to eke out a living in a band. But how deep does their resentment go?

SUZANNE ZIMMER, alto sax. Tall and husky, Suzanne can hold her liquor, but not much else.

MANFRED P. (MANNY) BLUNT III, the Ultra Belles' press agent. Manny knew they weren't goody-goodies, but he didn't expect to have a killer on his hands.

NINA CAVETT, a rich widow from San Francisco. Mrs. Cavett apparently believes that the way to hire the girls in the band is to go through their men.

LYDIA PARKS, president of the San Francisco chapter of the Good-Government League. Mrs. Parks is a lot more hep to the jive than she appears to be.

BARBARA ANN (BABS) FISHER, a youngster who's got the jitterbug. Babs is the Ultra Belles' number-one fan.

SERGEANT ELMO GRUMMAN, a rising star in the Santa Cruz Police Department.

DETECTIVE JOE FINN, a snarling veteran Sacramento cop.

SHERIFF GRAYSON TODD, the sheriff of Truckee, who could have stepped out of a Western movie.

DEPUTY TIM PETERSON, a sheriff's deputy who needs help dealing with women.

DR. GEORGE GALLUP, the noted expert on public opinion.

FOREWORD

Fifty-some years ago, this murder mystery died on the slush pile. How it came to be published now is a story in itself.

Hannah Dobryn was a ghostwriter of girl-detective series books in the 1930s, and served in World War II as a writer and performer in USO shows. After the war she returned to mystery writing, but this time with a grown-up heroine named Katy Green.

I met Hannah in the 1970s, in Honolulu, where we were neighbors. She played piano and sang Broadway show tunes; and when she heard I was a mystery writer, she showed me the Katy Green mysteries that she'd written between 1947 and 1951, and had submitted to publishers. But she was out of sync with the postwar mystery market. Many hardback publishers had abandoned the field, and the new paperback publishers wanted heroes—not heroines.

In the whodunits of the late 'forties and early 'fifties, women could be only victims or vamps. But Katy is clever and self-reliant,

a working musician with both classical training and up-to-date swing skills. She is also able to keep her head in emergencies, and to defend herself, physically, when necessary—skills that I suspect Hannah developed during the war, although she never talked about her years in the service.

I corresponded with Hannah after I moved back to the mainland; but in 1994, I learned that Hannah had died, aged ninety-six, and that she'd willed her Katy Green manuscripts to me, along with the notebooks and file folders of clippings from which she developed them. Moreover, she'd assigned the copyrights to me—on condition that I make an effort to get the novels published. And so I did.

Unfortunately, Hannah was out of sync with the market again. By the 'nineties there were plenty of heroine-sleuths, of course, but too few mystery imprints in the new publishing conglomerates. Yet Hannah's stories were so compelling, they deserved to find an audience. I adapted the first novel into script form, and produced it in 2000 as an audio-play, with a Broadway cast, sound effects, music and songs.

Today it's the adventurous small publishers, like Perseverance Press, that are the leaders in bringing worthwhile new mysteries to the reading public. I feel that Hannah would be especially pleased to know that, after so many years, such a brave publisher has brought her brave heroine into print. So here it is, from 1947, the first novel in the Katy Green mystery series: *Too Dead To Swing*.

TOO DEAD TO SWING

DON'T let anybody write a song about your love affair. Oh, it's flattering, all right. You make everybody quiet down when it comes over the radio. You murmur, "That was *our* song" when someone picks it up in a music store.

But too many songs are about the *end* of the affair. Do you really want everybody to know why it all went wrong? And do you still need to be reminded?

WITHOUT MESSAGE

SUNDAY

IN MAY OF 1940 I WAS
looking for work in Los Angeles. I'd ridden
the noisy red streetcars over to the Musicians' Union every
day, and the hiring hall got me a couple of one-night stands. But
I needed something steady. I had enough money to stay on at the
YWCA through the end of the month, but not enough for a train
ticket home to New York, where my rent was coming due. Worry-
ing about it only made me clench my teeth and bite my nails —
which didn't improve my sax-blowing or my violin-fingering
one bit.

Downtown, the days were very hot; most afternoons there was
no breeze. If you looked up at the sky, the air was an ocher color
and had a funny smell to it. I needed to spend a Sunday down at
the ocean.

I'd heard that at the western end of the streetcar line, in Santa
Monica, there was an amusement pier and a wide beach. But
when I got off the car, you could barely see the sand for the

crowds. I walked along the boardwalk, then out onto the pier, hoping to catch at least a few ocean breezes before the rest of California did. People were trying their luck with the fortune tellers and the peep shows and the shooting galleries. I didn't have much to spend, except time, but maybe it wasn't a lucky day anyway. A couple of army guys couldn't seem to win Kewpie dolls for their girls, and even the fishermen weren't reeling in much worth eating.

Out past the hawkers and hucksters, at the far end of the pier, a brass band was setting up to play in a half tent that served as a bandshell. The audience benches were filled, and I thought about standing, but I didn't need to be reminded of gigs I hadn't gotten.

It was three in the afternoon. I'd chewed gum for lunch. I had to have *real* food, but my budget wasn't in the shrimp-cocktail range. Heading back toward the food stalls, I sidestepped through a clutch of kids playing tag and rolling hoops.

There was a line at the hot dog stand. The guy in front of me looked familiar: he had a full head of wavy brown hair, which I noticed because he was the only grown man around who wasn't wearing a hat. That was familiar, too. I had to see. I pretended to be jostled, so I could bump against him.

"Sorry."

Sure enough, it was Ted Nywatt. Being a gentleman, he instinctively excused himself and extended a hand in case I'd lost my balance. But when he saw it was I, he squeezed my arm and gave me a big smile, just the way he used to.

"Katy Green! I don't believe it!"

"I thought it might be you, Ted. What're you doing out here?"

"We've got the day off, the girls and I."

Ted was a songwriter, mainly; but "the girls" would be the Ultra Belles, an all-female swing band that he'd pulled together

last year to showcase his songs. "I saw the ad for your gig at the Ambassador, Ted. How'd it go?"

"They loved us. If I'd known you were in town, I'd have gotten you in for free."

I looked around and made a half smile. "Are you here by yourself?"

He let a beat go by before he said, "I took one of the girls out for the day."

"Oh."

"It's strictly platonic with her. I'm actually going steady with the singer."

"You old Casanova!"

"What's yours, Mac?" said the hot dog man.

"Two with everything and…" Ted smiled at me.

"One with just kraut."

The vendor was a pro. Without stopping, he opened three thin buns with one hand, plopped a pink frankfurter down into each of them, slathered mustard, relish, and sauerkraut on two, kraut on mine, traded them for Ted's half dollar, slipped him a nickel change from between two knuckles, turned to the guy behind us, and said, "How about you?"

Ted saw the quarter I was holding out to him and said, "Put it away; it's my treat."

I slid it back into the pocket of my sundress. He may have been a Lothario but he was never a cheapskate.

"Come on and meet Lois Dumont. She's our violinist; you can swap stories. She's waiting down there—" He gestured toward the ocean end of the pier.

The brass band was starting to play, the tune faint and indecipherable from so far away. But as we walked closer the brassy *oompah* turned out to be Sousa's "United States March."

I'd run into Ted briefly last summer, but we really knew each

other from a few years ago back in New York. He and I were…
well, I do mean we knew each other in the biblical way. I'd gotten
a call to fill in one night at a roadhouse in the Bronx where the
regular violinist had gotten himself poured into the drunk tank.
Ted was playing trombone with the combo, to make ends meet,
between writing songs.

I'd heard about Ted before: he had a love-'em-and-leave-'em
reputation among the females in Local 802 of the American Fed-
eration of Musicians. But I wasn't seeing anybody at the time.
And he had gentlemanly manners: no roaming hands, no "acci-
dentally" rubbing up against you—not like most of the wolves in
the music business.

No, his gimmick was: he'd sing you a little ditty that he said
he'd written just for you, called "My Sweet Someone, My Sweet-
est Dear." He'd substitute your name for the "Someone" or the
"Dear," depending on whether it had two syllables or one. Most of
the women he tried it on either fell for it or let him think we did.
It was such soft soap and he was very good-looking.

I look all right now, for thirty-three, but even when I was
twenty-nine, men's heads didn't turn when I walked down the
street. His paying attention to me, topped with a few choruses of
"My Sweet Katy," made me feel pretty.

And I liked being seen with him. As I said, he didn't care for
hats, so a suntan was practically his trademark, and he kept a sun-
lamp at home when I knew him. He was just a little older and a
little taller than I, with a slender build, and muscles that were
knotted, not swollen. He looked for all the world like a dancer—
and he could dance, too!

We were a couple for a couple of months. I've never regretted
it. He was a lot of fun, and a first-class musician. He made me feel
special. He even wrote me a real song, once.

But he got offered a gig playing trombone with the Casa

Loma band, and went out on the road. I'd never asked him to swear he loved me, and he'd never promised me a ring. The only time I hurt was in the weeks before he went away for good. Not knowing what he felt made me edgy, and I stayed indoors a lot.

But you won't hear me moan. A fling with a Lothario can be a lot of fun if you don't get all mushy over him. Guys like that really know how to please a girl: they've got great technique, if you take my meaning. You just have to remember that they're always looking for somebody to practice on.

Eating our hot dogs kept us from talking much as we walked. Just as we got close enough to see the yellow braid on the band's uniforms, though, somebody across the pier let out a shriek that was louder than the trumpet.

A dozen people started yelling for help, and half the crowd turned around to see why. The bandmaster kept the beat going for a few more seconds, but finally realized something had happened. He whisked his baton from side to side and shook his head, then lowered his arms and turned around as the music stopped.

I followed the crowd's eyes toward the south rail.

Ted dashed ahead of me. "That's where I left Lois!" He pushed through, calling, "Lois!" and apologizing only when he bumped someone too hard.

On the fringe of the crowd, people were asking, "What happened?" while those closer in were calling back, "Somebody fell in," and the ones who were leaning over the rail were screaming, "There she is!" and "Get the lifeguard!"

"I can't find her!" Ted yelled to me.

I reached the rail right after he did, elbowing away whoever closed in between us, and saying, "I'm with him" to excuse myself.

Ted stood still at the rail, panting and looking around, and calling, "Lois! Where are you? Lois!"

A young woman in a snug, old-fashioned yellow bonnet poked him in the ribs and said, "You lookin' fer th' l'il brunette 'n a white blouse?"

"Yes."

"Then that's her, sure 'nough." She pointed into the water.

"Lois!" he yelled.

I stepped up onto the lowest rung of the railing and held on to the top one as I looked over. The ocean was about fifty feet down. She was slapping the water, but she made no headway toward a life preserver that somebody had thrown over. A few feet beyond, a large straw picture hat with white ribbon for trim rode the crests of waves that picked the girl up and knocked her repeatedly against the pier's black creosoted pilings.

The woman in the bonnet—an Okie, I guessed from her accent—was saying, "I seen her fall in," to no one in particular. "Somebody bumped her, 's what happened."

"Somebody bumped her?" I repeated. "Did you see who? Did you see what happened?"

Buck teeth and acne scars soured her face; her shoes needed repair; a scarf tied into a bindle hung from a knot in the rope that belted her patched dress. She jerked a thumb toward Ted. "You with him?"

"Yes."

She looked at me for a moment, and ran her tongue over her big front teeth. "I seen her sittin' up there on the what'd'y'call — the railin' — watchin' the ban' playin'. And then, sudden-like, she was in the drink."

Ted was still calling down to Lois. I asked the woman what happened.

"I don' know 'zactly. Lady walked past, 'tween me 'n' her.

Next thing I seen was the gal lost her balance an' went right over, fanny-first."

That drew a laugh from the people who had gathered along the rail to watch, but it was the kind you can't help. When something horrible is happening, and there's nothing you can do about it, you're easily distracted.

New people had crowded in, so she looked around and began again. "I seen the whole thing, y'know. This girl was—"

"But, miss," I demanded, "when she fell did she say anything? Or cry out?"

"I couldn' hear nothin' 'cept the band. But I'm gone deef on this side—" she touched one ear. "You got a dime, maybe? Could you help me out?"

I pulled the quarter from the pocket of my sundress and gave it to her. She grinned her thanks, and spun back around to sell her story to someone else. "We was all watchin' the band. She was right behin' me when—"

"Here comes the lifeguard! Here comes the lifeguard!" a little boy sing-songed, pointing toward the beach.

A young man with big shoulders was running down the shore and into the surf. He swam like an Olympian, with incredibly long strokes, taking practically no breaths.

An elderly woman in a long dress started scolding Ted: "A fine escort you are, leaving your young lady alone." And nearby voices called out, "Yeah!" and "That's right!" and "Where were you when she needed you?"

The lifeguard reached Lois inside of half a minute. The people around us dropped their calumny and started cheering as he dove under her, came up beside her, crooked one arm under her chin, and fended off a piling with the other. A wave lofted them up together against it, but he kicked off from it, reached into a sidestroke with his free hand, and towed her back to the beach.

I could see Lois's upturned face. She was coughing, and there was blood around her mouth, like she'd banged her nose or cut her lip or broken her teeth.

Something glinted, down at my feet. I stooped and picked it up: a long hatpin with a bronze ball on the end.

Ted started to push through the crowd. He looked at the hot dog in his hand, the one he'd bought for Lois, and froze for a moment. Then he dropped it in a trash barrel. The woman in the bonnet dove for it and crammed it into her mouth as though she'd had to fight for every morsel she'd ever eaten. That upset me more than seeing Lois bloody in the water. I looked away, caught sight of Ted's back, and took off after him.

The ambulance had sped away with Lois aboard before we'd elbowed our way back through the crowd and onto the boardwalk. Another lifeguard at the rescue station told us where she'd been taken, and we walked there as fast as we could. The hospital was a couple of blocks in from the beach, a modern stucco building with glass-block windows.

By the time we showed up, they'd wheeled Lois straight into the emergency room, pumped her dry, given her a shot, and put her in a ward to sleep it off. Ted filled out the paperwork.

"She's having trouble breathing," the doctor told us. "I've ordered an oxygen tent for her."

"Will she be all right?"

"I can't do a thorough examination until she's awake. I want to keep her here overnight. Can you stick around for a couple of hours, just in case her condition changes?"

Ted nodded. "I guess she can't go back to work tomorrow, huh?"

"Oh, no. Even if she's all right in the morning, she ought to rest for a few days."

Ted nodded. "I better make a phone call—get somebody to bring her suitcase over from the hotel." He jingled a nickel out of his pocket and trotted down the hall to a booth.

Nobody was waiting for me back at the YW; there was no place I had to go. I walked down the hall to the waiting area by the elevators, and poured two coffees from a percolator on a hot-plate. When he sat down beside me on the bench I handed him his cup. "One sugar, no cream, right?"

"Right. Thanks."

"You know what would be nice? Tomorrow, you should go out and buy Lois another hat. The one that was in the water won't be—"

"She wasn't wearing a hat."

"She wasn't?"

"No. It must have flown off somebody else's head when they leaned over to see what happened. Serves them right for gawk-ing!"

"I found a hatpin. I thought Lois might've let go of the rail to fix her hat with both hands—" I pantomimed it "—when she slipped."

"You jump to conclusions, Katy. You always did. But thanks for asking around, out there. I was...well, I just froze." He looked at his watch. "I guess we've got time to catch up now. Where are you working?"

"No place for long. I was on tour until three weeks ago, with the road company of *Broadway Ballyhoo*. We hit a stretch of slow nights in New Mexico and Arizona, and we were supposed to have a two-week run here in L.A., but the show closed after six nights. I've been picking up occasionals and one-nighters since then, but nothing steady."

"We've been on the road, too," he said. "We started in New York, hit Chicago, Kansas City, Des Moines, Denver, Phoenix,

and San Diego. And as you know, we just played the Ambassador, Friday and Saturday nights." He waited a couple of beats, then said, "Lois has been with me since the beginning, and she knows the material cold. But she doesn't have your technique."

"I've been hearing some of your songs on the air. They're great. I've always thought so."

We looked at each other. I nodded. He smiled. Finally, he said, "What the heck! Lois won't be able to play this week, and I need a violinist to replace her. I don't want to go down to the union hall and hire a stranger. Could you take over?"

"When's the gig? Tomorrow night?"

"No, not Monday. Our week starts on Tuesdays."

"What 'week'?"

"Oh gosh! I didn't tell you: we're still on the road. It's practically the end of the tour, but we've got five more nights to play, up in Northern California."

It sounded like a great opportunity, but a week in a car with an old boyfriend could be trouble. "Gee, I'm sorry. I promised to play a wedding Saturday in San Pedro: twenty bucks to be a strolling violinist."

"I'll book you from now *through* Saturday. How does one seventy-five sound?"

One seventy-five a week was top scale in the American Federation of Musicians. It was also more than twice my rent for the month, so I'd have almost enough left for a train ticket back to New York. Swinging with the Ultra Belles would be a fine way to stretch my repertoire, too. I might even get other work out of it, from being able to say I'd played with them.

I was a little worried about how his girlfriend, the singer, might take it if she knew Ted and I had been romantic once. But I'd find a way to hide the fact or work around it, because I didn't

want to miss this chance. Females have it rough in the music business: men get most of the work, especially playing the new swing sound. None of the pros are making co-ed bands; if you want to play swing anywhere, you have to get into an all-girl orchestra—and they are rare.

I grinned and said, "I'll ride down to the union tomorrow and get someone to sub for me."

"I bet you're still a quick study."

"Conservatory training never deserts you, even if you wish it would sometimes."

"You've only got forty-eight hours to learn my arrangements. We leave tomorrow night and play Tuesday night in Santa Cruz; then we go to Oakland, Sacramento, Lake Tahoe, and wind up in San Francisco."

"Then are you heading back east?"

"No. The tour's open-ended after Saturday. If the Ambassador doesn't bring us back here, we'll probably stay up in Frisco. That's the radio hub of the West Coast; we should be able to land a guest spot on one of the networks. Even if we don't, there's plenty of hotel gigs that we could take. And the Treasure Island World's Fair just reopened last month: fairs always need bands. If Lois isn't better soon, can you stick with us for a while?"

"As long as I can wire the rent back to my landlady in New York. Did you charter a bus?"

"No. The whole tour's been by train. We have an investor, so there's real money in this gig. We've had Pullmans for the overnights."

"I don't have to share your berth, do I?"

He chuckled. "Don't worry: I'm not going to reprise 'My Sweet Katy.'"

"Thanks."

Ted was going steady when I'd seen him last summer. He'd

sold a dozen of his songs to a dilettante playwright who'd written a show called *To the Nines*. It was being tried out in Philadelphia, in hopes of bringing it to Broadway, and Ted was keeping company with the leading lady.

"So you're still seeing that singer, huh?"

"Uh-huh."

"That's great," I said, and I meant it. "You were hoping it would last."

"Huh?"

"I met her, remember? You brought her up to New York last July to see *Hellzapoppin'*, and I ran into you in the lobby. I forget her name. Short hair, button nose, pointy chin…she was very cute."

"Oh, no. Not Belinda!"

"I'm sorry. I thought—"

"No, Belinda is the girl you met. But that's all over now."

"The romance and the show both closed out of town, huh?"

He shrugged.

"You took me aside while she went to the ladies' room, and you told me she was 'the one.'"

He sidled up closer to me. "At the time, she was the one."

I tilted my head toward him. "What happened? You couldn't sing 'My Sweet Belinda' with three syllables?"

"She…she didn't work out, for the Ultra Belles. Nice voice, but all wrong for the job. She's a good actress: she's been on the stage since she was a child, played everything from ingenues to character parts; got good notices. But as a singer in a working band, she didn't have the right approach for a swing band. She can project to the back of a theater when everyone's sitting still, facing front. But she can't work a crowded ballroom or a noisy club. I gave her a few weeks to work up the right style, so she started imitating other singers, copying what they do—"

"Like an actress developing a character."

"Exactly. But I didn't want an imitation of somebody else. I need an original voice who can showcase original tunes."

"You did get Billie Holiday to record 'Walking on Eggshells'!"

"I didn't 'get' her: I had to hustle her manager with some dough, just to put it on the B-side of 'Some Other Spring.' I sure can't afford to hire her as my canary."

"Can't you parlay that platter into something big, like a song-writing job in a Hollywood studio?"

He lowered his voice. "That's what I'm hoping to do. The Ultra Belles just got picked up by a big talent agency, so I think a call might come through, soon. As long as I'm out here, I'm available. The agency's going to line up some gigs anyway, though, in case Hollywood *doesn't* call. But enough about me. You need the band's play-list. Let me put you in a taxi back to the Y, and I'll send a messenger around in the morning with the arrangements. No, wait. You need to go to the costumer and be fitted for your outfit. I'll take you there tomorrow. I'll pick you up at nine o'clock."

"Who's your new canary?"

"Eileen Wheeler. She's a good egg, Katy. Real bright. Like you. I'm sure you'll get along fine. I'll bring the arrangements to-morrow, too. You'll have all the rest of the day to look them over. I'm sure you'll pick up on our style right away. And if you've got any questions, we can go over everything tomorrow night on the train."

A cab was waiting at the hack-stand by the hospital entrance. I opened the door, but before I got in I turned and asked, "How come you didn't ask me to join your band last winter when you started it up, Ted? You needed a sax and a violin. I play sax and violin. You're based in New York. I live in New York. Is it because we used to—?"

"No. I phoned the union for your number, but they said you were out of town. Weren't you playing up at some ski lodge all through January?"

"Oh. Yeah, I was. I hadn't worked much after Christmas. I thought I was *lucky*, getting that gig."

MONDAY

NEXT MORNING, TED

picked me up in a rented Plymouth coupé.

"How's Lois?" I asked, as I squeezed in and shut the door.

"Her throat's sore. She can't talk, can't even swallow. She really hurt herself."

"I'm sorry." A block or so further, as we turned onto Third Street and headed west, I said, "Tell me about Eileen. Is she 'the one' now?"

"I think she might be. We've been going together since March. But I can't make a move while her divorce is pending."

"She's *married?*" I giggled. "You're catnip to girls, Ted, I swear. Wasn't what's-her-name married, too? That stripper who—"

"Katy, you need to know this—the whole band knows. The situation with Eileen and me is very delicate."

"I'm sure it is."

"No, really. I can't make a play for her until her divorce is

31

final. If anybody saw us together, I mean in any situation that wasn't strictly professional, they might tell her husband and he might decide not to go through with it. That's why I was taking Lois out yesterday: to make it look like… You see, Eileen wants me to go on playing the ladies'-man, and pretend that she's just another member of the band, until she's free to marry me."

"I don't believe I've ever heard the words 'marry me' come out of your mouth."

He looked at his watch, even though there was a big clock in the dashboard.

I changed the subject. "What're our band costumes like? Are we little Shirley Temples in dirndls? Wait. No. You wouldn't do that. Tunics and epaulets. No, not that either. I've got it—" I snapped my fingers. "Eileen's the bride in white, and the rest of us are bridesmaids, all in pink chiffon."

"You've never lost your sarcastic edge, have you, Katy? Think about 'Ultra,' like sophisticated, or ultra-new. And 'Belles,' like belles-of-the-ball."

"Okay."

"You're in evening clothes: maroon satin, full-length and bias-cut."

"Whooo!"

"They're the gowns that were made for my show—for *To the Nines*, last year. I got a deal on them."

We pulled up in front of a small theatrical shop on Melrose Avenue. A willowy blonde in a tight green suit and matching cloche hat opened the door and waved.

"Eileen Wheeler, this is Katy Green," he called across the seat as I got out. "Katy and I played in a band together in New York, a few years ago, so I know she's good."

"Pleased to meet you." She shook my hand firmly and said,

"Let's get you fitted. I brought the extra gowns; I'm sure one of them will do. Ted, why don't you drive out and visit Lois, and take her these." She handed him a couple of gift-wrapped candy boxes and a wad of magazines. "Tell her everybody misses her, and we'll see her as soon as we get back here."

"Of course. Bye, Katy. Here's those arrangements." He passed me a thick manila envelope from his briefcase. "We're meeting at Union Station. The *Starlight* leaves at six. I know you're punctual, but be there at five-thirty at the latest, please. North side of the waiting room."

I thanked him again, and he drove off.

Eileen was in her mid-twenties: a looker—the kind men notice—especially in the figure department. But she was this side of glamorous. Long hair concealed a long neck, and her eyes were set rather close together. When she pulled off her gloves, a couple of carats beamed, and she wore a platinum wedding band, too.

The costume fitter ran a tape around me, top and bottom, front and back, then opened each of the boxes and checked the sizes. She picked one out, handed it to me, and pointed to a curtain. I slipped my dress off over my head and held the gown up against my slip, expecting to smell mothballs. But it smelled of naphtha: it had just been dry-cleaned.

As promised, though, it was a full-length gown of sleek maroon satin, cut on the bias so it would cling tight. I stepped into it and pulled it up to my shoulders. It was smooth all over and very cool to the touch, like lingerie. I could never afford a dress that was made this well. And fashionable! You'd never call a bias-cut gown "last year's dress." It won't go out of style as long as men like to look at what's inside.

But it was, after all, a costume. A real evening gown has buttons in the back that you need somebody to help you with. This

one had a zipper up the left side, so you could put it on and take it off backstage all by yourself.

The fitter checked the drape and the selvage edges, and ran her thumb along all the seams. "Close enough. The hem is a bit low, but on stage you will wear heels, yes? Come back in half an hour. I also pull the bodice in a little more tighter; you are not as big on top as Miss Dumont."

"This is *Lois's* gown?" I looked at Eileen.

"She won't need it."

So that was why it had just been cleaned. I wouldn't try to sing for a living, but I can carry a tune, and as I stepped back into my own dress I sang, "'Secondhand Rose, I'm wearing secondhand clothes....' Don't worry, Eileen, I only sing in the tub."

While the fitter made the alterations, Eileen and I walked down Melrose Avenue to a luncheonette, and talked about the music business. I told her she was lucky being in a band right now, 'cause it was hard to find steady work.

"Oh, we've got competition, though. There are distaff bands all over the country. Ina Ray Hutton and her Melodears are playing at the top hotels. And a guy standing in front with a baton isn't original either, now that Phil Spitalny and his Hour of Charm Orchestra are on the radio."

"Sure, but those midwest bands aren't playing original songs. And Phil's band..." I drew a square outline in the air with my index fingers. "Have you ever seen them? Twenty-four girls in white organdy dresses with polka-dots. And a sound so sweet you get cavities in your teeth."

She smiled. "Our trumpet player was with the Hour of Charm. You'll meet her later."

"Can you get gigs that are strictly swing?"

"Oh no. We have to play a lot of sweet stuff, too. But we

bought back the rights to Ted's songs from *To the Nines*. Ted's put them into some very innovative swing arrangements."

"The last time I read about the Ultra Belles in *The Billboard* magazine, you were six nights a week at a hotel in Philadelphia."

"You don't get famous working in Philly. So in February we cut a demonstration record and sent it around to the big talent agencies. Then we put this tour together by ourselves. But just last month we were picked up by Consolidated Talent Services. They're practically the biggest agency in the country, and they've assigned one of their people on the West Coast to join us, starting tonight. He's going to represent us and work up the publicity materials we'll need to keep going national in a big way, and maybe get us some radio time, too. Or some movie shorts."

"Congratulations." I smiled. "I know Ted wants to do something in the movies."

She touched wisps of hair that had drifted out from under her cloche.

"So do I."

The waiting room in Union Station wasn't crowded, but it was hot. Wherever sunlight slanted down through the big arched windows you could see little dust-glints in the air. Most of the people were commuters heading to the suburbs from the nearby tracks, where the interurban cars waited to take them home. The long-distance train platforms were at the far end of the waiting room.

I'd been on the road so long, it had taken me almost no time to pack everything I'd brought west into my big suitcase and my overnight case. Along with my violin and my sax, they were a bulky load. But since I'd given away my lunch money on Sunday I was counting my quarters, and saving one by carrying my

own bags instead of letting a Redcap do it. So I was perspiring when I reached the gate—hardly the first impression I'd wanted to make.

Four women were standing with Ted and Eileen at Track 6.

The tallest was wearing a big red picture hat, and a gray suit that downplayed her wide hips. It was Suzanne Zimmer. I knew her slightly. She was a sax player. We'd met last January in New York, at the audition for the band that played at that ski lodge. We slipped our gloves off to shake hands.

"I remember you, Katy. How did it go, up at the Inn in— where was it? Vermont?"

"It was easy: we shucked ears every night."

"Oh, have I got stories about corny bands!"

I'd gotten that gig, and she hadn't. But now, it seemed, that was *her* good fortune, since it left her available when Ted came along with the Ultra Belles. I didn't expect her to thank me, and she didn't.

Suzanne was almost six feet tall; the top of my head just reached her fleshy nose. When she turned away to light a cork-tipped cigarette, her hat brim brushed my face. The crown was fixed to her hair with old-fashioned hatpins that had little black felt birds for decoration. She turned back and puffed her Herbert Tareyton out over my hair, and said, "We'll catch up on the train."

I put my hand out to greet the drummer and the clarinet player. We'd never met before, but I recognized them. Sonia and Helen Bliss were "Kid Sisters" when they were headliners in vaudeville, playing ukulele duets and singing funny novelty songs. They kept their gloves on to shake hands.

"I'm so glad to meet you two. My mother took me to see you when I was in my teens," I said. "I always loved that song you did: 'My Canary Has Circles Under His Eyes.'"

They sighed little thank-yous, but Sonia turned away and coughed politely into a lace handkerchief, so Helen said, "I hope you like what we're playing *now*."

"I'm sure I will."

I smiled, and nodded some more. They were in their forties now, both of them: long-waisted, with curly hair atop almond-shaped faces. Sonia looked to be the elder by four or five years, and her bones showed through paler skin, although she had a stronger grip than Helen when we shook hands. On her lapel she wore a pin in the shape of the American flag, and a presidential campaign button that read NO THIRD TERM.

Helen wore steel-rimmed eyeglasses. She was a bit taller, and fuller in the bust than her sister, but her dress was equally plain, and more than a few years out of date. Both of them paid more attention to their faces. At their age, I suppose, one is entitled to wear thick pancake makeup; although they'd tweezed out their eyebrows, fresh ones were outlined with black pencil.

I waited politely for one of them to say something further, but finally I just said, "Thank you," and turned to introduce myself to the last woman, who right away said, "You'll get used to the Dolly Sisters!"

"That's enough of your sass, Jacqueline!" Sonia scolded. "We are not as old as the Dollys!"

I said, "Nice to meet you, Jacqueline," and extended my hand.

"Call me Jack."

She was younger than I, probably not even thirty, and about my height, but slender—skinny, really—with tightly marcelled brown hair. More boyish than manlike, she had on a trousered wool suit with a kerchief for a necktie, no gloves, and practically no makeup. I was reminded of that movie, *Sylvia Scarlett*, where Katharine Hepburn pretends to be a boy, but you never quite

believe it, and you can't imagine why nobody else on the screen can see that she's pretty.

Jack offered me a smoke from a crushed pack of Spuds, but I declined and she lit one for herself. I glanced at the big clock overhead, then at my watch—which was only a minute slow—and said, "I hope the other girls don't miss the train."

"We're just waiting for the agent from Consolidated," Ted said. "Ivy and Lillian will get on in Santa Barbara. We had these last two days free."

Jack snorted smoke out her nostrils. "There was a surfboarding competition up there this weekend, and they went up to see if they could ride a couple of the surf-riders."

"That's not funny," said Sonia.

But Suzanne and Eileen chuckled, so I did, too, to be sociable.

Helen leaned in toward Ted. "How about giving Katy your 'Five Commandments.'"

He smiled at me. "Now Katy, I'm ver-r-y strict about these rules."

"I bet you are."

"The First Commandment is: No jazz."

I squinted. "Huh?"

"No spontaneous solos, no riffs. Just play everything the way it's written."

"Oh, sure. You're the arranger."

"The Second Commandment is: No smoking on stage, or where—"

"I don't smoke."

"That's good, Katy," said Helen. "Sonia and I don't smoke either."

"On the road or in your room, it's okay," Ted went on, though he was looking at Jack. "But no smoking in public, or wherever

the patrons or the club managers can see you. Some of them are very old-fashioned."

I nodded.

"The Third Commandment is: No drinking on any day that we're playing, until after the last set. And if you do drink afterward—" now he was looking at Suzanne "—make sure your hangover's gone by the time we play the following night. The Fourth Commandment is: No traveling to a gig on your own. I don't want anybody driving away with some guy they've just met and saying they'll catch up with us in the next town, because they never do. The Fifth Commandment's the most important of all, and that is: If any stage-door johnnies come around to see you…no fraternizing!"

A tall man—out of breath—caught up with us just as we were boarding the train. His double-breasted seersucker suit jacket was unbuttoned and flapping. He clutched a gray fedora, a portfolio, two suitcases, and a portable typewriter. He set down the smaller cases, pushed his right hand into Ted's, and shook it hard.

"You must be Nywatt. I'm Blunt, Consolidated Talent Services. Are these your girls?"

He had an English accent—and it didn't sound phony. He was in his forties or early fifties, and a little puffy around the face. His hair was thick and black, but unfluttered after his run. A lot of older guys in show business feel they have to wear a toupee.

We each shook his hand and said our names.

"I'm pleased to meet you, ladies," he told us. "You look beautiful. I've heard your demonstration record, of course, and I must say the Ultra Belles swing beautifully, as belles-of-the-ball ought to do."

He meant well, I'm sure, but that wasn't an endearing remark. In our business we women hear a lot of applesauce along

the lines of: "You play pretty good, for a girl." But he'd been hired to promote us, not flatter us. And to his credit, as soon as he'd tossed his luggage onto a seat, he helped the Bliss sisters squeeze theirs down the aisle.

Our train took the coast route north. It pulled a diner and a club car that were on opposite sides of our car—which was a Pullman. Our car wasn't fancy, though it was new enough to be air-conditioned; but it had the familiar layout that old-timers on the railroad call a "sixteen-and-one." There was a men's room at the forward end; eight pairs of facing seats that converted to sixteen upper and lower berths at night, and one private compartment at the back end, just ahead of the ladies' room.

We pulled out of the station on time at six o'clock, and were zipping past the factories north of downtown a few minutes later. While Ted and the conductor did their business with our tickets, our new agent balanced his typewriter on his knees and gestured toward the rest of us to move in close to him.

"I'm going to take notes for your publicity materials. Until Consolidated assigns a press agent as well as an artists' representative, I'll be handling both jobs. So when I call your names, I'd like each of you to come forth. Mrs. Wheeler, what is—"

"Do we have to call you *Mister* Blunt?" Suzanne demanded.

"My colleagues at the agency have pared 'Manfred P. Blunt the Third' down to a nickname, and I have got into the habit of responding to it. So you may call me 'Manny.' Mrs. Wheeler, may we start with you, please? What's your age?"

"Twenty-three. And you might as well call me Eileen."

"How long have you been singing professionally?"

"Six years. I won a contest in high school and—"

"What was the prize?"

"A radio appearance and a year's supply of Pond's Cold Cream. Pond's took my picture for a magazine ad."

"Any nightclub work?"

"I teamed up with a piano player for a couple of years, doing covers of songs from stage shows and revues in a hotel lounge in Pasadena. That's my home town, by the way; and we still live there, my husband and I."

Suzanne leaned in, fussing with the long pins that fastened her picture hat to her hair. "Ask her if she's happily married."

"Shut up, stupid!" That was Eileen.

Manny looked around at us all. "Please, ladies. No one needs to know any more about your personal lives than we choose to tell them. I've been with Consolidated Talent Services for more than fifteen years, working out of their Hollywood office since 1932. I wouldn't have lasted in this business if I couldn't keep secrets, and I'd prefer that you do likewise. My job right now is to make you girls look good in print, and with a little luck, to get you a spot on the radio, or a film short, or a cameo appearance in a feature. The responsibility is mine and mine alone, so I'd rather nobody talked to the press if I'm not around. I don't want anyone to blurt out something that's supposed to be hush-hush. Is that clear?"

We all nodded that it was.

He pulled horn-rimmed glasses out of a leather case and set them halfway down his nose. Then he touch-typed for half a minute—almost as fast as a secretary. He peered at the paper, made a small correction with a fountain pen, and then yanked the page out. By then Ted had joined us, and Suzanne slid over in the seat so he could sit next to her.

Manny tipped his head up. "Another thing: There have evidently been changes in the line-up after your recording session." He peered down at a handwritten note in his typewriter case. "Lillian Vernakis—she's been playing trumpet since March, is that right?"

"Yes," said Ted, "but she's not here yet. She and Ivy Powell, the bass player, are getting on in Santa Barbara."

"All right. What about Miss, uh, Katherine Green?"

"It's Katy."

"Thank you. You're subbing for the girl who had the accident yesterday?"

"Yes."

"Unfortunately, you're not in the band photo that's been sent ahead to the clubs and ballrooms where you'll be playing. They'll have it pasted up on their display-boards—"

"We hope!" Suzanne chimed in.

"—but it no longer matches the band as it's presently constituted," he went on. "If anyone asks you how come, or what happened to Miss Dumont, you must send them to me."

"Sure."

Manny waved the typewritten page around. "A very important part of my job is to produce little squibs that a journalist can just drop right into his or her column. It's too bad you aren't booked into a gig in Pasadena. Are any of the other whistle-stops a home town for you girls?"

"Helen and I grew up in San Francisco," said Sonia, "although we haven't lived there for many years."

"I'm from San Francisco, too, but I'm no nabob from Nob Hill," Jack sneered. "I'm strictly south-of-the-Slot."

Helen leaned in toward Manny. "That means she's from south of Market Street. It's where the slaughterhouses are."

Jack leaped up.

"Please!" Manny held up his hands, palms out. "I don't care where you come from. The important thing is, Jack: do they love you in Frisco?"

"Huh?"

"Will a crowd turn out to see you play?"

"My pop might come if I can get him a free pass. But the places we play—nobody I know can afford the cover charge. Besides, I'm not the star of the show: Eileen's the—"

"We're going to make Eileen famous, don't you worry. I'll do a quick little interview with each of you this evening, as I did with Eileen here. This is just a rough draft—" he held the paper up again "—but it'll give you an idea of what I'm shooting for. I'll be up most of the night getting carbon paper all over my fingers, so that when we arrive in Santa Cruz in the morning, I'll be able to put a copy in every editor's hands in time for their afternoon editions. In the towns where we get in too late for that, I'll send my deathless prose ahead by night-wire."

Eileen grinned. "I've never had a press agent before. Can I hear what you wrote about me?"

"Certainly." He pulled his glasses down past the bridge of his nose and peered at the page. For a man with a puffy face, Manny had surprisingly agile features. While he talked his eyes were in motion. Even when he was silent, his lips fluttered. "'Eileen Wheeler is a twenty-three-year-old soprano with a starlet shape. Sponsored on the radio by a leading beauty cream since she was seventeen, she's sung more Broadway show tunes than Ethel Merman and Gertrude Lawrence put together. But—sorry, boys—she's a housewife, too.'"

"Not bad," Suzanne shrugged.

"It's terrific!" Eileen shot back.

Manny turned aside, toward the sisters. "Now, how about Helen and Sonia Bliss? There are plenty of people who remember you from vaudeville, but we're going to tell them why they should come hear you now. Tell me: what has been your happiest experience in this band?"

"May we talk it over between us first?" Helen said.

"We have some publicity materials of our own," Sonia

declared. "We've been very active in the presidential election campaigns since we left the stage, and we'd like you to mention that in your write-up."

"We have a photograph of ourselves with President Hoover."

"Autographed!" Sonia added.

Manny nodded, and ignored the chuckles from the other girls. "I see by your lapel pin, Sonia, that you're no fan of President Roosevelt. That may draw in some, uh—"

"Reactionary America-Firsters," Jack said loudly.

"—conservative audiences," Manny went on. "It's always good to broaden one's base."

Suzanne guffawed. "My base is too broad already!"

"So," he continued, "why don't you and your sister go and organize whatever materials you have, and I'll come back to you in a few minutes."

They retreated to their seat, opened a traveling case, and began whispering to one another.

Manny looked at Suzanne. "All right, Miss Suzanne Zimmer. It's your turn. Alto sax, right? Have you played anywhere famous?"

She took a long draw on her Tareyton. "Atlantic City and New York."

"I mean: with any famous bands?"

"Girls don't get those gigs."

"Hear! Hear!" I chimed in.

"What do you want people to know about you?"

"I'm single."

We all laughed out loud.

"Give me something from your professional work."

"I've done radio transcriptions."

"Such as…?"

"D'you know, on the Marx Brothers' radio show, when Groucho and Chico finish swapping insults, you hear this dirty sax

going 'harr-harr-harr' for a couple of seconds? That's me. The sound guy drops the needle on a recording of my solo, and the announcer cues the audience to applaud. That lasts a few seconds, then I segue into the sponsor's jingle, playing it straight."

"I recognize that riff. That's you, is it?"

"Damn right."

Manny typed for a moment, scrolled the page up, and read, "'Take a gander at statuesque Suzanne Zimmer: she's got *sax*-appeal. And radio fans, pay attention—this gal can get a laugh out of Groucho Marx.'"

"That's good! I like that. And nothing about my pear-shaped...tones! You're okay, Manny. Can I buy you a drink?"

"Later, perhaps."

"I keep a scrapbook; there's some clippings about the band in it—"

"The agency sent me their file. Thank you."

"Well, if you want to see what I've got...if you'd like to see anything that I've got...you just let me know. I'm single, remember?"

He made a prim smile. "Thank you, Suzanne."

"Okay. When you want that drink...anybody want to go get a drink?" None of us moved. "Well, I'll see you later. I'm going to the club car." She stood up and walked away toward the rear of the train.

Manny looked at Jack, who was slumped down with her legs up on the seat across; a Spud dangled from her lips, almost touching her neckerchief. "Miss Jack Morel. What's 'Jack' for? Jacqueline?"

"It's not short for anything, Comrade. It's just Jack."

"'Comrade'?"

"Da."

"Don't you find that a tilt to the left is passé in California?"

"Listen, Manny, I was born in America and I'm proud to be an American. But the Depression isn't over for everybody; Roosevelt's takin' his sweet time pulling us out. He hasn't got the nerve to go fight Hitler, either. If Upton Sinclair was governor or if Henry Wallace was president—"

"Sing us 'The Internationale,' why don't you?" Sonia called over.

"Buzz off, Sonia!" Jack shot back. "Who hired lawyers for the Scottsboro Boys? Who sent the Abraham Lincoln Brigade over to Spain to fight against Franco? The American Communist Party, that's who."

"You heard her, Manny. Write down that she's a Communist."

"It's not against the law!"

Manny nodded. "You're right, Jack, it isn't. But I think we won't mention it anyway. You can argue over politics another time. Is there anything of substance that you'd like me to include?"

Jack took a drag on her Spud and glanced at Ted for a second. "I'll give you a good quote for your paragraph, Manny: 'Jack refuses all requests to wear falsies.'"

"Irrelevant. What's your instrument?"

"Guitar."

"Where've you played?"

"I was in *To the Nines*—in Philly, last year. Played in the orchestra. That's how come Ted tapped me for the Ultra Belles, when he formed the band in January. I know all his material."

"And before that, where did you work?"

"Some New York clubs, in Greenwich Village mostly."

Manny smiled, and for a moment, looked as though he were going to say something, but he didn't. Instead he typed for a moment, and read what he'd written aloud. "'Feisty Jack Morel is young, but she's the senior member of the band, with a big

following among progressive social thinkers and swing-loving bohemians.'"

Jack grinned. "That's okay!"

"Friends?"

She shook his hand. "Comrades."

Manny smiled, looked around and found me. "Katy Green, where d'you come from?"

"I've been based in New York City for eight years."

"Violin, right?"

"In this band? Yes."

"You play something else?"

"I double on alto sax. A girl's got to eat."

"Worked with any headliners?"

"Not until now."

Ted called out, "Thank you!"

"I presume you had formal music training?"

"I majored in music at Syracuse University, and spent a year at the Rochester Conservatory after that."

"Do you still play classical music?"

"Whenever I can. But females don't get a lot of longhair gigs, at least not where they can work their way up the ranks, like a symphony or an opera house."

"There's more work playing swing violin, eh?"

"Not enough. Same problem: no girls allowed in the clubhouse."

"What's your background, Katy? Dark hair, dark eyes. Are you Greek? Italian, maybe? Are you a 'Latin from Manhattan'?" he sang, treating the song's melody badly but shaking his arms and shoulders as though he were playing maracas. We all laughed, and joined in to sing it through the chorus.

Finally I got a chance to say, "No Latin or Greek or Italian in my family. We're from upstate New York. I'm the fifth generation.

But what about you? Where are *you* from? I wasn't expecting an Englishman."

"No doubt." He looked around. "You were probably expecting an unshaven oaf from Tin Pan Alley who chews his cigars and snarls for speaking. Consolidated Talent Services has more than its share of such men. But it's rather advantageous being an Englishman in Hollywood these days." He started typing while he spoke. "We English have a sort of colony in Los Angeles. It's quite a lark. The film studios love the way we move our vowels. Now, how's this: 'Dark-eyed Katy Green left the straight and narrow back in the sticks, and swapped her conservatory violin for a hot swing fiddle.'"

"Sounds good to me," I said. "Thank you."

It sort of implied I was easy, but I didn't ask him to change it. A blurb could never say everything about who I am. People are too complex and inconsistent to be boiled down to a couple of phrases. It's like when somebody writes a song: you can never sum up everything you want to say in thirty-two bars. I don't know why sailors get tattoos either: one little image can't possibly express an entire personality.

Manny called over his shoulder to the Bliss sisters, "Are you ready?"

Sonia nodded, and he got up and took his typewriter over to their seat.

Jack touched my arm. "I'm thirsty. Wanna go check out the club car?"

"Okay."

Then she whispered, "You said you knew Suzanne from before. Did you know she's a lush?"

"Uh-huh."

"Well, I hate it when anybody gets too many drinks ahead."

• • •

Luckily, Jack didn't try to match Suzanne drink-for-drink. I'd suspected Suzanne had a drinking problem since that audition last winter. I'd seen her take a quick nip from a flask in her saxophone case just before her name was called to go in and play. Maybe she lost out because the bandleader smelled it on her breath. Who knows?

She could hold her liquor now, though. Even after two hours her speech wasn't slurry, and she didn't seem to have any trouble standing when she got up and went out to the ladies' room.

But she was drunk, all right. She stepped in front of Ted, who was just coming in, and made a grand gesture of letting one arm drape over his shoulder. And in a theatrically affectionate voice, loud enough for all the other passengers to hear, she said, "Dahling, come to my bed this evening. We can get cozy in an upper berth. I know you like that!"

With an equally theatrical flourish, he dipped her over backward—like Valentino did to Agnes Ayres in *The Sheik*—and planted a noisy wet kiss on her lips. She moaned loudly, then wrapped one leg around his and thrust her hips up against him a couple of times. Unfortunately she was too heavy, and slipped out of his arms, landing on her bottom with a *thunk*.

A middle-aged man who'd been writing in a notebook looked up and chuckled. A young couple giggled and pointed. And an overweight peroxide blonde peered past the top of her magazine with a squinty stare of disapproval. We girls all burst out laughing.

When Ted helped Suzanne to her feet, she looked at him with what seemed to be more than humor in her eyes. But then she continued on out, waving hello to Eileen and Manny as she passed them, and then to two more women who were just coming through the door into the club car. They were the band members who had come aboard in Santa Barbara, and I was introduced to them. They were both a little older than I, closer to forty than thirty.

Lillian Vernakis, the trumpet player, had an olive complexion, shiny white teeth, a thick pile of black hair…and a very big chest that undoubtedly turned heads on the street. But Lillian wasn't a pin-up candidate: she wasn't tall or young or slender. If Suzanne was a pear, Lillian was an apple.

Ivy Powell was more conventionally proportioned, but she stood only about four-feet-ten: like a tiny scale-model of a woman. She was wearing a sleeveless dress, so I could see how muscular her arms were: she'd have to be strong to pick up and carry an instrument as big as a bass.

Ivy had a moon-shaped face that she held tilted up, chin out, probably the result of being surrounded by taller people all her life. But it gave her a belligerent look—something that also came through in her language, which was as salty and uninhibited as a sailor's. After her first swallow of Scotch she turned to me and said: "A fiddler, huh? D'you know the one about the fiddler with a harelip? All the girl-bands wanted her, because she said she was a 'diddler'!"

Ted gestured for quiet, then briefed us on our itinerary. We'd be playing tomorrow night—Tuesday—at the Coconut Grove ballroom at the Beach Boardwalk in Santa Cruz. Then on Wednesday night we'd be at the Piedmont Country Club in Oakland. We'd go to Sacramento for a gig at the Golden Eagle Hotel on Thursday; play the Tahoe Tavern on the shores of Lake Tahoe Friday night; and catch the Western Pacific's new diesel streamliner, the *Zephyr*, back to San Francisco the next morning, for a one-night stand Saturday at the Top of the Mark.

Then Manny took care of some band business for Consolidated. He checked our union cards, just to make sure we were all up-to-date. And there was an extra form he had to fill out for the Social Security Administration, so we all had to get out our new little white cards and read off our numbers to him.

Ted gave him the ticket stubs for the boxes that were con-signed to the baggage car: the larger pieces of luggage, the crates that held Sonia's drum set, and those containing our gowns and our bandstands. He asked if anyone else had baggage stubs; Ivy gave him hers, for her bass, and the rest of us surrendered our lug-gage receipts. He put them all in his billfold.

We heard the steward call the last dinner seating, and Ted told me that the tour picked up the tab for all our meals on all the trains, but any liquor we ordered was strictly Dutch treat.

I hadn't known what arrangements he'd made, so I'd brought along some tunafish sandwiches with mayonnaise dressing, and two bottles of Coke, in my big pocketbook. I got them out, un-wrapped the waxed paper from the sandwiches, and broke them into chunks to share.

Eileen took one, and with a theatrical flourish said, "Mmm, *hors d'oeuvres.*"

Ivy, however, squeezed one into a ball in her fist, wedged it into her mouth and mumbled, "Mmm. Horse's ovaries."

Jack said, "Watch this!" She stuck one of the Coke bottles in her mouth, and pried off the cap with her teeth.

All in all, the Ultra Belles were a fair cross section of the dis-taff ranks of the American Federation of Musicians.

We ate supper while the train skimmed along the rugged Pacific coast, past promontories and inlets and beaches that were dimly visible under the crescent moon.

Before I'd left the YW in L.A. that afternoon, I'd spent a cou-ple of hours going over the band arrangements Ted had given me. But I had some questions, so I buttonholed him in the aisle and asked him to come back to the club car with me. We settled into big leather chairs beside Eileen and Manny. Ted bought beer for me, Manny, and himself, and a martini cocktail for Eileen.

"It's all these rests," I said, opening the music sheets and pointing. "Thirty-two bars in this tune; sixty-four bars in that one. I'll be sitting out almost half the time. Not that I'm complaining, but—"

"All the other parts look like that, too."

"Now you've really got me confused."

"It's an original idea of mine."

"You said, 'no jazz,' but this looks like 'no music.'"

"I'm trying something I used to do in a small combo: I'm separating out the soloist and adding just a bare minimum of backup, to the point where there's practically no full 'chord' to be heard at all, like in a duet or a trio."

Manny sipped his beer. "I never heard of such a thing, even in a small band this size."

"It sounds awfully progressive for hotel ballrooms," I said.

"So what?" Eileen demanded. "It'll make Ted famous, and that's the whole idea. Why, Jack and I are already working up some duets: guitar and vocals, like Eddie Lang and Bing Crosby. We ran through some songs yesterday at the hotel while Ted and Lois were…well, anyway—"

"They're my own songs, so they should have my own sound. I've been working up these arrangements for months, and I'm dying to try them out on real audiences."

I gestured toward the music sheets. "So, what do you call it? 'Ted's Big Toot'?"

He chuckled. "I don't have a name for it. Manny, you're the publicity expert; how about a name for the baby?"

Manny rubbed the soft folds of his chins with a bitten-down thumbnail. Then he shrugged. "They're Nywatt songs. Call it 'the Nywatt Sound.'"

Ted smiled. "What do you think, Eileen?"

"They'll remember your name, and that's what you want."

"We've got time for a full rehearsal tomorrow afternoon in Santa Cruz. 'The Nywatt Sound'… Thank you, Manny."

Manny smiled and said, "Baby-naming is only one of the many services our clients enjoy, at Consolidated." He took a brown leather pouch from his jacket pocket, extracted a briar pipe, and tucked tobacco into it with his finger. "Now, Ted, you and I must go over my squibs before I make carbons for the newspapers. Would you excuse us, ladies?" He lit the pipe with a gold lighter.

I started gathering up my music pages to take them back to our car, when Eileen asked me, "Are you sleepy? Can you chat for a minute?"

"What is it?"

She motioned me over to a pair of seats a few yards away, and drew hers up right against mine. "Ted told me that you and he used to be…closer than just in a band together. So I want you to know that it's okay with me."

"I have no intention of —"

"I'm sure you don't. But you're not the only girl around here that he's been involved with."

"Oh." I made a half smile. Maybe it wasn't "okay" with her about Ted and me.

"Ted's had some, uh, hands-on experience with girls in the band. Before me there was Joan Barber, but she…well, I'd rather not go into the details. It all ended back in February. Since then he's been seeing a lot of Lois."

So she did have a jealous streak. Well, she wouldn't have to worry about me. "I'm sorry he's not faithful to you, Eileen, but that's the way he's always been. Maybe he's not ready to change, even for you."

She took a long drink from her shallow martini glass. "Have you ever been married?"

"No."

"Well, it's real easy to get married out here, but they make it hard to get *un*married. There's only one legal ground for divorce, and that's adultery. My husband had an affair with his secretary last year, so I can sue *him* for divorce."

"That's lucky! Oh! No. I'm sorry. I didn't mean—"

"We've been married for three years, but we fell out of love after the first. I hired a detective to get proof of the affair, and he took a photograph of them checking into a motor court down in La Jolla. It'll stand up as evidence, I'm sure. But our case won't be heard until September. I'll marry Ted just as soon as the divorce comes through, but—" she took another sip "—my husband doesn't want everybody to know he cheated on me. I can't blame him: it would be embarrassing for him professionally to be tarred as an adulterer. But the law's the law: if we want a divorce, one of us has to prove adultery."

"You could go to Reno," I said. "I heard that if you live there for whatever it is, a month or two, you become a Nevada resident. And they aren't so strict in Nevada about grounds for divorce."

"That's what my husband wants me to do. If I went to Reno he'd give me the divorce with no questions asked."

"So what's the problem?"

"That residency requirement. It's six weeks in the desert! I can't leave the band now, even for one night. We could pick up a steady gig in L.A. or Frisco, or go out on another tour. We're on a roll! They love us everywhere we've played. We'll have plenty of work for the rest of the year. I can't afford to cut out now. This is my big break."

"You have the law on your side," I said. "Your husband had his affair and you can prove it."

"It's not sitting well with him. He went to one of those big detective agencies and hired them to spy on Ted and me while we're on tour."

"Well, fair's fair. You did it first."

"No, *he* did it first. Before we were married, he hired them to check up on me, to make sure I was all right. It was the first breach in our marriage, when I found out he'd done that. And now he's brought them in again. If they get wind of my affair with Ted—especially if they can get a picture or something that makes it look like I'm bunking with him—the judge will throw out my suit. Then it could be months, maybe even years before I can get a divorce. Will you help me?"

"How can I help?"

"Ted's a man who loves women; you know that."

"Oh, yes."

"So if he flirts with you, like he flirted with Suzanne tonight, go along with it. Let the detectives see him do it. I'm sure some-body was following him and Lois yesterday."

"Where was the detective when Lois fell into the water? If he saw what happened, why didn't he say so? I asked all around there, but the only—"

"He probably followed Ted to the hot dog stand and watched him run into *you*. We wanted him to think Ted was interested in Lois, but now that you're here, it's perfect! You were actually a girlfriend of his. What could be more natural than for the two of you to get…re-acquainted? Let him paw you a little in public."

"I will not!"

"Okay. But don't slap his face."

"Does Suzanne know about the detective and the divorce?"

"Everybody knows about it. So I'm telling you myself before the spinster sisters do."

"What makes you so sure you're being spied on?"

She drew even closer. "I can spot them. There's a man in our car—he's pudgy, and he's got a notebook. He's been writing things down. I want him to go back to my husband and swear

that Ted's living the gay bachelor life. So let him flirt with you, okay?"

Ted doesn't wear a wolf suit—not like some men I've known. So I shrugged and said, "Okay. If Ted wants to be sweet to me, and you don't mind…"

"Just don't f—"

"I know. Fifth Commandment."

Our Pullman was the next car forward, and I'd seen most of the sleeping-car passengers in the club car earlier.

The heavy blonde had the private room. Her door was open for ventilation; the inner curtain was drawn but it fluttered as I passed. She was sitting beside a big steamer trunk, reading a *Look*. She glanced up at me, mumbled, "Good evening," and went back to her magazine. By the lines in her face that thick makeup couldn't hide, she was in her fifties at least, and she needed to renew that peroxide treatment because her dark roots were embarrassingly obvious. I averted my eyes and walked on.

In the first row past the compartment was the young couple who'd giggled at Suzanne's tumble. I hoped they were on their honeymoon: they were cooing and wooing behind the curtain of a lower berth—so much that, if this had been a hotel, the house detective would have asked to see their license.

Across from them was the middle-aged man Eileen had warned me about, who'd been writing in a notebook with a gold fountain pen. Corpulent and sweaty in a tight vest, he looked more like a traveling salesman than a detective. He saw me looking at him and smiled; but then he burped loudly, reeking of beer and cheese, and I turned away.

At the far end of the car there were two handsome college boys in matching white cardigans with Greek letters sewn on. They kept looking at us girls, especially at Lillian, and joshing

with each other. Ivy kept one ear out in their direction and finally struck up a conversation, which fast became a swapping of smutty jokes.

While we'd been eating and drinking, the porter had made up all our berths. The college boys were bunking at the forward end, closest to the men's room. Ted took the upper across the aisle, so Manny could have the lower.

We girls were in the middle of the car. Eileen called for a lower without explanation or apology. Suzanne shrugged, and tossed her picture hat onto the upper berth over Eileen's. Lillian claimed a lower, and Jack said she'd take the upper above her. Across the aisle from them, Sonia took the lower and Helen the upper. Ivy said she needed a lower because she had a bad back from carrying her bass, so the upper above her was only slot left for me.

I've always prefered uppers. That high in the car, you don't get a window, but the windows by the beds don't open anyway. If somebody's walking to the toilet in the middle of the night, and the train lurches, they fall *down*, not up. And I don't need the ladder: I can get in without it. Besides, there haven't been too many times in my life when I've been treated to a Pullman ride, and uppers are cheaper.

Suzanne called an inebriated greeting up to me as the porter held the ladder for her. She climbed unsteadily into her berth, picked her big hat off the blanket, and hung it on one of the pegs. She wedged her saxophone and traveling case between the mattress and the wall, near the foot of the bed, along with a small leather-bound flask that she pulled from her suit jacket. Then she rummaged through her traveling case, yanked some magazines loose, and held them out to me, across the aisle. "Have you seen these?"

The Billboard was on top, folded open to the Orchestra

Routes page, with the itinerary for the rest of our tour circled. Then she wiggled a finger at this month's issue of *Band Star,* the fan magazine. "We got a nice mention in Darlene Duncan's column. Last month she wrote we were going on this tour, and d'you know what? We got a letter from one of her readers. Some kid out here on the Coast wants to start a fan club."

I smiled. "Darlene's written some nice things about me, too, since I helped her out of a bad scrape once." I beckoned, and we both leaned into the aisle so I could whisper. "There was a horn player who was two-timing *both* of us. But she can be a pest, too, when she wants to get the dirt on somebody."

"Want to see what other people have written about the Ultra Belles? I've got a lot of it in my scrapbook. Wait a second." She reached into her traveling case and rummaged, but tossed me another magazine first—the current *Look.* "You can read that, too; I just got it from the big blonde down there in the compartment. Her door was open while I was waiting to get into the ladies' room. The scrapbook's in my other bag. Want a little of this?"

It was her flask; I shook my head.

She nipped once and screwed the top back on. "I told the blonde we were in a band, and she wanted to know what it's like, and what instrument do I play. She asked if Ted's sweet on me. Of course, I said he was! I just wish it was true. He wouldn't look twice at *her,* though, that's sure, even if she were younger. Did you see her hair? I'd die before I'd let my roots show! D'you know a good hairdresser in Frisco? I need another treatment. I'm going gray and I hate it. Is that your own color, Katy? It's very nice, even if it isn't. Anyhow, here's my scrapbook, if you want to see."

She passed it over.

I smiled and said, "Thanks. Good night." I've been known to talk a lot, if I get the chance, so I can't object to somebody else

chattering away.

"G'night." She slid back into her berth and snapped the green curtains shut.

I took my face cream, toothbrush, and toothpowder from my toilet kit, and jumped down into the aisle in stocking feet. I wished I'd worn slippers, though, because inside the ladies' room I stepped in a damp spot on the floor that smelled of ammonia, where the porter must have mopped up a spill.

Back in my bunk, I draped my wet stocking over the foot of the bed to dry. But when I closed the curtains and lay my head back on the feather pillow, I discovered that I wasn't sleepy — which was strange. Mother denies it, of course, but I think I was born in a train. I never get carsick, or miss my step, and I can fall asleep to the rhythm of the rocking, even in a coach seat. I was looking forward to my soft Pullman berth — especially after two weeks on a hard mattress at the YW.

So I sat up again, switched on my reading lamp, and opened Suzanne's scrapbook.

In a band, whoever's in the habit of keeping a scrapbook becomes the unofficial historian for the group; the others give you stuff about themselves to help fill it up. Ted had gotten a nice write-up in *Down Beat*, but I couldn't bring myself to read it through. I hate *Down Beat*. Two years ago they published a scurrilous editorial headlined "Why Women Musicians Are Inferior." Some bandleaders still quote from it when they turn us down for work.

There were other clippings. The Brooklyn *Eagle*, two years ago, gave Lois Dumont one of their Proud-To-Be-from-Brooklyn stories. She grew up right near Ebbets Field, and once caught a Dodger's home run ball. I glanced at a story from 1929 about Sonia and Helen Bliss: The *New York World*'s vaudeville critic (they had one, back then) said the sisters ought to take their act to

Hollywood, now that talking pictures were perfected, because they could sing better than the Dolly Sisters. But right next to that in the scrapbook was a Where-Are-They-Now? story from *Variety* about sister acts: theirs *and* the Dollys'!

Suzanne had clippings about *To the Nines* from the Philadelphia papers, too. Sad to say, they'd panned it. The reviewer from the *Bulletin* was downright nasty. The *Inquirer* critic was more generous toward the music, though most of his review was a flattering profile of Ted's ex-girlfriend, Belinda Beale. He'd seen her playing in a lot of WPA Living Theater productions, like Elmer Rice's *Street Scene*, before she got the lead in Ted's show.

Inside the back cover Suzanne had pasted a little gravure calling card: the sort of thing she'd hand out to bandleaders, or post on the bulletin board in the hiring hall. It showed a caricature of her (in a big hat, of course) playing her alto; and underneath it, in sleek modern letters, it said SUZANNE ZIMMER — SWINGING SAX FOR ALL OCCASIONS.

Her address wasn't on the card, but her phone number was. It was in the ENdicott-2 exchange, the same as mine — so she lived in my neighborhood in Manhattan. It would be easy to keep in touch.

There was more in the book that promised to be interesting, but finally I was getting tired. I switched off the light, thinking how lucky I was to have run into Ted when I did. I was getting a week's pay at top scale for work that was actually fun. True, I was put off by the intrigue that Eileen wanted to drag me into. But that was balanced by having unexpectedly gone down the road toward a new friendship with Suzanne. I fell asleep trying to count how many combinations of two instruments Ted could get us to play in his "Nywatt Sound."

Sometime in the night I heard somebody coughing, and plumping the pillows. I opened my eyes and lifted the curtain

flap a little from the bottom, to see if it was dawn yet. But the only light came from the dim bulbs of the rest room signs at the far ends of the car. I saw the back of a white jacket pass down the aisle, and felt a bit of a breeze that seemed to carry a tang of sea water.

I rolled back and let the curtain fall, tugged my wristwatch out of the mesh bag, and squinted at the radium dial: it was only three-thirty. I closed my eyes and slept again.

Casino on the Beach

TUESDAY

WE WERE DUE TO PULL
in to the Watsonville junction, to connect for the Santa
Cruz local, about six in the morning. Around five, though, an
alarm clock went off somewhere—in Ted's berth, I figured—and
within a few minutes I could hear the chatter of girls' voices. I
stretched out my arms, unbuttoned the curtains, and swung my
legs down.

"Watch it!" said Ivy, who had just stuck her head out below
me.

"Sorry." I called a cheery "Good morning" to Lillian and Ei-
leen, who were passing.

Lillian asked, "Sleep okay?" and I nodded.

Ivy looked up at me. "Did the drunk wake you?"

"I'm sorry. What?"

"Suzanne. She snores all night after she's been on a bender."

"I didn't hear her."

"I've roomed with Suzanne," Lillian called back, "and gotten

blasted right out of bed." She made a short snort that segued into a full-length Bronx cheer.

"Shhh! Don't embarrass her," said Eileen.

"She's always the last one up!"

"It's the booze," Ivy chimed in.

"Can't you girls say anything nice about anyone?" That was Helen, followed immediately by Sonia, with: "It's early in the morning."

"Yeah, can you all please wake up quiet, for once?" said Ted, who'd come by wearing a long plaid robe over his pyjamas and carrying a leather toilet kit.

I looked down at Ivy. "I didn't hear her snore. Just somebody coughing."

"Aw, that must've been Sonia. She's gonna sing Mimi in *La Boheme*."

"I resent that!"

"Sor-r-y, So-nia! Didn't see you there."

Ted stopped at Suzanne's berth and knocked on the outside edge of the bedframe. "Wake up, sleepyhead!"

There was no answer.

"Dead to the world!" declared Jack, padding down the aisle. Ivy followed her. The honeymooning bride stepped away as Helen left the ladies' room, then went inside herself. Jack lit a Spud while she and Ivy waited their turn.

At the other end of the car, the pudgy salesman and the bride's new husband waited in their undershirts, suspenders drooping over bare shoulders. They stepped aside to let Manny get out of the men's room and squeeze past them. The fraternity brothers stood in the aisle shirtless, which drew some attention from Lillian, and they returned the compliment.

Ted still hadn't woken Suzanne. "Come on! Don't be late again," he called in to her. When she didn't respond he glanced at

us, as if to ask if it was all right to look. Then he unbuttoned the curtains and pulled them aside.

"Oh, no!" He backed up hard against my bunk.

Eileen screamed.

Everyone nearby turned to see. The porter had been picking up bedclothes and turning the berths back into seats. He looked up, took a deep breath, then dashed out toward the dining car.

The blonde in the compartment opened her door, tiptoed into range, and squinted up the aisle to see what the fuss was about. But as soon as she saw, she screeched and ran back inside, throwing her door shut with a bang.

From right across the aisle and high up, I had the best view. Suzanne lay on her back. Her eyes were wide open. Half of her face was covered with blood that had seeped out of her nose and mouth in a long, dark red stain that extended down past her ear and her cheek, along the pillow and onto the sheets.

My father was a doctor, but one of his knees had been shattered in the War, so he couldn't drive our car. There were times, especially when Mother was busy, that I'd driven him to his house calls, or taken him out to where there'd been an accident. So I've seen what dead people look like, and Suzanne was dead.

One of the college boys ran up, saying, "I'm pre-med, can I help?" He lifted Suzanne's arms over her head and tried pumping them, but after only a few seconds he could tell it was useless.

By then his buddy had come alongside. "Lemme see. Wow! Look at all that blood!"

The medical student looked back at us. "She could've had a brain hemorrhage. It says in our textbook that people who drink a lot of alcohol—"

"Come back after you graduate, Junior," said Manny, pushing his way up the aisle and elbowing the boys aside.

"But—"

"Shut up! Someone hand me a suitcase, please."

I passed mine down. He laid it on the floor and stood on it, so he could see Suzanne up close. He touched the side of her neck, lifted the sheet, peered under it, and let it drift down again. He glanced around her berth two or three times, before stepping down and handing me back my case.

With the two boys, all of us girls, Ted and Manny, the honeymooners, and the salesman, we made such a thick crowd in the aisle that the conductor and the porter (bearing the ladder) had to push their way in.

The conductor climbed up, checked Suzanne's pulse as Manny had done, shook his head, and closed the curtains when he'd stepped down.

The college boys shuffled away, and the salesman walked back through the aisle, head down.

Helen and Sonia sat on Sonia's lower, side by side, sharing a vial of smelling salts. Jack put an arm around Lillian's waist and led her away. Ted did the same to Eileen. Ivy looked up at me. I hopped down and gave her a hug around the shoulders.

The conductor knocked on the compartment door and beckoned the blonde out. Then he addressed us all. "I have to telegraph ahead to Santa Cruz, and I don't want anybody touching anything. I'm sure you understand why. Joseph—" he looked at the porter "—you'll be the official eyes and ears of the railroad until I get back."

"Yes, sir."

"Some of you, I'm sure, will want to move out of this car. You can get dressed and go sit in the day-coach just ahead of the diner—" he pointed toward the front of the train "—but leave all your belongings here. And if you do go, please don't tell anybody why, or what happened here."

"I have a connection to make, for Del Monte," said the salesman.

"I'm sorry, but I'm sure the police will want all of you to stay on board until they've finished talking to you. Give me your through-ticket, sir, and I'll make sure you don't pay extra if we have to put you on a later train." He took it and stepped through the crowd in the aisle, past the men's room and out.

Ted looked around. "I don't want any of us going. I want us all to stay together."

The honeymooners whispered, and then walked up into the next car. But the medical student and his pal declared that they wouldn't miss the police examination for all the world.

The blonde opened her door, tugging at the strap of her trunk, which was covered with steamship, railroad, and hotel stickers. She called to the porter to haul it out for her.

"I'm sorry, ma'am. The conductor said all the baggage got to stay here."

Ivy poked Lillian in the ribs and blinked theatrically, tipping her head in the direction of the compartment. "I can't see too good. Which is the fat lady and which is the trunk?"

Lillian giggled, but the blonde glared daggers at Ivy. She shoved her trunk back inside, pulled her door shut, and stalked up the aisle, bumping Ivy as she passed, but without saying a word.

"I-vy!" Ted was exasperated.

Eileen shrugged her shoulders, and the Bliss sisters clucked, "*Tsk-tsk-tsk.*" Apparently this wasn't the first time Ivy had embarrassed them by shooting her mouth off. The porter pretended he hadn't heard, and went back to converting the berths to seats—all except Suzanne's upper, and Eileen's lower beneath it.

Ted shook his head and took a deep breath. "All right, listen everybody. We have to work up new arrangements now, without a sax."

"You mean we're playing tonight?" That was Jack, but it could have been any of us.

Manny muttered, "This isn't good publicity."

Lillian nudged his elbow. "You can say that again!"

"Ted's right," said Eileen. "We have to stick together. If anybody bails out, we can't play at all."

Ted opened his hands, touching Ivy and me on our arms. "It's terrible, I know. But what happened isn't our fault. Suzanne was a big woman but she wasn't strong. She had a...a weakness. I brought her along on this tour knowing full well that—there's no other word for it—she was a dipso. Maybe 'young Doctor Arrowsmith' over there is right, and she drank so much she burst a blood vessel. I don't know. What I do know is: we all have responsibilities. We've been hired to play tonight, tomorrow, Thursday, Friday, and Saturday—and payday isn't until the end of the week. If we don't play out the tour, we don't get our money. Anyone who bails out now has to reimburse me for her train tickets, and pay her own way home besides. As soon as the police have finished with you, just go away: shoulder your bags and your instruments and start walking. Now, who wants out?"

Nobody left.

The Santa Cruz policemen who boarded at the junction were polite enough, under the circumstances; but they made us wait until they'd questioned and dismissed the blonde, the salesman, the honeymooners, and the fraternity boys.

Then they asked each of us if we'd heard Suzanne cry out or choke in the middle of the night. I told about the coughing and pillow-plumping I'd heard, and the white jacket I'd seen go by. They thanked me and sent me back to my seat.

While they were quizzing Lillian, two uniformed cops lifted

Suzanne's body down onto a white stretcher. Her head, unsupported, fell back. Her mouth gaped open. From across the aisle I saw something flash inside. It startled me and I gasped. The men looked up.

"I'm sorry. I thought…I guess it's a gold tooth."

"What is?" They set her down and one of them peered inside her mouth.

"Son of a gun! Will you look at this? She must've choked on something. Hey, Sergeant!"

A plainclothesman trotted over. He squatted down and said, "Gimme a flashlight." One was placed in his outstretched hand and he flicked it on. "All this blood! Can't see…oh! You're right, there *is* something in her mouth. Looks like metal. I'm not gonna touch it. Drive her downtown and let the doc poke around."

The officers covered the body, lifted the stretcher, and took her down the aisle to the end of the car and off the train. The sergeant went up the ladder, poked around in Suzanne's berth, and pulled a case out. "What's this? Her saxophone?"

He was looking at me, so I said, "Yes."

A beanpole with crew-cut sandy hair, he had large brown eyes and a lantern jaw that gave his face a horsey look. He made a gather-round motion with his arms and we girls edged in closer. "I'm Sergeant Grumman. I'm the officer in charge of this investigation. Now, does anybody else in this band play the sax?"

"I play clarinet," said Helen. "The fingering is very similar."

"I don't care about the fingering," he said. "My sister's kid is learning the sax, and he walks around with a reed in his mouth. His mother tells him he's gonna bump into something and choke on it. Is that possible?"

"It's dangerous," Helen said. "He shouldn't do that."

"I'm not askin' about him, lady! Could it have happened to your friend?"

Helen straightened up. "She was not my friend, Sergeant. We didn't like her very much."

"'We' meaning all of you girls?"

"No," said Jack. "I liked her just fine."

"I'll say you did!" Sonia hissed.

"Drop dead!"

Ivy jerked her thumb. "Those harpies are always—"

"Don't you call us—"

"Hold it!" Sgt. Grumman looked at the sisters. "Was there some kinda personal grudge? Did the dead girl steal a boyfriend from you?"

"Who do you think you're speaking to?" Sonia drew herself up to her full five-and-a-half feet.

"You can't talk to her like that!" Helen put in. "We do not lead the sort of life that Miss Zimmer did, so we have never been attracted to the sort of men that she ran after."

"What sort of men would that be?"

The sisters looked at each other for a moment, then Sonia said, "Men like Ted Nywatt."

The rest of us couldn't help but laugh. Even Sgt. Grumman grinned and shook his big head. But he asked Ted, "Were you her boyfriend?"

"No."

"Did she have one?"

Ted shrugged.

Sonia looked at Helen, then at the sergeant, and said, "She went off with a man on Sunday, in Los Angeles."

"Who?"

"I don't know. We—my sister and I—we never actually saw him."

"Did any of you see him?"

"When she left the hotel, she told me she was meeting a

date," Eileen volunteered. "But maybe she was just saying that. She could've been going to the movies or to the park by herself."

"Excuse me, Sonia," I said. "Was Suzanne wearing a straw hat yesterday? Not that red one—" I pointed toward her berth "—I mean a wide, straw hat trimmed with white ribbon?"

Sgt. Grumman called, "Hey, you! The taxpayers hire *me* to ask the questions. You're the one that heard the coughing, right? D'you think she could have swallowed a saxophone reed and flung her arms around and banged into the wall and bloodied her nose?"

"Actually, I thought it was the sound of somebody getting sick; so the white jacket I saw may have been the porter, mopping it up."

The cop glanced down at the carpet. "It's not wet here. Porter?"

"I didn't have to mop anywhere last night."

"Did anybody call for the ladder before dawn?"

"No sir."

"Did you go through the aisle during the night? Picking up shoes, maybe?"

"Yes sir. But I'd done that already. I shined 'em right after midnight and had 'em all back before two, so I could catch a little shut-eye, over in my chair."

Sgt. Grumman looked around Suzanne's berth again. "Is there anything metallic in a saxophone reed?"

I answered, "No. But there's a metal ring with little screws that holds the reed onto your mouthpiece."

He opened the sax case. "Tell me if that thing is in here."

I looked inside and pointed. "That's it."

"Good. One less headache."

Ted leaned over to me and whispered, "Katy, you're going to have to double on sax now. Why don't you—"

"What?"

"Helen's got to play clarinet. There's nobody else."

"Call the union for a sub."

"Even if the Santa Cruz local could find us somebody in a hurry, what about the rest of the tour? You're already here. I don't know if we'll have time to rehearse now." He looked up at Sgt. Grumman. "We're two hours late already."

"Sorry, buddy."

Manny stepped over and touched the officer's arm. "Excuse me, Sergeant. We're running late. You don't want the girls to skip their rehearsal, do you? As it is, they may not even have time for a dinner break."

Ted turned to us and said, "Please don't tell *that* to the union."

Sgt. Grumman thought for a moment, then said, "Well, okay. Why don't you do that—go on ahead. I'll send one of my officers along, in case somebody tries to quit the band in a hurry."

Manny smiled. "I'll see to it that no one leaves."

We began packing up our cases and stacking them down the aisle to go. Carrying my violin case, I stepped over to Ted and said, "You didn't even ask if I'd *brought* my sax. It could be back in L.A."

"I saw it under your arm at the station."

"It's just to jam with. I really don't think I should double."

"You'll get the differential."

That meant extra money—almost as much as two paychecks: Suzanne's *and* mine.

Lillian patted my shoulder. "You lucky stiff!"

But Ivy nudged her aside. "No, stupid. Suzanne's the stiff."

If you've ever been hurt in an accident, you know that you may not realize it immediately. You can talk, maybe even walk away,

although your heart is pumping a mile-a-minute and you've got broken bones. You don't feel any pain until much later. Something keeps you going.

I think the band went through a similar experience, collectively. We all saw what happened to Suzanne, and yet we didn't react. Instead, we were as wide-eyed as any tourists, on the drive from the station to the oceanside Boardwalk. We pointed and gaped at the Giant Dipper roller coaster. And we were speechless—but for *oohs* and *ahhs*—at the size of the Coconut Grove ballroom: quite possibly the largest any of us had ever seen.

We managed to rehearse that afternoon and play that night, too, as if what happened to Suzanne had never happened at all.

I know I had to concentrate on the arrangements. And after an hour or so, I could see exactly where on the musical spectrum Ted had put the Ultra Belles: it was right down the middle between sweet and swing. Even when we played his new "Nywatt Sound" arrangements, we weren't strictly in one camp or the other.

Sweet is what you can dance to and still hold on to your partner. Sweet is what high-society types go for, so that's what gets booked into hotel ballrooms and fancy pavillions, like the ones on our tour. Sweet is where the money is. A violinist like me can get work playing sweet, because sweet arrangements feature a lot of lush strings.

I would never say this out loud, especially where Ted or any other bandleader could hear me, but playing sweet is easier than playing swing. You can practically "phone it in." Nobody expects you to put your soul into it. Horace Heidt and Lawrence Welk and Guy Lombardo front the top sweet bands today, and you don't have to know a thing about music to enjoy their sound.

Don't get me wrong: sweet is not corn. But it ain't swing!

Swing is what Benny Goodman and Count Basie and Artie Shaw and Fats Waller are playing. They're pretty far out in front of

the public's taste right now, but plenty of youngsters will fork over a buck to leap into the aisles when those bands play the Paramount Theater on Times Square.

Swing is the direction we're all heading for. In those enormous orchestras — what the trade papers are calling "Big Bands" nowadays — there may be four or five musicians playing the same lines in unison. In a combo like the Ultra Belles, with just one of us playing each line, we can hit the swing sound all right. But we're too small to get a gig at the Paramount, and there aren't a lot of small venues that'll pay us to play. We can keep going on tours, but to really make it on the swing scene today we'd need more than a few mentions in local papers, or Darlene Duncan's gushing columns in *Band Star*. We'd need Consolidated to get us a steady gig at a big hotel roof garden in San Francisco or New York, or a national radio hookup.

But we might not get those gigs now, if the first thing people heard about the Ultra Belles was what happened to Suzanne.

Once our rehearsal started, I was right in the groove. With my conservatory training, and ten years of professional music-making, it wasn't hard for me to step in and join the Ultra Belles. And after my initial confusion over Ted's "Nywatt Sound," I knew how to play those arrangements, too. I did miss a couple of cues during those awkward times when the sax was supposed to come in right after the violin, or vice versa. But Helen had set up her stand right next to mine. She'd look over and play my violin lines on a C-major clarinet, which gave me enough time to switch to sax for my next entrance.

We'd been rehearsing for about an hour, and were almost through "Zesty," one of Ted's instrumentals. All of us were standing up and swaying side-to-side in unison playing the last thirty-two bars, when Sgt. Grumman walked in. He pushed a chair up

in front of the band, straddled it backwards, drew his finger across his throat, and smiled: meaning, of course, that he wanted us to stop playing—which we did. But it was an unpleasant sort of pun. And when he spoke, he didn't bother with formalities.

"She wore big hats, didn't she?"

"It was sort of her trademark," said Ivy.

"How does a girl keep a big hat on? An elastic band?" He wrapped his hands around his temples to demonstrate. "A chin-strap?"

"No, that would make it a bonnet," said Sonia. "What Suzanne wore—" she started coughing, but managed to squeal out "—they were hats."

"She used hatpins," said Jack.

The sergeant nodded. "There was a big red hat on the peg over her berth. Obviously she didn't go to sleep with it on. So where would she have kept her hatpins?"

"Most girls just stick them right in the hat itself," Eileen replied.

"We found two in her hat. Is that enough?"

"She had plenty of hair," said Eileen, running her fingers through her thin bangs. "Not all of us do."

"Would she have kept extra pins someplace?"

Eileen said, "Possibly," and the rest of us nodded.

"Before the War," Sonia volunteered, "when every young woman wore big hats, we carried our hatpins in folding leather cases. Like wallets, only smaller."

"We didn't find anything like that. We found a third hatpin, though, with a shiny bronze ball on the end. It was stuck in her throat."

Lillian gasped.

Sonia coughed roughly, said, "I'm going to be sick!" and sat down hard. It was half a minute before she stopped coughing.

Meanwhile, Manny strode up to the sergeant and said, quietly, "May I speak with you for a moment?" They walked to the far side of the room.

I wanted to say something about the picture hat in the water and the hatpin I'd found on the pier in Santa Monica. But what Ted had said to me at the hospital that day was true: I do jump to conclusions. Thousands of women wear big hats. Sergeant Grumman had reprimanded me for interfering before. If he took me downtown for questioning, I'd miss the gig. It was my first day in the band: I couldn't do that.

When Sonia had calmed down, Ted tapped the baton on his music stand and said, "Let's take 'Zesty' again from the violin break, please."

I looked up at him, and when everyone was ready he snapped his wrist and we all came in on the downbeat.

We finished about three minutes later. Sgt. Grumman applauded, and called out, "I'll be seeing you!"

"We don't play that song!" Ivy quipped as he walked out the door.

Manny stepped up to the bandstand and motioned for us to come in close. "We are reprieved for the time being. The official police report will be fairly simple, and what's even better is: they will not be releasing any details to the papers. As far as the news hounds of Santa Cruz are concerned, it was just some girl who died on the train—and it was an accident."

"How'd you get him to do that?"

"I'm glad you asked, Jack. The fact is, I've been thinking about what happened all day, and here's what I now believe: Miss Zimmer fancies big hats, which she fastens to her hair with hatpins. What does she do with those pins when she takes them out? She puts them in her mouth, between her lips. Wait—don't tell me 'no'—I've seen it a thousand times: girls do this with straight

pins and sewing needles, too. Ummm? So here we have Suzanne, who's a dipsomaniac. That's no secret either. Last night she's drunk again; she's not thinking straight; her coordination is shot. Suddenly the train jostles her and she swallows the pin. It's jabbing her in the back of the throat. She's tasting her blood. She coughs, she tries to fish it out, but she's choking. She panics. She thrashes about. But she can't catch her breath. She loses consciousness and dies."

Ivy whistled a long, low, "*Whooo*" and added, "What an imagination!"

"Have you got a better story?"

"Sure. Somebody heard her snoring, peeked in the curtain, saw her mouth hanging open, grabbed a pin out of her hat, and stuck her with it to shut her up."

"That's horrible!" Sonia wailed.

"Who could have done such a thing?" said her sister.

Ivy snorted. "You didn't like her very much, did you, Helen? Maybe it was *you*."

"You little viper!"

Helen made a grab for Ivy's hair, and Ivy balled up her fist. "Touch me and I'll bash your skull! I'll cut your throat!"

"That's enough!" Ted yelled. "Everybody just—"

The front door had popped open, and Ted turned around. The ballroom's manager, a gray-haired gentleman in a tailcoat, walked over to the bandstand. He was smiling. We stayed quiet.

"I didn't mean to interrupt your run-through," he said. "I just came to ask if you have any other pictures of the band, for our lobby display. The one you sent last week shows eight girls, but when you checked in there were only seven. Has there been a change in the lineup?"

Ted looked at Manny. "Would you help him, please?"

"Hello, Mr. Charleton."

"Oh, Mr. Blunt! How nice to see you again." They shook hands. "I didn't know *you* were handling these girls' publicity. Welcome back to Santa Cruz."

"Thank you, sir, it's always a pleasure to be here. I must apologize for the photo mix-up. One of our girls couldn't make it. It was a last-minute thing. Say! You remember the famous Bliss sisters, don't you?"

"Do I? 'My canary,'" he sang, pantomiming a ukulele, "'has circles under his eyes'!"

"Well, look—" Manny gestured. "There's Sonia and Helen Bliss."

They smiled and curtsied—the way they must have done a thousand times in vaudeville.

He smiled back. "If they're in the band, I'm sure the rest of you are all refined young ladies. Welcome to Santa Cruz."

"I'll introduce you to everybody later, after the rehearsal. I have some photos of the sisters, though; perhaps you'd like one. Come with me." Manny took his arm and they went out.

We were still quiet. Ted shrugged, arms extended. "Do I have to spell it out? With guys like him watching, I don't even want you to *smoke* in public, much less tear each other's hair out. It's bad enough that we're down from eight musicians to seven. Ivy, you're the worst. But you and Helen have been ragging each other for months. I want it to stop. You get into a catfight again and you're *both* out on your fannies! That goes for the rest of you, too. You'll never work for me again. And I'll tell the union why!"

We were able to forget about Suzanne for a while, pay attention to the music and play our gig. I was impressed by the way Manny gave the ballroom manager the runaround, but I was positively awestruck by his handling of the police: despite the sergeant's parting remark, he never came back.

And Manny fixed the press, too. He told the reporter from the evening *Gazette* that we'd arrived too late and were too busy rehearsing to give interviews, but would he please accept a three-page write-up that he'd prepared? And the *Gazette* printed it practically word-for-word. It made us out to be as popular as the girls in Spitalny's Hour of Charm. The article mentioned Billie Holiday's recording of "Walking on Eggshells," the "Kid Sisters" vaudeville act, even Eileen's endorsement for Pond's Cold Cream. But somehow it failed to mention that our saxophone player was carried off dead in a puddle of her own blood.

That story did run in the *Gazette*, but it was exactly one paragraph at the bottom of page twelve. It said that the conductor found a girl on the train who was on her way to Monterey, and that she'd choked to death in the middle of the night after accidentally swallowing a hatpin.

Manny came to the gig wearing a double-breasted tuxedo, his shirt fastened with studs and cufflinks that were probably real emeralds. He sat at a ringside table with a slender, dark-haired woman in a green satin gown. Having known a few men in his line of work, I assumed Manny had a girl in every port. They danced a few times, and he brought her up to the bandstand to meet Ted just as we were finishing our second set.

Nina Cavett was her name. She was maybe forty, had a beaky nose, and was more heavily made-up than I think is becoming.

"What a gay little troupe!" she proclaimed. "And maroon! My favorite color!"

Her throaty voice and straight carriage bespoke culture, and well, money. Like her white gloves, though, her manners were starchy. And she kept people at bay by waving a Chesterfield cigarette around at the end of a long holder.

While we were on our next break in the "green room" (that's what musicians call whatever warm-up or lounging space they

give you), Manny came in alone and motioned for us to gather around him. "You all saw the woman who was with me—Mrs. Cavett? She's a rich widow from San Francisco."

"Lucky for her, her husband croaked, or she couldn't afford all that makeup!"

"Must you insult *everyone*, Ivy? I just met her. She asked the maître d' to seat me at her table because she wanted to talk about the band. She likes what she's heard tonight."

"We take requests," Ted said.

Manny smiled. "Wait till you hear what she's requesting. She's president of a garden club that's putting on a benefit for a hospital in June. She wants to hire the Ultra Belles to play that fund-raiser, but she has to speak with her committeewomen before she can make it official. Now listen: I told her you still had a couple of play-dates open after this tour. But stop your intramural warfare, and don't hang your troubles out on the washline. We can count on you for a June date in San Francisco, can't we?"

Ted said, "Sure," but he glanced at the rest of us and added, "if nothing else goes wrong."

"I think I've hooked her, but I want her to feel as we do that the Nywatt Sound is something special and unique. She's going to try to catch the act again this week, possibly in Sacramento on Thursday, but definitely in San Francisco Saturday night."

"Maybe she just wants to see you again," said Ivy.

"I'll do anything to get this band some high-profile gigs—"

"Anything?"

"Well, not *everything*." Then he turned to the rest of us. "Women like Mrs. Cavett are your meal-tickets. The Ultra Belles could be like Eddy Duchin's band, playing fancy parties for a living. Wouldn't you like the social register for a fan club?"

"We have a fan club out here already," said Eileen. "We got a

letter last month from some girl here in California, in Placerville, saying she wants to start one."

Manny looked up at the ceiling. "Placerville hasn't seen any action since the Gold Rush! You want to be stars in Los Angeles and San Francisco. I'm going back to Mrs. Cavett's table and build you up some more. I don't want the Ultra Belles to be the opening act at her party; I want you to be the headliners."

We led off the third set with "Walking on Eggshells." It's got a real pumping beat, something like "Caravan" but with a more sophisticated chord progression; and it's in a minor key, a little like "That's A'Plenty." It sure gets people dancing, though, and it's a great showcase for the band. Ted's arrangement called for a long instrumental lead-in, before the vocals, so each of us got to play a solo. No matter what the editors of *Down Beat* say, women are every bit as good at playing swing as men are.

Sonia was a first-rate drummer. I got the impression that she'd have preferred to play more in the Gene Krupa style, if Ted would let her, because musically (and despite her age) she was up-to-date. There was hardly a trace of the old-fashioned, "up-and-down" sound of the 1920s in her rhythm. Close your eyes and you could move her into any of the Big Bands today.

Helen was younger than her sister but, curiously, her clarinet playing was more traditional, more like the sound musicians were making in the 'twenties. That's not a criticism, just an observation. She played in a way that I imagined Artie Shaw might have played before he got the swing religion.

Ivy certainly knew her way around the bass. She had flawless technique: slapping the strings against the fingerboard and tickling and rubbing them for special effects with perfect control. I needn't have wondered how she handled an instrument that was so much bigger than herself, because it wasn't. She played a

three-quarter-size bass—what classical players call a "bowing bass"—that was only a little over five feet high.

Jack's guitar rhythm was solid, too, but I'd expected no less. When she took her solo she picked out the melody with considerable embellishment. And when she played straight rhythm she never speeded up, though she sometimes struck her chord just ahead of the beat. That's a trick a lot of good guitar players are pulling, nowadays: it gives them a little edge when they're sharing the rhythm section with a bass and drums, and it definitely gives the tune a boost in the right places.

Lillian wanted to break out, too, I think, though in a different way. Some of her trumpet solos pushed the edges of Ted's arrangement into the realm of jazz. But she was so good, technically, especially in the higher registers, that she was a natural for the duets of the Nywatt Sound, which we went into right after we'd each taken our solos.

Eileen introduced her vocal over the last instrumental runthrough, saying "Folks, what you've just heard is a new style of American music, written and arranged by Ted Nywatt, that we call 'the Nywatt Sound.' But this tune has words, too, and here's how it goes...."

I'm walking on eggshells when I'm with you.
I'm sitting on thumbtacks, knowing you're untrue,
I wait up for hours hoping you'll 'phone,
And I tiptoe past your door—I'm so alone!

Without my lover close by my side
There's no concealing how much I've cried.
They say you can not make an omelette
Without breaking something, dear,
I'm walking on eggshells when you are near.

I'm walking on eggshells when you walk by.
You give me that big kiss, but your lips are dry.
There's always been something we've left unsaid,
But now you're keeping a suitcase packed up
 and under your bed.

I know our love-life could stand repair.
But when you look my way, it's like I'm not there.
 They say the whole world loves a lover,
 But I guess you don't love me.
I'm walking on eggshells. Please set me free.
I'm walking on eggshells. Set me free.

At the hotel, I was assigned to a room with Jack. She asked for the bed by the window so she could smoke, which she did as soon as she'd put on her pyjamas. Flopping back onto her bed, and lacing the fingers of both hands behind her neck, she let her cigarette jiggle at the edge of her mouth when she talked. "Y'know, Katy, with this 'Nywatt Sound' of Ted's there's a lot of room for fiddle-and-guitar duets. I was working some up with Lois, but you could pick up on them now, easy enough. How about tomorrow, on the train? We can find an empty row to jam in."

"Sure." I slid down and pulled the covers up to my chin.

Jack lit a fresh Spud from the butt of the last. "Don't take this wrong, but I gotta ask: are you interested in the Cause? The Socialist movement? I got pamphlets I can give you."

"Sorry. I'm for Roosevelt, not Stalin."

"Hey! I'm an American, too. Don't you forget it."

"No offense."

"I'm not one of those girls that reads *The Communist Manifesto* in college and spouts it at cocktail parties. Hell, I never went to college. My pop's a longshoreman in San Francisco. I went out

on the barricades with him in 'thirty-four, when they went on strike. We got tear-gassed by the cops."

I didn't know what to say, except "I'm sorry." I stretched and pretended to yawn.

"Listen, there's something else. You're gonna hear things about me and Suzanne. Maybe you did already. From Sonia?"

"No."

She rolled onto her side, facing me. "What they're sayin'—it ain't true."

"She hasn't—"

"Come and ask me anything. I won't lie to you. It's not just about politics. Sonia's all dried up. She's got no sex drive anymore. Her and her sister both. And they're jealous of anybody like Suzanne who's got it by the carload, or like—"

"Jack, this is my first day in the band. Please don't force me to take sides in anything, all right?"

She stubbed out her cigarette in the little ashtray that was built into the nightstand. "You strike me as the open-minded type, Katy. That's good enough for me. Thanks." And she switched off the lamp.

CLAREMONT HOTEL AND BERKE[LEY]

WEDNESDAY

THE NEXT MORNING AT NINE
o'clock, we boarded a train to Oakland. It was a slow local
that ran through farm country first, with rows of lettuce on one
side and artichokes on the other. After an hour, though, we were
out of the vegetable fields and into the orchards of the Santa
Clara Valley, with fruit and nut trees and hardly any houses, all
the way out to the hillsides.

Most of the passengers in our day-coach (and there weren't
too many) were riding only from town to town. Other than an eld-
erly couple with a teenaged girl who was nursing a baby of her
own, a grossly outsized woman in a green coat who practically
took up two seats, and a lanky young man who sported what was
probably his first mustache, we were the only people who got on
in Santa Cruz.

We turned four double-seats so they faced one another, but
we weren't doing much of anything together. Some of us weren't
fully awake yet, and with no drinking allowed until after we'd

played our gig that night, there wasn't much of the banter that had been so engaging on our first train trip. But at least we didn't have a dead woman in our row.

I went over my parts again. Ivy laid a *Redbook* magazine across her lap and played solitaire on it. Helen and Sonia shared a copy of *Look*. Lillian read a paperbound novel: I couldn't read the title from across the aisle, but the cover showed the bony hand of an evil-looking man reaching out toward an innocent maiden. Eileen worked a crossword puzzle. Ted was apparently composing something new, writing musical notes on ruled manuscript paper. Manny typed and collated his pages to give to the Oakland newspapers.

Jack got her guitar out and sat alone in the row behind us, experimenting with some single-string solos. I was going to take out my violin and jam with her, but after a minute or so she stopped playing and said, "You know—" to no one in particular "—I've watched Suzanne put her big hats on and take 'em off a hundred times. And even when she was too drunk to know which end of the pin was sharp, I never saw her come close to swallowing one."

"I don't remember her sticking pins in her mouth anyway," Ivy said, "though I could name something else she's stuck in there!"

"You're wicked!" Sonia said.

"No, I'm funny!" Ivy retorted. "All I need's an audition, and I could be the next Gracie Allen."

"Stick to the bass, Ivy," said Helen. "You'll live longer."

"What's that supposed to mean?"

Sonia leaned in. "You're wicked. You aggravate sensitive people, with that foul mouth of yours."

"Maybe you and Helen got too much sensitivity. I could whip out my razor and take a slice off the top."

Ted looked up. "Hey! Both of you. Knock it off!"

Jack set her guitar down and leaned over the top of the seat between Lillian's head and Ivy's. "Manny," she called, "I got a question. How'd you get the cops yesterday to buy your 'accident' story?"

"Do you have a better one? Please go back to Santa Cruz and offer yourself up for interrogation. Perhaps Sergeant Grumman will give you the third-degree. Would you like that?"

"But how—"

"Be still! The fact is, the police had nothing of substance. They had a dead girl on a train, a lot of blood, and that's all."

"Flop, flop, cold fish," said Lillian.

Manny waited a moment, then said, "Let me tell you something. I used to handle publicity for a bandleader who had a winter-season gig in one of the big Florida hotels. One night, he died in bed—yes, *in flagrante delicto*—and the young lady was not his wife. But there was no scandal, and do you know why? Because everybody rallied 'round. The hotel reported his demise without mentioning the specifics. They even hung crepe on his picture in the lobby for a few days. But the important thing was: the musicians played out their contract and were able to go home with all of their pay. I don't suppose you girls care about finishing your tour and collecting your money, but just in case you do, you can save yourselves a lot of nervous indigestion by taking a small piece of advice from me."

He paused until someone (it was Lillian) asked, "What's your advice?"

"Shut up and play!"

"Aw, cops are the same all over," Jack declared. "How much did you have to pay your Sergeant Grumman to—"

"Buzz off, Jack! I work for Consolidated Talent Services, and our client is Ted Nywatt. I don't answer to you."

• • •

We were quiet for a few moments, during which the sisters looked at each other, and then around at the rest of us. Sonia called out: "Does anybody here read detective stories?"

Lillian held up her book with the lurid cover. "I do. I'm reading *Creep Shadow, Creep* by Abraham Merritt. It's real spooky. Wanna read it next? There's this maniac, see, who—"

"No, I—" Sonia coughed hard, five times "—I wanted to know if anyone else, besides us of course, knew something about how crimes get solved."

"I've read plenty of whodunits." Lillian puffed herself up. "What d'you want to know?"

Ivy leaned in and whispered, "What we all want to know: why did Suzanne go from drunk to dead?"

"Hey!" That was Ted. "What Manny said—he's right. Could you all just drop it?"

Eileen declared, "The newspaper said it was an accident. That's good enough for me, and it should be good enough for all of us."

"Do you believe everything you read in the papers?" I asked.

"*We* certainly don't," said Helen. "We think that Suzanne was murdered, and for a reason, which is—"

"Helen!" Ted threw up his hands. "Why don't you talk a little louder? The engineer can't hear you."

She looked around. So did Ivy and Lillian. But I was facing the front of the car already, and neither of the remaining passengers—the fat woman in green and the kid with the mustache—had turned our way. "Nobody can hear us, Ted," she said.

"Keep it down, okay?"

Lillian sat up straight. "You don't need a reason if you're a crazy man. There was a maniac loose on the train last night. He escaped from the asylum, and he went creeping barefoot along the carpet with a—"

"Stop that!" Ivy tapped Lillian's shoulder. "You've been reading too many of those gruesome Merritt books!"

"But you all saw what happened to Suzanne! He's a psychopathic monster! He tore her throat out!"

Helen gasped, "I don't feel well," and sank back in her seat.

Sonia dug a vial of smelling salts out of her purse and held it under Helen's nose until she coughed and sat up again; then she fanned her with their magazine.

I just couldn't help putting in my two cents. "I'm sorry, Lillian, but I don't think a monster got aboard our train. The porter would have noticed anyone coming through from the diner ahead; and the night-steward would have seen him coming our way from the club car behind us."

"Maybe it was the porter himself," said Sonia.

"There *was* a maniac on board! And now he's following us, with a...a corkscrew, maybe!"

"That's enough, Lillian, please," Ted called out.

"He is!"

I turned to face her head-on. "If there were a maniac on the train, why didn't he strike the first person he came to? Compartments lock from the inside, so maybe the blonde woman in there was safe. But just beyond her room, in the first row of berths, there was that young honeymoon couple, and the heavyset man in a vest. This maniac of yours had to walk right by them and—"

"He isn't *my* maniac, Katy. And suppose he came from the other end of the car."

"That's where the college boys were. And Manny and Ted. Suzanne was in the middle of us all. And how come he didn't kill somebody in a lower? That'd be a lot easier. Why reach all the way into an upper berth that's more than five feet from the floor?"

"He must've been a giant, with claws instead of fingernails and—"

"Pack it in, Lillian, will ya?" Jack called back to her.

"Perhaps the porter did it," Sonia suggested. "Who else has a ladder on a train?"

I shook my head. "Anybody can turn a suitcase on end and stand on it, like Manny did."

"But you saw his white jacket."

"*If* what I saw was a jacket. It could have been a dining car steward, going through to set up for breakfast. But it also could have been a shirt or a bathrobe—somebody on their way to the toilet."

"I read a mystery once where the killer was one of the patients in a hospital, and he put on a white coat, so everybody'd think he was a doctor."

Eileen gasped. "Lillian! Are you saying it was one of *us*? It couldn't be! It mustn't be! That's a terrible—"

She stopped. Something like a green curtain floated by. But it was only the big woman from the far end of the car, walking past us. With a belly and hips that no corset could ever tame, under an enormous woolen coat dyed an unflattering lime-green, she strode—waddled, really—down the aisle.

But just as she passed, Ivy glanced up and sang out, "*Ee-i-ee-i-oh!* With an *oink-oink* here and an *oink-oink* there, here an *oink*, there an *oink*—"

Jack went, "Shhh!"

Ivy cut it short with a chuckle. But the woman must have heard. She twitched, making her straight black hair bounce, then kept on walking.

As soon as she was gone, Helen rebuked: "That was a disgusting thing to do, Ivy."

"Oh, come on! How can a woman let herself go like that?"

"She's got bad glands, I bet," Eileen volunteered. "She can't help it."

Jack nudged Ivy's shoulder. "Just like you can't help being a little shrimp."

Ivy laughed out loud. "Shrimp cocktail, anybody?"

"I see," Helen snapped. "Jack calls you a name and you take it in stride. But if Sonia or I—"

"That's different."

"It's not nice to make fun of people's afflictions," said Sonia. "I think you should go apologize."

"Drop dead!"

"You were right across the aisle from Suzanne, in the lower. Maybe you scampered up the curtains like a little monkey—"

"You're askin' for it!" Ivy cocked her arm, fist clenched, but Jack caught her by the shoulders and restrained her. "Lemme go! You heard what Helen said!"

Ted called over, "Just remember what *I* said, about fighting."

"And what *I* said, about shutting up," Manny added.

There was a silent moment. I wanted to ask a question, but I couldn't phrase it. I got distracted by something inexpressible. I was trying to assemble the whole thought, when Jack said, "Cool down, Ivy. Helen wasn't accusing you. Isn't that right?"

"That's right. I wasn't accusing you. I'm sorry if I gave that impression."

Sonia nodded. "And I'm sorry, too. I was just—"

"'Scuse me." Ivy slid sideways out of the row and shouldered her pocketbook. "I'm goin' to the ladies' can. What's the nex' stop on this milk-train? Anybody know?"

"San Jose," said Ted. "And I don't want you doing anything that would make the conductor put us off there. All right?"

Ivy just walked away.

Sonia looked around, then whispered, "Glands or no glands, that woman was as big as a phone booth."

"She can't *fit* in a phone booth!" Helen said, a little louder.

"And I thought *Suzanne* had big hips!" said Lillian at full voice.

"Evidently," Manny sneered, "all of you believe that you can make fun of people as long as they're out of earshot."

Jack snorted. "You can't get further out of earshot than Suzanne!"

I looked around and kept mum. I hadn't been in the band long enough to complain, but it's never a good idea to rag the folks you've got to play with.

Lillian said, "I've got somebody we can dish! And she can't hear us. That Mrs. What's-her-name, from last night?"

Eileen supplied, "Mrs. Cavett, from San Francisco."

Jack whistled a waltz-tune.

Manny smiled. "'The Merry Widow.' Very funny!"

Sonia leaned in. "Ohh, wasn't she atrocious?"

"And so affected," Eileen added, "waving her cigarette holder around like a baton!"

"You were dancing with her, Manny. Did she say—" Lillian's nose went up and she slid her voice into falsetto range "—'Oh, Mister Blunt! I just love your big…pipe.'"

We all burst out laughing: even the sisters, and even Manny.

Finally Helen said to the group, "I did think Mrs. Cavett was strange, in a way. Most of the women who come by to chat seem mainly to want to get Ted alone, if you catch my drift. But she didn't seem to pay particular attention to him."

Sonia shook her head. "On the contrary, dear. Perhaps you didn't see, but I did. When she and Manny were going back to their table, I distinctly saw her turn and give Ted a long, soulful look. It was like Merle Oberon staring through the window at Laurence Olivier."

"Oh, Sonia!" Helen's brows went up, and she looked around at us. "We went to see *Wuthering Heights* on Sunday. And I'm

afraid my big sister has a little weakness for Mr. Olivier. She still has Cathy and Heathcliff on the brain."

"Too bad we had to leave town right away, huh Ted?" Lillian called to him. "Or you could have put another notch on your gun."

"I think this has gone far enough."

"You should look her up, when we get to Frisco. That'd be all right with you, Eileen, wouldn't it? You want Ted to have his flings until you're free to get your hooks into him."

"There is nothing going on between me and Ted!"

I glanced up the aisle. The thin young man with the mustache had changed seats; he was sitting nearer to us than before.

"Ted's a man," Eileen went on. "He enjoys flirting. It doesn't mean a thing to me."

"'It don't—mean a thing—if it ain't—got that swing,'" Jack sang out from the row behind her. Lillian and I, and eventually all the rest of us chimed in with the "*Doo-wah doo-wah doo-wah doo-wah doo-wah doo-wah doo-wah.*"

Our musical salute to Duke Ellington—if not the reason for it—drew a smile from the big woman in green who passed by us again, heading back to her seat.

The train was slowing down; it came to a stop at the San Jose station, where an awning blotted out the sun. Helen opened her *Look* again, to the page with the crime-photo puzzle. But Sonia pushed the magazine down in her sister's lap and declared, "I simply can't believe it was an accident. And furthermore—"

"Quiet everybody, 'Gangbusters' is on." Jack threw back her shoulders, and let her half-smoked Spud dangle down from her lip. "Goils—it's a case o' moi-duh!"

"I'm serious," Sonia continued. "I think that what we were saying before is right: that Suzanne was killed, and that the person

who killed her could just as easily be a woman as a man. A man would have just reached in and...strangled her, perhaps. Men don't go walking around with hatpins. They don't...you know... do that awful thing...with blood all over the—"

Something made me insist: "Say it!"

"What?"

I was frustrated, and didn't know why, but a tone of annoyance had crept into my voice. "What are you so squeamish for, Sonia? Say it out loud."

"I...I..."

"Then I'll do it: Somebody pinned Suzanne to her bunk like a beetle!"

"You have a morbid sense of humor, Katy."

"I wasn't trying to be funny."

"Sonia's right, though," said Jack. "Don't you think it could have been a woman, same as a man?"

"It was a maniac with a—"

"Take a bromide, Lillian, and sleep it off," Jack snapped.

"Whoever did it—" Sonia blinked and coughed twice "—would need a motive."

"Maybe Suzanne carried life insurance," Helen suggested, looking around, "and one of us is the beneficiary."

Eileen said, "We've all got the regular union policy."

"If that were enough to kill for," I put in, "half the musicians in the world would be dead at the hands of the other half."

I appreciated the chuckles they gave my quip; but a tense feeling had come upon me even as I said it. My throat constricted. I didn't want to say more. In the quiet of the stopped train, even my breathing sounded loud. Fortunately, the whistle blew and the train started up again.

But Sonia said, "It was *you*, Katy. It must have been!"

"What?"

"You had the berth directly across from hers. You could have reached right over and done it."

"All the way across the aisle?"

"You were so calm when you saw the body. It was as if you'd seen it before. You have the *sangfroid* of a killer!"

I said, "I hope you're not serious," but I could see that she was.

"I think—" Helen paused for a second "—that what Sonia means is...you had a motive."

"Like hell I did!"

"Aren't you better off now? Aren't you playing two parts instead of one, and getting the extra pay for it?"

"Look, I joined up to play fiddle. Ted can tell you: I didn't want to sub for Suzanne."

"That's right."

"And as for my *sangfroid*, I'm a doctor's daughter. He trained me in first-aid. I've helped him deal with accidents where people were badly injured—killed, even. But I am not morbid or cold-blooded! Sonia, Helen—you have no cause to say I killed Suzanne just because I didn't need smelling salts when I saw her blood all over the place."

"You're playing her gig now!"

"You're getting her pay!"

"Next, you'll be saying I pushed Lois Dumont off the pier so I could play violin with you in the first place."

"Did you?"

"Yes, did you?"

Ted stood up. "Stop it! Katy was nowhere near Lois when she fell in. And you're foolish if you think you can hang your accusation on the way Katy reacted or didn't react to the sight of blood."

"Ted's right," Eileen put in. "Morticians' children probably enjoy similar experiences."

"I hope you meant 'endure,' and not 'enjoy,'" I said. "Would you all excuse me?" I stood up and headed for the ladies' room.

In biology class, in high school, we learned how to kill frogs so we could dissect them. You stick a pin in the back of its neck, at the base of the skull, and push it all the way up into the brain. The teacher said it was painless.

I don't know if you can kill a person that way, or if you can do it by going in through the mouth, but that's how I'd been figuring Suzanne was killed with a hatpin. It did seem awkward, though, especially if you missed hitting just the right spot. When a doctor asks you to say, "Ahhh," and sticks a tongue depressor down your throat, you have to make a conscious effort not to gag; you're fighting a reflex. But maybe you can't fight it when you're asleep.

The ladies' room latch turned easily enough, but the door opened less than an inch. Something was blocking it. The way I was feeling, I didn't want to ask anyone for help; so I pushed against it with my whole right side, and got it to open just enough so I could squeeze my arm and shoulder in.

Then I heard somebody moan.

I scrunched my head sideways and peered inside. Ivy was on the floor. I'd been pushing against her head.

"Ivy! Can you move? I can't get in to help you if you don't move to one side."

She gave another moan and rolled over, so I could push the door open. Closing it behind me, I dropped down to one knee and helped her roll onto her back again. "Are you okay?"

There was blood in her hair, but she opened her eyes. "Where is she?"

"What happened?"

"Help me up."

I put my arms under hers and lifted. She was more muscular,

and therefore heavier, than I'd expected. I set her down on the upholstered stool in front of the vanity mirror, dampened a towel in the sink, and dabbed her bangs with it. She needed iodine and a bandage. "I better get the conductor."

"Tell him to throw her off the train. And don't wait'll we stop!"

"Throw who?"

"The pig!"

"The woman in green?"

"Who d'you think? I've got a razor in my kit. I'm gonna kill her!"

"What happened?"

"She was in the stall when I came in. If I'd known it was her I'd have headed for the next car. But I waited, and when she came out she saw me in the mirror. What could I do? I smiled and said, 'Good morning,' like I was just anybody. But she swung her arm around and pinned me against the door. And she had this enormous handbag in her other hand that she hit me up with. Then she brought it right down on my head. I didn't stand a chance. She did it a couple more times."

"I'm surprised. A scrapper like you—"

"I tried punching her. I connected, too. But she was real soft in the gut: it was like hittin' a pillow. I couldn't hurt her. I grabbed her coat, but I couldn't push her away. I had no leverage. There was nothin' to do but play possum. I let her hit me one more time, and I just crumpled up and fell over."

"It must have been a heavy bag to draw blood like this. Maybe you hit the edge of the sink when—"

"Hell, no! She kicked me when I was down. Knocked me out."

"Are your hands okay? Open your fist." She relaxed her fingers and a button fell out. It was about an inch across, and

covered in the same green cloth as the coat. I smiled. "You can charge her with assault: here's your evidence!"

"Haul her into court. That's what I'm gonna do. But first I'm gonna *catch* her! See my pocketbook anywhere? Uhh…there it is, under the sink. Thanks, Katy."

It was wedged among the cleaning supplies; I pushed aside the sponges and the ammonia, the scouring pads, cleanser and bleach, untangled the strap, and pulled her bag free.

Ivy got up and leaned on the window ledge for support. "I'll be okay. Go on back."

As it turned out, Ivy couldn't revenge herself. She couldn't even bring charges. When she got back to her seat and told the rest of the girls what had happened, Eileen said, "I saw that woman leave when we stopped at San Jose."

"It serves you right, Ivy," Sonia declared.

And Helen added, "I knew you'd get in trouble some day, with that big mouth of yours."

"Knock it off, huh. Anybody got aspirin?"

Lillian took a bottle from her purse, pulled out the cotton ball with her fingernails, and shook two tablets onto Ivy's outstretched hand. I walked down to the water cooler, drew a paper cone full, and brought it back to her.

I wanted to do *something*, but I didn't have anything particular in mind. So I moved to an empty seat, a couple of rows away, to sit alone, taking my suitcase down from the rack and opening it beside me.

At the bottom I encountered Suzanne's scrapbook. I'd forgotten about it in all the confusion. She'd pasted in matchbooks and napkins from the Franklin Hotel in Philly, where the Ultra Belles had had their last steady gig, and clippings from the club dates they'd played on this tour. The band would be especially welcomed back in Chicago and Des Moines. The reviewer in

Denver was excited by Ted's newest song, "Remember To Forget," which I hadn't had a chance to play yet.

Some of Ted's songs had been covered (that means performed or recorded) by other people. Surprisingly, the reviewers didn't rate "Walking on Eggshells" very high. One critic was as fond as I was of Billie Holiday's slowed-down version, while another thought Artie Shaw improved it by taking it up-tempo. But neither of them cared much for the lyrics.

Jack had her picture in *Life* three years ago, in a story about a women's hotel in Greenwich Village; Jack wasn't written up, but she was in one of the photos, playing guitar, and her name was in the caption.

There was an article in *Variety* from last summer, about Phil Spitalny's Hour of Charm Orchestra, where Lillian and Lois had worked before joining the Ultra Belles. In the photo, Lillian was in the trumpet section, standing on a riser. Alongside her, another trumpeter's face was circled with a red pencil. I checked the caption; her name was Joan Barber.

There were two articles about Eileen from the Pasadena *Parade*. The most recent, around last Christmastime, told about her leaving the club where she'd been singing for a year, to join the Ultra Belles. Her husband, Philip Wheeler, was described as "a speechwriter for movie studio executives." The other article was six years old: it was about the singing contest that she'd won back in her school days. She was Eileen Spence then, and was identified as "Queen of the 1934 Pasadena Debutante Ball," and as "the daughter of Assemblyman Brandon Spence."

If I had a rich politician for a father, and a guy with big Hollywood connections for a husband, I might be seeing detectives everywhere, too.

There were some personal things in the scrapbook, too, like Suzanne's calling card, with the funny little drawing of her, and a

dried-up gardenia. And non-musical things that Suzanne had torn out of books or magazines, like "How To Make a Perfect Sidecar," from an *Old Mister Boston Bartender's Guide*, and—right next to it—a pamphlet from Alcoholics Anonymous.

I shut the book. My eyes were tearing; I wiped them with my sleeve. Maybe you could kill somebody by pushing a pin up into their throat, but you couldn't accidentally kill *yourself* that way.

Hatpins are long. Even if one got stuck in your mouth, there'd be plenty to grab hold of and pull. Besides, the pins Suzanne used to anchor her red hat—the one she'd boarded the train with—had little strips of black felt folded into the shape of tiny birds. The pin that Sgt. Grumman got from her throat had a bronze ball on the end. And so did the one I found on the pier in Santa Monica.

Sonia and Helen were right about one thing: what happened to Suzanne wasn't an accident.

The Piedmont Country Club had mounted our band photo on a big hand-painted sign:

<div align="center">

TONIGHT!
OUR MONTHLY SUPPER-CLUB EVENT
DINNER AND DANCING TO THE
SOPHISTICATED SOUNDS OF
THE ULTRA BELLES

</div>

Words like "dinner-and-dancing" and "supper-club" sound pretty glamorous. But even the people who come for the music want to eat first. And country-clubbers are very social animals. So all the couples, as soon as they got there, wandered from table to table shaking hands. Anybody who wasn't eating was talking; and a lot of them were doing both at once…while we were trying to play.

Enthusiasm was lacking on the bandstand, too, so our first set was atrocious. Maybe we were finally reacting to Suzanne's death, but not much had gone right all day.

The train had been half an hour late getting into Oakland. Ted had hired only one car at the station, which needed four trips to carry all of us and our gear. Our hotel was way uphill, beyond the town: an old-fashioned pile of a resort called The Claremont, with turrets and gables and antique gingerbread trim everywhere you looked, all painted a shiny white.

The Piedmont Country Club was about five miles away in a fancy suburb, up yet another hill. They expected us to play at mealtime, so the kitchen staff was in the middle of cooking when we came to set up. Meaning: we didn't get the pressed duck and chocolate cake; we got liverwurst sandwiches and shortbread cookies.

Ivy's head was still sore. Sonia's cough had gone away, but she looked tired, and was slow to hit a few of her downbeats. I'd been clenching my teeth all day; even four aspirins didn't cure the ache in my neck and jaw.

That first set, none of us did our best, though we did manage to pump some life into Ted's up-tempo numbers like "Let's Make Mischief" and "Back East Where the Sun Comes Up." But our bickering on the train had frayed whatever cohesion we'd built up the night before.

So I wasn't surprised when Ted threw open the green room door and called us all together.

"Excuse me. They must have hired the wrong band tonight. The picture on the sign out front shows girls who smile and show their dimples. But the act that just played didn't even smirk. Maybe I forgot, and left the Ultra Belles on the train. I think we ought to give the audience what they're paying for, next set. Don't you?"

We nodded and murmured agreement.

"Thank you, Ted," said Manny, pulling the pipe from his mouth. "I have something to add. Some of you haven't been this deep in the music business before, to the point where you need talent management and a press agent. So for your benefit, let me say that my job is *not* to get your picture in the papers. Practically every editor in America will run free cheesecake on his front page. My job is to see to it that in those pictures, the marquee in the background doesn't say 'Jail.'

"I'm here to perform many small services, and I pride myself on doing them rather well. I've held girls' heads while they threw up bad liquor. I've restrained lady wrestlers from challenging strangers in bars. I've sprung kleptomaniacs out of department stores a few moments before the police arrive. Now, of course, there are a few policemen who have need of such services themselves, once in a while. I think of them as rising stars on *their* stage, with careers and reputations of their own to nurture. They…grant me an occasional favor, which is very useful when I have to do something more delicate, like switching drivers' licenses after an automobile wreck.

"But policemen are always willing to help pretty girls keep their violent boyfriends at bay, and they also like to catch those boys if they should happen to get through the net and damage the goods. So the Santa Cruz police wired to their counterparts in Los Angeles yesterday, and now there's a manhunt on across the state of California for Suzanne's boyfriend."

Jack cleared her throat. "I didn't know she had a boyfriend."

"And with a temper!" Ivy put in.

Manny's pipe had gone out; he relit it, then said, "As I understand it, she sent him a 'Dear-John' letter last weekend, but he wanted her so badly that he, uh, followed her onto the train and killed her when she wouldn't take him back."

Eileen sighed. "I was really hoping it had been an accident."

"It couldn't have been an accident!" I blurted. "She'd have plucked the pin right out, or at least thrashed around in her berth and made lots of noise."

Manny looked at me. "Quite true, Katy. No one with half a brain—least of all Sergeant Elmo Grumman of the Santa Cruz Police Department—thinks that Suzanne swallowed her own hat-pin."

"Was that an insult?"

"No, Eileen. But the fact is: we planted the accident story in the papers deliberately—Sergeant Grumman and I—to keep Suzanne's boyfriend from realizing he's wanted by the police. So Lillian—"

"Yeah?"

"You may have been closer to the answer than anyone else."

"See? What have I been saying all along? There *is* a homicid-al maniac loose, and it's him!"

"I'm glad that's the end of it," said Ted. "It's time for our second set. Everybody ready?"

Before going back on stage, Lillian, Helen, and I dabbed red Mercurochrome on our lips. Reed and horn players have to do that because the mouthpiece makes lipstick smear. And even though Ivy and Sonia and Jack didn't need to, they each borrowed the bottle and did their lips the same way.

We headed into our second set with real smiles on. Ted probably thought it was the result of his pep-talk, or Manny's candor. But it was that little bit of primping—of sharing something, really—that lightened the mood.

A bunch of young jitterbugs had arrived by then, and we gave them a couple of lively numbers to dance to. I figured they wouldn't have stood a chance in a rug-cutting contest against Harlem youngsters; but for rich boys and girls from Piedmont,

California, they were pretty hep. They jumped and trucked and shagged and flipped into some aerial moves that made me reconsider their odds in a color-blind competition. Even their parents beamed and pointed, and remarked, "That's my boy!" and "Look at my girl go!" to their friends.

For the older folks, we paired the fast numbers with fox-trots and waltzes; and the kids just danced to everything.

Eileen did an especially fine job singing "Yours Till Dawn," which was one of the ballads Ted had written back when we were together:

> *If love is a flower, as poets say,*
> *That opens on the break of day,*
> *Then my love is quite a different story.*
> *For mine has evening's blossoms near us:*
> *Jasmine and night-blooming cereus.*
> *Not for me is the morning glory.*
>
> *I'm yours till dawn, till robins are a-flutter,*
> *And toast is spread with butter, and we yawn.*
> *I'm yours till dawn, till coffee stops a-perking,*
> *And gardeners start working on the lawn.*
>
> *Pretend and scheme. Don't rend your sleeve.*
> *For I'm a dream, and only make-believing.*
> *Yours till dawn, with love and sweet affection.*
> *But it's my predilection to be gone.*

Even the Philadelphia critic who'd had kind words for *To the Nines* nonetheless hated that song, saying it was in bad taste to brag about a one-night stand. And I'm sure a lot of people hear it that way, even now. But to me it's honest. For Ted—and for more

women than you might think—love is fun, and often funny, even when it's brief. Sometimes it's okay to let your love grow only by spreading over the surface, and not by setting down roots.

Eileen's performance also brought out something Ted had said about her stage presence, compared to how his old girlfriend, Belinda, had sung. Eileen could really work the room. She didn't look over the heads of the audience: she looked right into their faces, as though she were singing to every one of them individually. When I caught a glimpse of Ted, watching her sing, I saw him smile—a deep smile, with his whole face. It was the kind of smile you make toward somebody you love.

The lyrics to "Yours Till Dawn" aren't conventionally romantic. But when she sang the last refrain almost everybody stopped dancing and just stood and swayed, eyes closed, clutching their partners tight. It was a fantastic moment, and I was thrilled to be part of it.

The audience clapped, and Ted extended his arm toward her, calling her name into the microphone over the noise of the applause. The clapping got even louder. He stepped over to her and gave her a warm embrace. But she stiffened a little and pulled back. So he quickly raised her hand in his and twirled her around as though they'd just been dancing, and as though that was what he'd meant to do all along. The women in the audience sighed with delight.

If you aren't a phenomenon like Bix Beiderbecke, or a unique stylist like Lionel Hampton, or a trendsetter like Gene Krupa—if you're just an ordinary musician making a living on the edges of the big time, like we were—then it's in moments like that when you feel you're really in the groove that the masters have cut.

I knew I had finally clicked with the band, too. What happened to Suzanne was cleared up; nobody was going to say I'd killed her, ever again. The cops would catch the boyfriend

sooner or later. And we were all part of this new musical thing now, called the Nywatt Sound. We played two more sets, and even when we were packing up afterward, if I happened to catch one of the other girls' eyes, I couldn't help but smile.

"Looks like the 'Fourth Commandment' doesn't apply to men," Ivy said when we got back to the hotel. A bottle of California champagne was waiting for us, with a note from Manny attached, saying he'd be staying in Frisco and would meet us at the Oakland station in the morning.

"We don't need him if we're going to jam," Ted replied. "I brought along my trombone, just in case," and he got it out. The Claremont had lodged us in a wing that was closer to the kitchens and the staff's work areas than to any of the guest rooms, so nobody would complain about the noise.

Eileen and I had been assigned a room together, and somehow everybody crowded into it to jam. We made short work of the champagne, passing it from hand to hand without glasses. Jack declined the champagne, and uncorked a fifth of Scotch that she passed around, too.

Ted called for "Autumn in New York," a slow song with a complex chord progression that wasn't in our play-list, but one that he knew a very pretty break to. It also gave Lillian a chance to mute her trumpet for a subtle effect. Sonia didn't set up all her drums: just the snare, which she struck with sticks that had brushes at one end. Helen surprised me with some swingy, slurred clarinet notes—not at all in her regular style. Maybe she was hep after all?

Ted grinned. "You could try that in the Nywatt Sound arrangements."

"Well, well!" Ivy declared, "The 'First Commandment' falls, too!"

When it was Eileen's turn to call a tune, she asked for "All the Things You Are." She had an easy way with the lyrics; and in the trickiest change, when the last note of the first half becomes the first note of the second, she was right in the sweetest spot of her range. Helen and I supplied a smooth clarinet-and-violin glissando underneath her, that got a nod of approval all around. Eileen kept her eyes on Ted, though, and it didn't surprise anyone that, a few minutes after he said good night and headed down the corridor, she did, too. With Manny away, and Ted therefore alone in his room, I knew Eileen would be gone all night.

Around three o'clock, Sonia and Helen went to their room, and the jam session wound down. You can tell a jam is over when nobody wants to play even simple twelve-bar blues! Jack and Lillian went back to their room, which was next to mine, and pulled Ivy along with them.

I heard their voices through the connecting door, though, and since I wasn't sleepy I knocked and got invited in. They were sitting in the trench between the two beds. Their window was open. I smelled burning leaves, but it was springtime—not fall; and the smoke wasn't coming from outdoors. Ivy and Lillian were smoking reefers.

"D'you want one?" Lillian asked me right away.

"No thanks. Smoking cuts my wind."

Ivy squinted at me. "Ever try it?"

"A few years ago, before they made it illegal. It was nice—and it didn't give me a hangover."

I slid down between the beds until I was sitting next to Jack, across from Ivy and Lillian. She passed me her Scotch bottle, then shook a Spud out of her pack and lit it. "I don't know why anybody smokes that green stuff. Cigarettes'll kill you, but *mari-hoo-wanna* makes you stupid."

"Listen to her!" Lillian sneered back. "You think there's no

stupid drunks? What about Suzanne? How about that clinch of hers, with Ted, in the club car? Doing what a dog does, up against his leg."

"She was plastered!"

"Yeah, and did you see the way Eileen looked at her? I did. If looks could kill...oh, hey! I didn't...you know what I mean." Lillian drew deeply from her reefer again, held her breath, then let out the smoke in a thin stream through pursed lips. "But I don't get it. Eileen keeps saying it's okay for him to flirt and all, and then she's staring daggers at anybody who does. She's jealous as hell, no matter what she says."

"I miss Suzanne," Jack said. "When she was in a groove, she could take us all along with her."

Lillian leaned forward. "I miss her, too. She owed me twenty bucks."

Ivy wrinkled her brow. "Is that the same twenty bucks she asked me for last week? I wouldn't give it to her. She'd only drink it up, and I told her so. But that sneak! Y'know what she said? She said if I didn't give her the twenty, she was gonna tell Ted that I had reefers."

"Did you give it to her?" I asked.

"Are you kidding? I told her she better *not* tell!" Ivy slipped one hand into the pocket of her jacket. "And don't *you* go telling, Katy, or so help me I'll *cut* you!"

Her hand shot out of her pocket, straight toward my face. There was something in it, and I didn't wait to see what it was. I ducked to one side, brought my open hand around, and pushed *her* hand aside with my palm. Then I wrapped my fingers around her wrist and slammed her knuckles down on the floor. Her arm—and the rest of her—followed, and she landed sideways.

She'd been holding a straight razor. It wasn't open. But I kept

her arm pinned to the floor until it fell loose. I leaned in close to her face. "I...would...*never*...tell." Then I let her go.

She sat up and caught her breath. "Jeez-us!"

Jack nodded. "You've got quick reflexes, Katy."

"It's *ju-jitsu*: that's what they call 'the gentle art of self-defense' over in Japan."

"Lemme tell ya—it's not so gentle!" Ivy rubbed her wrist. "How'd you do that?"

"My brother and I learned it together, from a book, when we were kids. It really comes in handy when some wolf tries to get fresh."

"I could've used you on the train, when that pig came after me."

I picked up her razor from the floor, smiled, and tossed it back to her.

Jack blew a smoke ring in Ivy's direction. "Why'd you insult that fat gal on the train, anyway?"

"I don't know. I've been thinking about it all day. She reminded me of somebody."

"What about the one you insulted on the other train? The bleached blonde in the compartment. She looked like she'd have hit you, too, if the rest of us hadn't been standing around."

"Naahh." Lillian shook her head. "That one wasn't half as big as this one. Ivy, you're just building up a grudge against big ladies. What do you want to make them mad for? It won't make you any bigger."

Ivy had been smoking her reefer continually while they talked, till it was almost gone. She took one last drag, pinched the ash off, and popped the last half inch of it into her mouth. Then she said, "Gimme a pull on that bottle," and took it from me. "There was a big gal back in Philly that used to come around every night when we were playing the Franklin. You must've seen

her, Jack: she always came real late; only caught the last set, stayed in the back. Remember?"

"Oh, yeah. Red hair. Pink face."

"That's her! Well, she never clapped. She just sat there, staring."

"So, she didn't like the band," Lillian said. "So what?"

"So why did she keep coming back? It really got my goat, worse than when somebody's talking while we're playing. She just sat there and wouldn't even pretend to clap. I don't know why, but that gal on the train today reminded me of her. I'm sorry."

"Well, next time you see a fat lady—" Jack took back the bottle "—keep your mouth shut, okay? Besides, you didn't have to worry about your reefers with Ted. He doesn't care, as long as you keep them under wraps. I asked him once, back when we were doing *To the Nines*, if he ever smoked that *mari-hoo-wanna* stuff. And he said—" Jack made her voice artificially deep "—I've had 'mary-jane' a few times."

Lillian lit another reefer and started giggling. "He's had Mary-Ellen, too. And Mary-Beth and Mary-Claire and—"

"Thank you, Lillian," said Ivy. "I just didn't want Suzanne to tell the Harpies about the reefers, 'cause they'd go runnin' to the cops, for sure."

Jack shook her head. "What you've got to watch out for are the detectives who are following Ted and Eileen everywhere. You know about that, Katy?"

"Yes."

"—and Mary-Rose and Mary-Lou and—"

"Ignore her, Katy. She goes on jags."

"You know the trouble with Eileen?" Jack looked around, but we waited for her to answer herself. "She's got too much money. She doesn't need this gig to make a living."

"—and Mary-Mary-Quite-Contrary!" By now Lillian was

laughing so hard that she slipped down and lay nearly supine on the floor. Then she started singing, "I'm the queen of everything, I got to get high before I swing," and waving her arms around.

She didn't have much of a voice; and apparently all she knew of "You's a Viper" were those two lines, because she sang them twice more. Then she stopped and wiped her eyes, took a deep drag on her reefer, and peered at me. "Did you ever have a roll in the hay while you were smokin' the hay?"

Maybe I'd been breathing in the smoke that she'd been breathing out, because I didn't feel embarrassed to say, "Yes."

"And…?"

"Yeah, Katy, what happened?"

"I felt like I was floating."

"Ooohhh! Flo-o-oating." Lillian's head lofted as she said it. "That's what it's like."

"I couldn't make music too well, though. The reefer took my mind off on tangents. I couldn't concentrate."

"Oh! Well. That's different. For concentration," Lillian said, "you need coke-caine! I've got some, if anybody wa-ants."

"Jesus, Lillian!" Ivy chuckled. "If there was a contest for Miss Narcotics of 1940, you'd win it in the first round!"

"Know what I like, Katy?" Lillian went on. "I sniff it up my nose and I get ting-ly all down my spine, and between my legs. I just go berserk!"

Jack took hold of Lillian's shoulder and gently slapped her face. "Please don't go berserk and kill yourself, like Joan did."

I asked, "Who's Joan? I've heard that name."

"Joan Barber," said Jack. "She was our trumpet player before Lillian. Her and Lillian and Lois were all in Spitalny's band together: you know, the Hour of Charm?"

"They both quit before I did," Lillian explained, "and went to work for Ted."

Ivy snorted. "You didn't exactly 'quit' his band, Lillian, re-member? Spitalny caught you and 'mary-jane' together. Anyhow, Katy, when Lois heard that Lillian was, well, out of work, she told Ted: if he ever needed another trumpet he ought to hire Lillian. And then Joan died, so he did need a trumpet. And that's how come Lillian's in the band."

"And I remember now where I saw Joan's name," I said. "There's a picture of her and Lillian playing in the Hour of Charm. It's in Suzanne's scrapbook."

"I gave her that picture. I want it back!"

"Sure, Lillian."

"Now!"

"Okay. I'll go get—"

"Sit down, Katy." Jack touched my arm. "You can get it later. Lillian's just touchy about what happened to Joan."

"You said she killed herself?"

"Yeah. But Lillian's extra-touchy, because Sonia and Helen harped on her about it. You remember, this afternoon, how they said you killed Suzanne so you could take her gig? Well, they ragged Lillian about Joan for a month, almost, saying things like Lillian must have *pushed* Joan out of that window."

"But they don't do it anymo-re! They came to the end of that little ditty and they stopped—" Lillian snapped her fingers "—like that! And do you want to know why, Quiz Kids? Because I found out something about Sonia that she doesn't want anybody to know. And nope! I'm not telling anybody."

Ivy plucked the reefer out of Lillian's mouth and took a puff. "I wish I could get something on those harpies. Maybe they'd be civil to me."

"You know why they don't treat you civil, Ivy?" Jack sipped the Scotch. "You don't think before you talk. Like today, with that fat—"

"I don't want to think about that anymore."

"Let's talk about something else," I suggested.

Ivy squinted at me. "Let's talk about *you*. What do you think of Ted? He stares at you sometimes, when you're not looking."

"He does?"

"I bet he's interested. Are you?"

Jack chuckled. "Ahh, he'll lay anything in skirts."

"Is that why you wear pants?" Lillian plucked the reefer back from Ivy and took a long drag. "What about it, Katy? Lois is out of the picture. You wanna be the next notch on his gun?"

I hesitated for a second, but I needed friends in the band. Eileen was too distracted. The sisters were too nasty. Suzanne was too dead.

I took a breath. "It's too late. We did it already."

"I'll be damned!"

"You've got quick reflexes, all right."

"I don't believe you. Where'd you do it?" Ivy demanded. "In the can on the train?"

"No! It was four years ago. Ted and I were an item for a couple of months."

"Months?"

"That's one for the record books!"

"Aren't you embarrassed to be around him now?"

"No. We stayed friends. I ran into him last summer, in New York. He was with that girl who sang in *To the Nines*."

"Oh. Belinda," said Jack. "You girls never met her. I didn't like her. She was an 'act-tress,' if you please. What did you think of her, Katy? Didn't you think she was stuck up?"

"I only met her once, in a theater lobby."

"How do you stay friends with somebody you've been making time with?" Ivy asked me. "Guys I've been with—when they walk out, I sure don't think of them as 'friends.' And Ted—of all

people! Wow. How can you watch him paw every girl that gets within arm's reach?"

"I just don't care."

"Joan cared," said Lillian, slowly. "She got her heart broke all the time, and Ted was just one more heartbreaker."

"Boy, was Joan the weepy type!"

"But not when she was high, Ivy. So I got her high a lot. And reefers didn't bollix up *her* playing," she added for my benefit.

Jack lit a fresh Spud from the butt of the last, then squeezed the old one into a crowded ashtray. "The thing is, Katy, while she was Ted's girl we all kept quiet about how many reefers she was smoking. But we didn't know she had the cocaine habit, too."

"She did not! And I ought to know." Lillian puffed herself up a bit. "I'm the one who likes nose-candy. But I never saw her take any. She said she'd tried it once, but it made her scared and jumpy, and she wouldn't take another whiff."

"Well, she must've whiffed it, and it made her jumpy all right," Ivy insisted, "'cause she jumped right out of her window."

Lillian protested: "It didn't happen that way! I know how the coke habit works. If you take a lot it makes you crazy. But she didn't take any, and she wasn't crazy. Weepy. But not crazy."

"What happened to her?" I asked again.

"It was back in February," said Jack. "We finished our gig at the Franklin, and Joan went home to her apartment in South Philly. The neighbors heard glass break. She'd gone straight out the window—didn't even open it first. That's how coked-up she was."

"I'm telling you, she didn't like the stuff! I gave her some once, for free, and she wouldn't take it."

"Movie theaters give away dishes," said Jack. "Lillian gives away cocaine."

"How does anybody know if Joan took it? Did it show up in the autopsy?"

Jack shook her head. "It was in the papers. The cocaine was in a little envelope, like the kind stamp collectors use. You know how the tabloids are, Katy, when they get hold of a really lurid story. They gave it a picture-spread: the car she hit on the way down; the neighbors in the street, pointing up to her window; the body under the blanket; a couple of shots inside her apartment— including that little envelope of cocaine that generous Miss Vernakis here had given her!"

A moment went by when nobody said anything. So I held the Scotch bottle up over my head. "We ought to drink a toast to Manny Blunt, for keeping what happened to Suzanne out of the papers."

We passed the bottle around. But as soon as Lillian had had a swig, she said, "Why did you have to remind me of those ugly pictures? I can't get 'em out of my head. I need another reefer. I gotta forget about all that bad stuff. Forget that girls I know can get hurt, and friends of mine can get *killed*—" her voice cracked. "I don't wanna *think* about it anymore! It's not happening now. It's all in the past. I'm gonna live for today, this minute. Henry Ford was right: history's all bunk."

"Naahh, that's garbage," Jack retorted, lighting yet another Spud. "We have a saying in the Party: If you don't remember the past, you're gonna repeat it!"

SACRAMENTO, CALIFORNIA

THURSDAY

MY LITTLE FOLDING ALARM
clock woke me at quarter to nine, and I pulled on
enough clothes to be presentable. I hadn't gotten into bed
until four-thirty, and I'd dreamed about running through broken
glass—but it was one of those frustrating dreams, too, where
everything is in slow-motion.

Most of the other girls were already eating breakfast when I
sat down. The sisters were tucking in scrambled eggs and toast.
Ted came into the dining room with his hair brushed, vest but-
toned, tie straight, like an *Esquire* model. "Everybody get a good
night's sleep? Great." Then he looked around. "We all had fun
last night, didn't we?"

"Some of us had more fun than the rest of us," Ivy said. But
she stared at her sausages for a long time without touching her
fork to them, asked for the pepper, and asked for it again after it
was passed to her.

Lillian had nothing but coffee for breakfast, with a lot of sugar

and cream poured in; she kept her hands wrapped around the cup, lowered her face to the rim, and sniffed the fumes. When Sonia asked if she was all right, Lillian replied, "Congested, that's all," and snuffled into a hanky.

Jack gave me a smile and a "Good morning," picked up a hard-boiled egg with her fingers, and dipped it in a little pile of salt.

Eileen was the last to come to breakfast. She had tiptoed into our room about half an hour after I'd gone to bed, and was still asleep when I'd gotten up to wash and eat. Even now, she hadn't put on any makeup.

"Tell you what," Ted announced, "we have a little extra time today. We were supposed to take the Southern Pacific route to Sacramento at eleven-ten. But we don't have to, unless you want more time up there in Sacramento. If you're tired this morning, we could take it easy a while longer here, and catch a Western Pacific train at twelve-fifty. I'll put it to a vote: who wants to leave right away?"

Nobody raised her hand.

"Who wants to stay here and goof off?"

We all waved our arms and cheered.

"The voice of the people has been heard," said Jack.

"All right. Pack your gear, though. I'll load the car and drive our stuff down the hill at ten. But I need somebody to help me tie it down and ride along to the station. Have I got a volunteer?"

"How're *we* gonna get down?" Lillian asked.

"There's a streetcar that stops in front of the hotel, just below the tennis court—" he pointed out the window. "It goes all the way into Oakland, and lets you off right at the train station."

Ted had looked at me when he said "volunteer," so I raised my hand. "I'll help you with the luggage."

The car-rental agency had attached a rack to the top of the station wagon. We stuffed as much of our baggage inside the car

as we could, and tied everything else — including Ivy's bass — onto the roof with hemp rope. We looked like we'd driven all the way from Oklahoma, like in *The Grapes of Wrath.*

The morning was warm. We cranked down the windows and the breeze brought us the pungent smell of eucalyptus trees. For the first mile or two we pointed to things along the way, like date palms and fruit orchards and unusual houses, and said, "Isn't that nice?" or "Look at that!"

But finally Ted said, "I'm glad you came along, Katy."

"You couldn't be seen alone with Eileen. Somebody had to —"

"No. I meant…on tour with the band. I can talk to you, Katy. Talk *with* you. As a friend."

"We don't have a lot of ice to break."

"Exactly." But then he was quiet again, for almost half a minute.

"Did you want to talk to me or not?"

"Don't tell the other girls."

"Of course not."

"Belinda is sending me telegrams."

"What's the matter, Casanova? Did she give you a disease?"

"No!"

"Watch the road!"

"Sorry. But that's you all over, Katy: jumping to conclusions."

"What did she say?"

"She wants me back."

"Half of your conquests probably want you back."

"She sounds frantic."

I was about to ask how she knew where to send her wires, but anybody in the music business could find our itinerary on the Orchestra Routes page in *The Billboard* magazine. "Do you want her to join you out here?"

"She wants me back *there.* She can't leave Philly. She's working six nights a week at the piano bar in the Club Deluxe."

"Piano bar. Now that's a dream job: you play and sing, mostly what you want; people give you tips, and you get to sit down while you work!"

"I'm serious, Katy. I don't think it's been dreamy for her. I know the Deluxe. It's a prestige gig. Society types go there. But it doesn't pay well, and the rich don't tip as much as you think. She's had to take a day job—cleaning houses, and she hates it. When she was growing up, her family had a live-in maid. So she thinks it's demeaning to wash other people's floors and do their laundry."

"I always helped Mother clean house. It sounds like an easy way to pick up extra dough."

"You're not her! She's, uh…"

"Stuck-up?"

"So what if she is? Anyhow, she got sick last winter and couldn't work for weeks. At least she's got this gig at the Deluxe, but it doesn't pay enough. She wants to quit house-cleaning and do music full time."

"Not many musicians can afford to give up their day jobs."

"She said she's lined up a gig for us. Here—read the wire I got Sunday, in L.A." He dug into his jacket pocket and handed me a couple of telegrams. The one from Sunday read:

GOOD NEWS TEDDY CLUB DELUXE WANTS ULTRA BELLES
FOR HOUSE BAND COME HOME SOONEST YOUR BELINDA

"You don't want to be stuck in Philly again, do you?"

"I don't want to be stuck with *her*. I think she pitched the band to the club and cast herself as the canary. And she *knows* I don't think she's right for my songs. Read the other telegram. It came yesterday to Santa Cruz."

I CAN'T GO ON WITHOUT YOU TEDDY YOUR BELINDA

"What does 'go on' mean?" I asked. "Go on stage or go on living?"

"You tell me."

"What did she used to do when she was upset? Did she ever threaten to kill herself?"

"No. But I haven't seen her for months."

"Have you called her?"

"She'd think I was coming back."

"But how else—"

"I can't take on her problems right now. I'd like to help her out, but—"

"I'm no expert, Ted, but isn't she more likely to throw herself out of a window if you *don't* call?"

"What?"

"Watch the road!"

"Sorry. But 'the window.' What did you mean? Were you talking about Joan? Somebody told you about Joan Barber, didn't they?"

"How about 'turn on the gas'? Is that better?"

"Be serious, Katy."

"I am serious! I don't know why anybody would want to commit suicide. But if she hasn't done it yet, there's a chance you can talk her out of it. You've got to try. I didn't join your band to be your psychoanalyst. Ugh! It would have been easier if she *did* give you a disease. You'd be doing her a favor by calling to let her know; and then you could go get cured and not have to say anything else. You want my advice? Here it is: get a lot of change at the news-stand; you're probably gonna be on the phone with her for a while."

"Thank you, Katy. I swear, you're the smartest girlfriend I ever had."

"I don't like hearing that I was 'had.'"

"You know what I mean!"

"But I do like hearing that I'm smart. So here's one more idea: ask Manny to put Consolidated in touch with her. You like her voice. She's worked professionally. Give her a good reference. And then, damn it, go call her!"

Like a lot of cities, Oakland has two train stations. Yesterday we'd arrived from Santa Cruz on the Southern Pacific, whose station was a mile or so from downtown, among warehouses and small bungalows, almost on the edge of the Bay. But today we were taking the Western Pacific to Sacramento, and that station was right downtown, between the harbor and the office buildings. It took up most of a block, with a huge brick facade of archways facing a street that had four sets of railroad tracks running down the middle of it.

A brace of Redcaps arrived with their carts to help us, and Ted gave them each half a dollar after they'd tagged everything for Sacramento. He looked at his watch, then up and down the sidewalk in front of the station.

"I hope Manny got my message and didn't take the early train. Stay here for a second; if you see him, tell him I'll be right back." He walked through the big doorway toward a bank of phone booths on the far wall.

It was going to be a warm day, and the sweater I'd put on for the car trip felt heavy. I pulled my arms out but left it draped over my shoulders while I knelt to open my traveling case. The lid flipped back, right into the path of an oncoming pair of black pumps.

"Goddamn!"

The woman had tripped, and though she'd caught her balance right away, one silk stocking snagged on the latch of my case, and tore open a ladder.

"I'm sorry! Excuse me. I didn't see you."

She tapped me on the shoulder with a cigarette holder a foot

long. I stood up and apologized again. A crescent of black veil hung over her eyes, but she looked familiar: beaky nose, thick face powder.

"You're one of the Ultra Belles, aren't you?"

"That's right."

"I'm Nina Cavett. I came backstage in Santa Cruz." Her voice had been throaty the other night; today there was a raspy smoker's edge to it.

"Yes. I remember. I'm really sorry about your stocking. Can I pay for it?"

"No, no. It was an accident. I have others."

"Thank you. I'm Katy Green." I put out my hand.

She extended her glove in one of those finger-shakes that they teach debutantes in finishing school. If I were a European man, the correct response would have been to bow and kiss it.

"I'm sorry I snapped at you," she said. "I didn't expect to bump into anyone here. Literally!" She puffed a little laugh. "From what Mr. Blunt said, I thought you'd be in Sacramento already."

"We're taking the later train. Mr. Blunt should be around here someplace, but I haven't seen him. And Mr. Nywatt will be right back. He's on the phone."

The other night I'd guessed she was about forty. In daylight she looked younger, but with all that makeup it was hard to tell. Across her chest she'd buttoned a brown tweed jacket that was probably too warm for a late spring day. But she didn't seem to be the sort of woman who'd break out in a sweat. She snapped open a black enameled cigarette case.

"Chesterfield?"

"No, thank you."

She stuck one in the long holder and lit it with a petite gold lighter, extending her lower lip out just enough to blow the smoke straight up and away. "Where are the other girls?"

"They're coming on the streetcar. Our train's not till twelve-fifty."

"Here's your baggage, ma'am," said a Redcap, wheeling up a steamer trunk on a handcart.

She gave him a dollar. "Leave it here. I'll tell you when I'm ready to go."

"Yes, ma'am." He walked away.

"Are you taking a train, too?"

"No, I just got back from Santa Cruz. I'm going home to San Francisco." Then she lowered her voice. "They're working on the lawn at my house and I swear you have to supervise everything personally, these days. Have you noticed? Nobody wants to work. Even my groundskeeper can't find a reliable assistant, so my lawn—which used to be the most fabulous greensward in Pacific Heights—is going to ruin. Now that the Depression's over, nobody's willing to do any hard work."

The Depression sure wasn't over for everybody. What she meant, I figured, was that there weren't a dozen guys standing outside her gate anymore, asking to rake leaves for a sandwich.

Being a musician these days is no picnic, but I'm doing better than a lot of folks. I couldn't help thinking of *The Grapes of Wrath* again, and that ragamufffin woman on the pier in Santa Monica who was still begging for dimes and grabbing hot dogs out of garbage cans. I wondered if I could push Jack and Mrs. Cavett into a debate. But all I said—and it wasn't what I wanted to say—was "Ummm."

"What do you think of my coat?" She held the jacket out with her hands and made a half turn, shoulders first, like a mannequin on a runway. "I found it last week at the City of Paris, on Union Square. It was only sixty-eight dollars."

That was *only* about what I pay for a month's rent in New York! But I said, "It fits you nicely."

"Do you mind if I ask you: who's the chesty one in your band? The trumpet player."

"Her name's Lillian Vernakis. She used to be with Phil Spitalny's Hour of Charm Orchestra."

"Oh, they're very good. I hear them on the radio." She cleared her throat. "I couldn't help noticing the way Mr. Nywatt looked at Miss Vernakis, the other night, when she was taking her solos. Is he…sweet on her?"

"I wouldn't know."

"Is she his special girl?"

"I don't think so. Not that I've noticed. Oh. Here he comes. You can ask him."

"Don't be silly, dear."

"Ted, do you remember Mrs. Cavett, from the other night?"

She gave him even less of her glove to shake than she gave me. "I was just telling Miss…I'm sorry. Miss—?"

"Green."

"—that I won't be able to hear you again this week until Saturday. But if Mr. Blunt is here I'd like to continue my conversation with him from the other night."

Ted smiled and let his eyes look into hers for a second. But she startled, waved her cigarette holder to give herself more elbow room, turned to stand obliquely to him, and pointed toward the street corner. "Ahh! Isn't that he, now?"

Ted called out, "Manny!" and waved him over.

Manny was carrying his suitcases, portfolio, and typewriter. He set them down, smiled, and touched his hat. "Good morning, Mrs. Cavett, how are you? Nice to see you again."

"Nice to see you, too," she gushed. "I was going to send you a wire today, but this is a marvelous coincidence: here you are. I know I told you I'd try to get to Sacramento today. But my Pacific Heights Garden Club is meeting this afternoon, and I want to tell

them all about the Ultra Belles, and how marvelous they'd be for our gala to benefit Saint Francis Hospital."

"I have a couple of ideas about that," Manny said. "Perhaps we could talk a bit about it before our train leaves. Coffee?"

"Tea, please."

Manny smiled broadly at me and Ted, then took her elbow. As he steered her toward the doors she glanced back and called, "Redcap! Mind that trunk."

Ted said dryly, "*That* was a coincidence," and we both snickered.

A streetcar slowed down and squealed to a halt in front of the station. The Bliss sisters stepped off, carrying their suitcases.

"The others will be coming along any minute," Ted whispered to me. "I'm gonna go make that phone call, like you said. See you on board, Katy."

Helen smiled at me. Then, as though I were their favorite niece, she and Sonia came around and stood like bookends on either side of me. Helen took hold of my elbow. "Katy, I want to apologize for…for what I said yesterday on the train."

And Sonia (though she didn't actually touch me) leaned very close to my face and added, "We were very distraught over what happened to Suzanne. We were just trying to make sense of it all."

"And does it all make sense to you now?"

"Please accept our apologies. We really don't believe that you killed anybody."

"We're somewhat older than the rest of you, and experience has taught us to be resolute in seeking the truth."

I've worked with plenty of older musicians, especially in my longhair gigs, and nobody ever pulled rank on me before. But if this was their way of apologizing, I didn't mind. And I did want to know what they thought "the truth" was. So I said, "Thank you."

"Do you know if there's a drug store nearby?" Sonia asked me. "I need some more smelling salts."

"I don't know, but there should be one around some place."

"Would you walk with us?"

"Sure."

Helen slid her arm around my waist with a surprisingly comforting grip; Sonia walked along on my right. We spotted a drug store two blocks down Broadway. Being long-waisted they weren't striders, but they set the healthy pace of experienced travelers.

While Sonia went inside, Helen motioned to me to stand and chat with her by the curb. She took her glasses off and cleaned them with a handkerchief. Finally she said, "My sister and I believe that you were a Girl Scout. Were you?"

I smiled and raised the three-fingered salute.

"We were, too. Are you a good American?"

"I vote in every election."

"Do you have sisters?"

"No. But I used to wish, sometimes, that I did. Especially after I saw you two on stage. It would have been nice to have a sister to perform with."

"Well! You must have loved our rendition of 'K-k-k-Katy.'"

"Ahhh…actually, no. I stammered a little when I was a kid. And just about the time I was growing out of it, my friends and I went to hear you on stage. And you sang 'K-k-k-Katy.' They taunted me all the way home from the theater, and for weeks afterward. I'm really sorry, Helen, but that song makes me cringe, the way chalk does scratching down a blackboard."

Sonia came out of the store with a small paper bag. "Did you tell her?"

"I was just going to."

"Tell me what?"

Helen took my arm again, and we started walking back

toward the station. "You know, Katy, it's easy to mistake a show of friendship for something as deep and binding as sisterly affection."

"In these close quarters that the band works in, women get lonely on the road, and they naturally turn to one another for advice, for help with their personal problems, for—"

"Where is this going?"

"To speak plain, we'd hate to see you make the wrong choice of friends. And Jacqueline is—"

"I'm sorry she's a Communist, too. But it doesn't seem to affect her guitar-playing. You don't think she's murdering people in their sleep, do you, under orders from Comrade Stalin?"

"All Communists are dangerous! Look at Mr. Roosevelt's Works Progress Administration: they hire Communist actors to mount plays written by Communists—plays that do nothing but tear down what's right about this country. Have you seen those so-called Living Theater productions? Where the actors supposedly behave like real people? There they are, most of them, on Relief, yet they're wailing about unfair working conditions!"

"I don't see what—"

Helen tightened her grip on my arm. "The danger to this country doesn't come from Russia and Stalin. It comes from That Man in the White House. *And* Communists like Jack."

"You'd take a loyalty oath, if it were required for you to keep working, wouldn't you, Katy?"

"Of course she would; she was a Scout!"

"Don't get too close to Jack," Sonia went on. "You could find yourself blacklisted, and never get work again."

"Besides, there's another reason you shouldn't get close to her." Helen looked me right in the eye. "You can't trust a…a girl like that."

"A girl like what?"

"She's not…normal."

"We believe that Mr. Blunt came closer to the truth than he realized, when he said that jealousy was the motive for Suzanne's death."

"Only it wasn't a jealous *boy*friend who—"

"I don't believe that."

We'd almost reached the station; the rest of the Ultra Belles were stepping off the streetcar a block ahead of us.

Sonia wagged a finger in my face. "Don't say we didn't warn you."

Having changed our train reservations, we were lucky to get seats. They were the last two rows in a crowded day-coach where a Boy Scout troop was climbing around in front, and a dozen local Shriners—fezzes clamped on tight—were carousing loudly in the seats behind them.

After we were underway, Ted motioned for me to follow him to the club car.

It was crowded there, too. Another knot of Shriners was drinking beer noisily; and a dozen well-dressed matrons were gossiping over sherry, and changing seats frequently to whisper to one another. A few other women sat apart, but they had their ears cocked, as though they hoped that dirt wasn't being dished about *them*.

We took the next chairs past the gaggle of geese, and Ted ordered us Cokes.

"I tried phoning Belinda—twice—but there was no answer."

"At least you tried."

"You don't think—?"

"No I don't. She's just fine." I looked at my watch. "It's the middle of the afternoon there; she's probably cleaning somebody's house."

"Should I tell her about Eileen? Should I catch her up on what I've been doing? We broke up right after they closed *To the Nines*, last October. She got that piano-bar gig, and then last winter she got sick and wouldn't let me visit. So, *not* seeing her got to be a habit, just like seeing her had been."

"Keep trying to call. Maybe you need to straighten out your past before you can work on your future."

"I told Manny what you said, and he said he'd do it. So I sent her a wire, to expect a call from his people at Consolidated."

"It's nice of you to do that for her."

"I still care about her."

He blinked. I clinked my drink against his.

"I believe you do. You're a man who loves women—even the ones you're not in love with anymore. When you tell us that from now on you only want to be friends, you really mean *friends*. It's rare in a man. You'd like to be a friend to all of your old girlfriends, but it's not always mutual. Only some of us care for you as a pal." I stood up and planted a red kiss on his cheek. "That's for Eileen's detectives. Wear it back to your seat."

The train was making good time rolling beside the broad, blue-gray Sacramento River. But I wasn't feeling happy, and I paused in the vestibule between the club car and our day-coach. Something about Suzanne's death still bothered me. If there had been a jealous boyfriend on board our train that night, and the conductor had taken a ticket from everybody, then—unless he had stowed away in the baggage car—where'd he come from?

The wind that surged up between the cars came from a landscape that was coarse and dry, like a desert. From what I'd read about California in the WPA guidebook, I'd expected the whole state to be filled with lush orchards—vineyards, too—like the Santa Clara Valley was. But all the hills we passed here were

covered with nothing but scrub grass that wasn't even green: it
was parched and brown, almost like weeds.

The Golden Eagle Hotel, in Sacramento, didn't brighten my
mood either. I'm a modern girl who likes streamlines, not
antiques. The place hadn't been renovated since the days when
ladies wore lacy bustles and trains, and the roof and all the eaves
were *still* gussied up that way, with finely carved wooden trim.
But the Golden Eagle wasn't a resort like The Claremont, with a
faraway wing where we could let our hair down after work. It was
a crowded hotel, close to the state capitol building, so the lobby
was packed when we went in to register. We had to push through
a convention of women, mostly middle-aged or soon to be. Some
of them had been on the train with us, and quite a few were wear-
ing political buttons and ribbons. A banner above a portico an-
nounced:

FREE LECTURE — 3:00 P.M.
"DO AMERICANS WANT WAR?"

And an easel beside the doorway to one of the function-rooms
held a large signboard proclaiming:

THE CALIFORNIA GOOD-GOVERNMENT LEAGUE
PRESENTS
DR. GEORGE GALLUP
NOTED EXPERT ON PUBLIC OPINION

Sonia and Helen declared that they wanted to attend, and asked
Ted to check them in first, so they could toss their stuff into their
room and hurry back down to get a good seat. It was nice to see
them excited about something besides gossip.

Electric lamps had long ago replaced gaslight, but the Golden Eagle did not keep its hallways very bright. And the place was such an antique that the rooms (which were tiny) still had little closets built into the doors, so the valet could pick up your laundry and return it without having to enter your room.

Once again Eileen and I were assigned a room together. As soon as we were inside she picked a bed, sat on it, took a hairbrush out of her pocketbook, and started her hundred strokes.

I pushed on the springs of my bed with my palm—it wasn't very firm—then looked over at her. "Can I ask you something?"

"Shoot."

"Did Ted drop Joan Barber for you?"

She stopped brushing for only a second. "Yes. Ted and I were just getting…started. So he told her it was over between them, and Joan told me she'd gotten over Ted. That's what she said, anyway."

"But she hadn't?"

"Joan and Lillian were old friends. You know Lillian's a dope fiend, don't you? Anyhow, she gave Joan some dope, and she must've been taking it—like drinking to forget, if you know what I mean. But it sent her off her head. Toward the end, she was scared of strangers—even the audience. It was creepy. We'd be playing our gig at the Franklin, and Joan would stare out into the crowd as though she were looking for somebody. Missed her cues a few times. She was *non compos mentis*."

"So much so that she killed herself?"

"She'd probably be locked up, by now, if she hadn't. Now you tell *me* something."

"If I can."

"Ivy says you're handy with your fists: that you know some kind of Oriental boxing—"

"*Ju-jitsu*."

"Is that what it's called? Is it true?"

"It's more like wrestling."

"Well, whatever it is, would you… I want you to protect me. I don't feel safe. I was in the bunk right underneath Suzanne! I mean, suppose it was *me* that the killer was after?"

"Who? Your husband?"

"Not him, personally. But he could have *sent* somebody to kill me. I wouldn't put it past him."

"Well, now I'm really confused. First you said he hired detectives to keep watch on you. But now you say—"

There was a knock on the door, and Ted called softly, "Eileen," from the hall.

"Just a *sec*-ond," she sing-songed, as though she were undressed. But she made him wait while she finished a few more strokes with the hairbrush.

I said, "You can't have it both ways."

She slid over and checked her makeup in the mirror over the dresser. "Either way I'm in trouble. Open the door, will you?" And as soon as I let him in she said, "Ted! Thank goodness. I saw him in the lobby when we checked in."

"Who?"

"Today's detective."

"Damn!" He hit his open hand with his fist.

"He was staring at me for the longest time."

"I bet some men do that," I said, "who aren't detectives."

"I'm serious! Ted, I need you to go down and see if he's still there. He's tall. He's wearing a tan Palm Beach suit and a Panama hat."

"Sure. I'll be right back."

Eileen leaned up against the door when she'd closed it behind him. "My goddamn husband. He just won't let up. It was a tall man in L.A., too: he followed us to an after-hours club, after

our gig at the Ambassador. But they had a different man waiting for us when we came out, who followed us back to our hotel."

"But if there was a detective on the train, he would have seen who killed Suzanne."

"He must have dozed off—the man in the vest, with the note-book—and didn't want to admit he'd fallen asleep on the job. So I'm carrying a hatpin now, for protection."

"You are?"

"I found it on the train."

"Which train?"

"The one Suzanne was killed in. It was on the floor, beside my berth. I thought it had fallen from Suzanne's hat, but it didn't look like one of hers; so I tucked it in my bag."

"And you didn't tell anybody? You didn't show it to the cops?"

"It was before…you know…before we knew. I'd just woken up, and stepped on it. I forgot about it until…after."

"Show me."

She pulled it out. It had a small bronze ball on the end.

"The sergeant said the one in Suzanne's throat was—"

"I know, I know! It's just like this one. But if I'd told him, he'd have kept me there for questioning. And then Ted would have had to cancel the show."

She was the star, all right. If I'd brought the pin *I'd* found to Sgt. Grumman, I'd have missed a day's pay. But if Eileen did that, our whole gig would be shot.

She touched the sharp point, then set it on the dresser along-side her earrings. "Do you think it's enough protection? Men can grab you from behind, you know, and choke you. Or rape you. Suzanne told me it happened to her, once. As big a girl as she was! She said that's why she got in the habit of wearing big hats: that it was like having an antenna, so nobody could get too close behind her."

The room felt stuffy. I opened the window, but we were only on the third floor—not high enough to catch a breeze. And the air was hotter outside than in, so I closed the window again.

There was a knock, and Ted said, "It's me again." When Eileen opened the door, he added, "I saw him. You were right."

"I'm no expert," I began, "but this detective sounds like an amateur."

"What do you mean?"

"They're not supposed to let you spot them."

"Are you on our side or theirs?"

"Yours. But—"

"We have to go out," Eileen interrupted. "Katy, will you create a distraction so we can sneak away?"

"I'll just leave for a while. You can have the room."

"No. We have to go out. We have…an appointment."

"Well, okay then."

Eileen opened the door and glanced left and right down the corridor. "Ride down to the second floor," she whispered, "and then take the grand stairway down into the lobby. When you see him, go over and ask him the way to the state capitol, or something—anything that'll get him to turn toward the side entrance. We'll hustle down the stairs when he isn't looking, and duck out the main door. Got it?"

"Yes."

"Good luck."

At the top of the big, formal staircase I paused, laid one hand on the gilded bannister, and looked around as though I were searching for a dance partner. Two outfits met Eileen's description. One tan Palm Beach suit was on a tall man who looked to be in his early forties, who stood in the middle of the lobby talking with a much smaller woman. He didn't seem to be listening to her,

though; he kept looking over her head and scanning the room.

The other tan suit fitted snugly around a man who was sitting in a Windsor chair, his back to the big front window. I couldn't tell how tall he was, and he held a newspaper very close to his face. But he was sitting right alongside the revolving door. A Panama hat hung from the arm of the chair. By glancing to his left from behind the paper, he could probably see everybody going in or out. He turned the pages, but in refolding them he brushed against the hat and knocked it to the floor. When he leaned down to pick it up, I realized he was a young, light-skinned Negro.

If I ran a detective agency I'd have sent *him* to follow Eileen. Most white people don't pay much attention to Negroes, so he probably could have tracked her all day without being recognized. But if she'd thought he was the detective, she would have mentioned his color.

Sonia and Helen were standing nearby, talking with three women who'd apparently come for the lecture. One of them, who sported a giant NO THIRD TERM pin on her blouse was pinning WIN WITH WILLKIE buttons onto the sisters' jackets.

When I got to the side entrance, I turned and made a beeline for the older man in the tan suit.

"Excuse me!" I gave him a big smile. He nodded to the woman who had been talking to him and—sure enough—he turned away from the door to face me. "Do you know where the train station is?"

But it was she who answered. "Oh yes, dear! It's over on First Street."

"Thank you."

I tried to think of something I could ask *him*, to keep his eyes away from the door, but the woman rested a hand on my arm. "Are you a registered voter?"

"Yes, ma'am, but not in California. Excuse me. I didn't mean to interrupt you and your husband."

"Oh, we're not married."

"Oh." I smiled.

"You've misunderstood," the man said. "I'm Dr. Gallup. This is Mrs. Parks, from San Francisco. It's her Good-Government League that's invited me to lecture today, and she's about to ask you to attend. But the train station is, indeed, over on First and K Streets, and any of the taxis out front can take you there." He touched his hat, said, "Good afternoon," and walked away.

"I saw you check in with the other girls," said Mrs. Parks, before I could excuse myself. "You're in that band that's playing here tonight, aren't you?"

"Yes. I hope you'll come to hear us." I glanced around to see if Eileen and Ted had been able to sneak out, and I couldn't spot them, so I guessed that they'd made it. But the man who'd been sitting by the door was also gone.

I caught a whiff of pipe smoke and turned around.

"Pardon me, Katy. May I steal you away?" It was Manny. "I need to talk to you. Would you care for a bite to eat?"

"Excuse me, Mrs. Parks."

"Good-bye, dear."

I took Manny's arm and we went out through the revolving door.

When we'd walked only half a block down the street, Manny stopped in a doorway and took his hat off. In the bright sunlight, his toupee was much darker than the hair along his neck and behind his ears.

"I'm sorry to bother you about this, Katy—" there was a tang in his breath, vaguely alcoholic "—but it seems that you have a... a reputation."

"That *bastard!*"

"Who?"

"You know who! That sax player in Providence. I don't care what he told you, but he tried to force it on me, so I kicked him in the groin. And his way of getting even is to tell every bandleader that I'm a nymphomaniac."

"That's not what I was referring to."

"Then what did you mean about my 'reputation'? What do you want?"

"Before we left Oakland today, I telephoned to New York. Walter Winchell didn't recognize your name, which is probably a blessing in disguise. But I called Darlene Duncan, too. I've worked with her to get my clients into her column in *Band Star*. She knew you."

"What did she tell you?"

"Something about a body in a car. In the Holland Tunnel, was it?"

"That guy was two-timing us both, and when he turned up dead in the trunk of her Packard—"

"I'm not interested in the details right now. Miss Duncan has a penchant for exaggeration, but she was very clear that you helped to get her out of trouble."

"I always help my friends."

"Then may I be your friend? I understand the obligation that doing favors imposes upon friends. My business revolves around them. So I can give as good as I get, if you should ever need anything. There's a little diner in the next street that makes a wonderful rice pudding. Will you join me?"

We took a corner booth in the diner, away from the other customers. When our rice pudding and coffee came, Manny put his pipe down in an ashtray.

"Frankly, Katy: I must have your help in keeping the Ultra Belles out of police custody, and I hope you'll extend it. I've had to buy this band its freedom one day at a time, but I can't do it alone anymore."

I felt like I'd been holding my breath for hours and could finally let it out. "I want to help."

"Were you friends with Suzanne?"

"I'd only met her once before. But I don't think she had a jealous boyfriend."

"Ahh. Well, I was in a hurry. It was the best story I could come up with to keep you all out of jail."

"Just another friendly service of the agency."

"A considerable portion of any publicity campaign involves spinning tall tales for the tabloids. I'm good at that sort of thing. Indeed, I'm the man Consolidated calls upon to handle many of its more…difficult situations."

"Like that bandleader in Florida?"

"Precisely. Now, Katy, we each need to know what the other knows. In good faith, I'll go first. We took on the Ultra Belles as clients knowing full well that the band has had trouble of a morbid nature before. What have the girls told you about Joan Barber?"

"That she killed herself. Except maybe she didn't."

"Who says she didn't?"

I didn't answer; I just shook my head.

"After what happened to Suzanne, we must take such an allegation seriously; it's how we look out for our clients' welfare."

"I take it that 'welfare' in this case means that Consolidated owns a piece of the act."

He opened both hands and half smiled.

"How much?"

He paused a beat, then said, "Right now, Ted and his backer each own half. But when this tour is over, and the last 't' is crossed

in our mutual contracts, we will each own one-third: Ted, his backer, and us."

"And as a loyal citizen of this 'Triple Alliance' I'm supposed to snitch on my friends?"

"You don't owe them anything, Katy; you just met them."

"I just met *you*."

"*Touché*. Give me your own impression, then, of something you saw first-hand. On the Santa Monica Pier Sunday: what happened to Lois Dumont?"

I shrugged. "I didn't see her at all until she was in the water. Have you called the hospital? Is she okay?"

"She's not in mortal danger, but she apparently picked up an infection from the water. God only knows what the city discharges into the Pacific! Her throat is badly blistered and she can't talk. She did, however, write a statement which the doctors passed along to the police. My friend Sergeant Grumman, in Santa Cruz, read it to me over the phone."

"So you tell *me* what happenened."

"I must know, first, why you asked Sonia, on the train, if Suzanne had worn a large straw hat on Sunday?"

"I saw one in the water where Lois fell in."

"I thought so. Lois says, in her statement, that a woman wearing a straw hat stepped directly in front of her. It blocked her view of the band, and she started to complain. But when the woman turned around, she leaned right in close. And then something caused Lois to gag. She thinks the woman may have thrust something into her mouth."

"A hatpin?"

"If it was, the doctors couldn't find it. Whatever it was, it was very painful and Lois couldn't catch her breath. She lurched backward to get away from it, and fell into the water."

"If it was Suzanne, Lois would have said so. Right?"

"Of course. But she didn't know the woman, and couldn't describe her. Everything happened too quickly."

"I found a hatpin on the pier, right where Lois had been sitting, and I think it's a mate to the pin that killed Suzanne."

"Let me see it."

"It's back in my room. And, uh…Eileen found one that's a lot like it, too, on the floor below Suzanne's berth."

He nodded. "We have to show the pins to Sergeant Grumman. There may still be blood traces. I'll phone him."

"You're a strange one, Manny. Most of the agents I've met would've run off when we got into trouble, and let us fall."

"An Englishman does not leave his chums behind to die. Don't smirk! It's not an idle platitude, these days. I owe America my life. All we expatriates do—in our snug little world over here. There's a war on. We can't go home again until you Americans help us win."

"We'll be in it sooner or later, I'm sure."

"Then we'd better get used to fighting side by side, so we'll know what to do when they put us in uniform." He knocked his pipe into the ashtray a couple of times, tamped a fresh pinch of tobacco down, and put flame to it. "Darlene said you and Ted were once, uh—"

"So what?"

"In exchange for her information, she wanted to know if you were still in love with him."

"That's *her* all over! What did you say?"

"That from what I can see, you are not."

"Thank you. It was four years ago, and as far as Ted's concerned, I was just Katy-along-the-way."

"But you're keen to help him—that I *can* see."

"I want him to get all the breaks. He writes good songs, and Eileen has the right kind of voice for showcasing them. And she's

a good catch: she's rich. Plus that, she's smart. Except for the detective thing."

"What's that?"

"She sees detectives everywhere. D'you know why I was asking Dr. Gallup where the train station was? Eileen swore he was watching her, and asked me to distract him, so she and Ted could duck out of the hotel together. There's a detective in every hotel and on every train, *she says*."

"You don't think so?"

"I don't know. She got dirt on her husband to prove adultery for her divorce suit, and now her husband's trying to do the same. I'm not telling tales out of school here. She's told all of us girls; you might as well be in the know, too. Why are you looking at me like that? What's the matter? Isn't she married?"

"Oh, she's married all right. Phil Wheeler is his name."

"Yes. He was mentioned in a newspaper clipping. He writes speeches, doesn't he?"

"More than that: he's a lobbyist here in Sacramento. I've met him in connection with my work. He represents the League of Decency and the Hays Office."

"Aren't they the prudes who squeezed all the sexy stuff out of the movies?"

"Yes indeed. If he didn't want a scandal, he could very well have hired detectives. Divorce is sexy."

"Maybe *he isn't*, and that's why she wants one!"

Manny laughed out loud. The waitress looked over, so he ordered us more coffee.

"There was a man on the train from L.A. to Santa Cruz," I said. "He wrote a lot in a notebook, and Eileen said he was a detective. But I think, if he were a detective he'd have shown his credentials. Maybe not to *us*, but certainly to the conductor or the police, and—what is it? You're grinning from ear to ear."

"Because you're right: nobody on the train flashed a detective's license. Still, Eileen may be right, too: there could be detectives waiting at every stop. I'll ask Sergeant Grumman to telegraph the big investigative agencies and ask. He'll do that for me."

"Is he one of those 'rising stars' you talked about?"

Manny nodded. "He needs my help because he's honest, and honest cops don't always get the credit they deserve. Men with less talent and more ambition will steal the glory away from them. For every promotion, he's in competition with men who do nothing on the force except what will get themselves noticed. I'm proud to say I've been able to place the name of Elmo Grumman before the public, in the headlines, on several occasions. I'm helping a worthy public servant to do his job. I never take any pay for it."

"But in return, he does you favors?"

"Aren't you glad of that? Let's go back."

Manny pulled a dollar out of a money-clip that was thick with tens and twenties, and told the waitress to keep the change. When we were back out in the sunshine he asked me for the hatpins.

"D'you want Suzanne's scrapbook, too? It should have gone back to New York with the rest of her stuff, but—"

"Give it to me when we get back to the hotel. I'll look through it, and then send it back to New York by Railway Express."

"The stuff inside's not all Suzanne's, though. Lillian wants a clipping back—the one with the picture of her and Joan in the Hour of Charm. And some of the others might want theirs back, too. Give it a good going-over. There may be something in it about Joan that's not in the file you got from the agency."

"Joan Barber again! You know, Katy, this whole business reeks of jealousy."

"You can almost smell it."

"How is it that you can watch Ted and Eileen together after he... I'm sorry. Darlene said he left you cold."

"He never blew smoke in my face."

Manny yanked his pipe away and mumbled an apology.

"I didn't mean it that way. I meant that Ted doesn't lie. He flatters you, he brings you flowers, he drops your name into a cheesy little ditty called 'My Sweet Someone' and tells you it's *our song*. But the word 'forever' isn't in his rhyming dictionary. Listen to his songs—he writes the best ones *after* the affair is all over: 'Yours Till Dawn,' 'Walking on Eggshells,' 'Remember To Forget.' What makes it all right is: he doesn't promise anything he can't deliver, and any girl that's been around the block can figure that out."

"But perhaps Eileen *hasn't* figured it out. If I were you I'd keep a weather-eye on her. She looks perfectly normal on the out-side—as normal as any girl with money can be. But she glares at the rest of you girls sometimes, behind your backs, and I sense that she's got green eyes. If they should ever pop out, they will make a grotesque and horrible spectacle."

"Have you been reading those spooky Merritt books, too?"

"I'm responsible for you all. I wasn't expecting ladies from the Junior League, but we're up the stream in a boat with no oars, and I'm supposed to be your coxswain. You're as rowdy as the men in this business."

"What happened to Suzanne wasn't 'rowdy.'"

"Of course it wasn't. But I no sooner get you out of that busi-ness *intacto*, when your scrappy little bass player launches herself into a catfight. She's lucky that behemoth in the green coat didn't smash her skull in. And what do you think Phil Wheeler will do if his detectives report that there's a card-carrying Communist in his wife's band? Oh, and tell your friends Ivy and Lillian to eat Sen-Sen: I smell reefers on their breath. Even Sonia Bliss could be

trouble. Take a close look at her cough medicine: it's Cheracol, which is mostly codeine and chloroform. I think she's addicted to it."

I smiled. That must have been what Lillian had found out, and why Sonia wasn't ragging her anymore.

"None of you is Goody Two-shoes," he went on. "Even *you* must have some secret vice. But at least now I'm convinced that assassination is not among them."

"'Now'?"

"I must confess: until I talked to Darlene Duncan, I thought the most likely murderess in the band was *you*."

A telegram was waiting for Manny when he picked up his key at the hotel desk. After he read it he showed it to me:

YES ULTRA BELLES PLAY PACIFIC HEIGHTS GARDEN CLUB
JUNE 22 BENEFIT ST FRANCIS HOSPITAL SAN FRANCISCO
NINA CAVETT

"Does she have a nice lawn?" I asked.

"How should I know?"

"Didn't you go to her house last night? You said you'd do anything to get us that gig. We all figured you put the make on her."

"Dancing should not be construed as 'putting the make' on anyone. I will grant you she's attractive, but—" he leaned closer "—truth be known, she's rather too dependent on cosmetics for my taste; even for a woman of…of a certain age."

"She could be younger than she looks."

"I'm sure you're better at guessing a woman's age than I am."

"So, it really was a coincidence, the two of you running into each other this morning?"

"I was as surprised as you were. It isn't any of your business, Miss Nosy-parker, but last night I was occupied elsewhere. If there's a sunny side to being divorced it's that you get to be single again; and there is a young woman with whom I keep company whenever I'm in San Francisco. I have no interest in Mrs. Cavett—" he waved the telegram "—except as a patron. San Francisco's a great town for society parties. Naturally, I'll make some telephone calls, just in case her garden club has a reputation for stiffing its entertainers. But you play at the top of your form and you'll get a lot more work—enough to keep you on the Coast for the rest of the year. Can you stay on with the band?"

"Not unless Ted replaces either violin or sax. I can't keep playing both."

"Of course. We'll do that first thing next week." He led the way to the elevator.

"I'll have to go home to New York eventually, even if it's just to pack a bigger wardrobe. And I think Ted needs to go back east, too, as soon as possible. To Philadelphia. For...personal reasons."

"Ummm. He told me. I phoned my people; they're contacting his former girlfriend now."

"Thanks. She's had some bad breaks."

"Haven't we all!"

The elevator came and we boarded the car. "I'll go get Suzanne's scrapbook, and the hatpins, too. What's your room number?"

"Ted and I are in five-sixteen. Take your time. I'll be on the phone all afternoon."

Back in my room, despite the coffee, I found myself yawning. It was only a little after four, and we didn't have to set up on the bandstand until six. So I set my alarm clock for five-thirty, took off

my shoes, stepped out of my skirt, pulled off my shirtwaist, unsnapped my stockings, and settled onto my bed in just my slip. I thought I'd take a nap, but I couldn't fall asleep.

When I was in high school I used to play a game with myself in which I rated boys according to how likely they were to ask me to dance. At the high end, 5 meant that we'd waltz under the stars like Vernon and Irene Castle. At the low end, a score of 1 meant that they'd rather dance with the school mascot, which was a goat. I found myself using the same method to calculate which of us was most likely to have killed Suzanne.

If Sonia was hooked on cough medicine, it might cloud her judgment, but it didn't necessarily make her a killer. And she was so squeamish! She'd never get right up close to Suzanne and push a hatpin into her throat. I couldn't rank Sonia higher than a 1.

Helen was younger and healthier, but almost as squeamish. And they'd been working together for months. If she'd wanted to kill Suzanne, why wait so long? Helen got a 2, meaning that it wasn't impossible, but it sure wasn't likely.

Ivy started way up at 4, with her temper. But did she have the temperament? Her anger was short-lived. She might get fighting-mad at Suzanne all of a sudden, but she'd cool down in a hurry, too. And Ivy wouldn't have used a hatpin—she'd have used that razor! At 3 was as high as I could put Ivy.

What about Lillian? People who drink too much or take dope sometimes forget what happened the night before. But she couldn't keep something like *that* from bubbling up to the surface. Besides, I figured it took the killer a full day at least to plan the killing, get the hatpin, and sit up all night waiting to spring out of hiding and make the kill. Lillian was too scatterbrained for that, so she got a 2.

I couldn't buy what Sonia and Helen were selling about Jack. She didn't seem to exhibit romantic feelings toward *anybody*, boy

or girl. I had a hunch that she was keeping *something* buttoned up—something connected with the Communist Party, maybe, that could land her in trouble with the government. If Suzanne had gotten wind of it, and threatened to tell—like she'd threatened Ivy about the reefers—then it was just possible that Jack might decide she had to kill Suzanne to keep her quiet. Jack was keeping secrets—of that I was sure. But I wasn't at all sure that one of those secrets was a murder. I gave Jack a 3, although I'd have pushed it up to 4 if I thought she was an anarchist instead of a Communist. There were just too many "ifs" with Jack.

Eileen? Like Manny'd said, she was the one I worried most about. Did she have blue eyes or green eyes? She was intelligent: perfectly capable of thinking through a course of action and carrying it out, anticipating every detail and weighing the risks. And she was the closest one to Suzanne that night. Eileen deserved to rank high up the scale, at 4. But why would she risk so much? What could she possibly gain from killing Suzanne?

I had to count Ted among my suspects. If Suzanne was a tattletale, she could have threatened to tell Phil Wheeler about Eileen and Ted. Ted couldn't fire Suzanne—she'd talk. The only way to keep her quiet was to… no! I knew Ted too well to believe that! He'd have gotten hold of some dough—borrowed it from Eileen, maybe—and paid her off. Besides, Ted wasn't likely to have a hatpin in his luggage, much less to think of it as a murder weapon. If anybody ranked 1 he did. But on the outside chance that Eileen had wrapped him in a spider's web, I made that 1 crawl up toward 2.

And finally there was Manny. He could have had a secret relationship with Suzanne, or a private grudge against her. Maybe they only *pretended* to meet for the first time on the train. He could have deliberately roused my suspicions about Eileen, and dwelled on Joan and Lois to distract me. But if Manny wanted to

kill Suzanne, he'd have waited until they were really alone. Still, there was too much I didn't know about him; so I gave him a 3.

So what did I have? A 1, too many 2s, a couple of 3s, and even a 4. But no certainty. No 5.

I must have fallen asleep, because I heard a noise and said, "Five!" out loud.

"It's after five, Katy. Almost five-thirty. Time to go set up for tonight."

I opened my eyes. Eileen was just stepping out of her dress.

"Thanks." I got off the bed and pulled on my shirtwaist, skirt, shoes, and stockings. "Coming?"

"Tell them I'll be right down, as soon as I take a shower." She emptied her purse onto the dresser top and shut the bathroom door behind her.

I went right over to swipe her hatpin, but I couldn't do it. She'd know I'd taken it. But as I stood looking at it, I couldn't help noticing that she'd been walking around with some greenbacks worth a couple of weeks' work. Jack was right: Eileen didn't need this gig to earn a living.

I got Suzanne's scrapbook out of my overnight case, wrapped the hatpin I'd found on the pier in a handkerchief, tucked them both into my thickest woolen sweater, and wrapped the arms around it tightly.

Holding the bundle under my arm, I climbed the stairs and knocked on 516. No answer. I knocked again and waited a little longer, but I still didn't hear anything.

The book wouldn't fit under the door. I tried the valet-closet. They're supposed to be locked, but this one wasn't. It opened only wide enough for a suit on a hanger, but that was enough. As I slipped my bundle in, I had a truly wild thought: maybe Manny was the detective following Eileen! He had a perfect cover: he was close to the cops; he was skeptical that *anyone* was following her.

And by sharing some facts, he'd gotten me to trust him and tell him what I knew.

Then I had a more disturbing thought. If Manny killed Suzanne over some secret they shared, maybe there was something about it that I'd missed in the scrapbook. I hadn't seen any clippings about him or the Consolidated agency. But they'd just taken us on. And if there was something in print, Manny could now get rid of it. The hatpin, too.

But then I shrugged it all off. In his professional capacity Manny had a lot more power than any of us. He could get someone fired, and possibly even blacklisted so she couldn't get work at all. In the music business, people stab each other in the back all the time, and a musician's agent has the power of life and death over her—figuratively speaking, of course.

The hotel crew was turning the afternoon's lecture hall, where Dr. Gallup had spoken, into a cabaret: polishing the dance floor, regrouping the chairs around small tables, and laying out tablecloths and ashtrays.

Jack and Ivy were assembling our music stands, and Lillian was draping them with the gold-and-silver flags that had "UB" monogrammed in black sequins. As they finished each one, Helen pulled the arrangement folders out of the trunk and set them on the stands.

I looked around and saw Sonia trying to lift her bass drum all alone, and gave her a hand.

Eileen came through the door and said, "Am I the last?"

She was, and the band's rule was that the last one had to repack the cloth wrappers from our stands, and stack the empty boxes backstage or in the green room. They were empty, so they were light, but she'd have to do it all by herself. Eileen made a sour face, but turned to the task and did it quickly.

At quarter to seven we were through.

"I'm hungry," said Lillian. "What time do they feed the animals in this zoo?"

Ted checked his watch. "We could go in now. The crew set a table for us in the dining room."

"Shouldn't we change first?" Eileen asked.

"No. They'll have to start serving the guests in another hour. We should eat now and get dressed afterward."

I hadn't realized, until I stopped, that my head hurt. I needed to take a couple of aspirins. I said I'd join everybody in the dining room and walked back through the lobby toward the elevator.

"Did you find the train station, dear?"

It was a woman's voice from alongside me, but I didn't realize she'd been speaking to me until a gloved hand touched my arm. "Was it a lost-and-found errand?"

Then I remembered her: she was the fiftyish woman who'd been chatting with Dr. Gallup that afternoon. A tailored wool suit and (I was sure) a snug girdle molded what was naturally plump into an elegant, mature figure.

I smiled. "Everything's all right, thank you."

"I'm Mrs. Parks, from the Good-Government League."

"Katy Green." We shook hands. "How was Dr. Gallup's lecture?"

"Why, I never realized it was so difficult to sound out public opinion. I thought you simply asked people a lot of questions! But he says it's a kind of a science, really."

"Really?"

She started walking alongside me. "And you're in that band that's playing here tonight! Well, my friends and I are not going back to San Francisco until tomorrow and we have nothing to do tonight. Maybe we should come and hear you."

"Hey!" someone called out. "The Ultra Belles! They're terrific. You *gotta* hear them play tonight."

I looked around. A much younger woman with bright red cheeks had popped up out of an armchair. She skipped in front of Mrs. Parks, turned and walked backward to face her, and said, "I read all about the Ultra Belles in *Band Star*. I'm their biggest booster. I wrote to them, care of the magazine, last month when I heard they were coming to California."

I smiled. "Ohhh. Then it's you who's starting a fan club in… uh—"

"Placerville. Yup. That's me. You gals are hot, all reet!"

"That's how young people say 'all right' nowadays," I explained to Mrs. Parks.

"I know that. I have a niece about her age. Tell me—" she turned to the youngster "—do the Ultra Belles really 'swing it'?"

"Do they ever! They swing it *hot*! If you old biddies've been sittin' on your rumps all day you oughta get out on the dance floor tonight, grab yourselves a couple of guys who can bounce you around, eight-to-the-bar. Anyway, you can always watch *me*. I'm a loosey-goosey gal, and I've got the jitterbug, that's for sure!"

Despite her vocabulary, her girlish sailor outfit with a baggy white middy blouse and bell-bottom trousers, and the bright rouge on her puffy cheeks, she wasn't a bobby-soxer. I guessed she was old enough to vote, but prefered to *look* younger, though she had on quite a bit of pancake makeup.

Mrs. Parks smiled at her. "Some of us 'old biddies' are nonetheless 'hep to the jive,' young lady! I happen to like the swing bands myself. Especially that Mr. Krupa, in Benny Goodman's band. The way he plays those drums, it's almost primitive!"

"A-l-l-l reet! I'm gonna be watchin' *you* swing tonight!"

I nodded and smiled. We reached the elevators, and I pushed the call-button. "You'll be able to hear us again, next month, Mrs. Parks. We're playing in San Francisco on June twenty-second. It's a benefit for, uh, Saint Francis Hospital."

"Another benefit already? They just had one in March."

"I wouldn't know. The woman who's putting it on is a Mrs. Cavett—Nina Cavett. She's in a garden club in Pacific Heights that's organizing the event."

"Nina...Cavett. Well, perhaps she's started a new club. I don't think the old one's been active since the Crash in 'twenty-nine."

"I wanna play in a swing band, too, some day. All I gotta do is learn to play an instrument or somethin' and I know I'd be hot stuff!"

Her squeaky voice was aggravating my headache. Finally, the elevator came. Mrs. Parks said, "Six, please." I said, "Three, please." And the kid said, "Gimme five!" extending an upturned palm to the operator. I don't think he—or Mrs. Parks, hep as she was—got the girl's pun: that's how Negro jazzmen greet each other.

"Fifth floor?" he asked.

"Uh-huh." Then she grinned at me. "I'm gonna write in my diary that I met you. What's your name? I don't remember you from the picture in *Band Star*."

"Katy Green. I'm new."

The elevator stopped. "This is my floor," I said, and got out. The door closed, and I suddenly noticed how very quiet the world was without Miss Jitterbug of 1940 talking my ear off.

I'll say this for the Golden Eagle—they fed us well: chicken croquettes, mashed potatoes, and asparagus; dessert was cottage cheese, and lime Jell-O with little marshmallows in it. When they brought the coffee, we were making up our set-list of songs for the night.

"What can we do for these ladies who are here with their Good-Government League?" Ted asked.

"Aww, shoot all the 'goo-goos' and bring on the revolution!"

"Jack! You're positively subversive."

"Just kidding, Sonia."

"I'm not so sure."

"As I was saying—" Ted tapped his spoon on the table "—we ought to play some numbers like 'Happy Days Are Here Again.'"

"That's Mr. Roosevelt's theme song. So to be fair," said Helen, "we should play 'Win With Willkie,' too."

"How about a medley?" I suggested. "We could start with 'Sidewalks of New York' for Al Smith, and—"

"Telegram for Mister Blunt!" It was a bellboy; he approached Ted's chair. "'Scuse me, sir. Are you Mister Blunt?"

"He's not here," Ted replied. "Try ringing five-sixteen."

"There was no answer there, sir; the deskman thought he might be eating with the band."

"I'll give it to him." He put a quarter in the boy's hand, and slid the envelope into the inside pocket of his jacket.

"Manny got another telegram, earlier," I said, "from that Mrs. Cavett in San Francisco. We're definitely playing her charity gig next month."

"That's good news for a change!" Helen declared.

Lillian looked around. "You'd think Manny'd be celebrating with us."

Jack jabbed her gently in the ribs with her elbow. "Maybe Mrs. 'C' squeezed herself here through the telegraph wires."

"Sure," Ivy grinned. "They could be up in his room now, making—"

"Ivy! You have a dirty mind."

"'Making *plans* for her party' is what I was trying to say, Helen. Who's got the dirty mind now?"

My head still hurt when Eileen and I got back to our room to change. Except for Mercurochrome on my lips, I didn't bother

with too much makeup; and I took two more aspirins. She got dressed before I did; and though I wanted to ask her how she'd mistaken the eminent Dr. Gallup for a detective, she hurried out without so much as a "See you later."

The stage lights and spotlights felt especially bright on the bandstand, aggravating the pain in my head. I pretty much "phoned-in" my work during the first set, just reading and playing the parts with no great delight.

The house lights came up during our break, and I saw that Mrs. Parks, still in her day clothes, was sitting with two other middle-aged women. The kid who'd worn the sailor outfit had changed into a high-necked, long-sleeved gown in shiny blue satin. She was standing beside a table on the far side of the room, chatting with two young men in evening clothes. One of them held a chair for her and she plopped down into it with a big grin.

I felt a new pain down the back of my neck, and I was having trouble finding a comfortable posture. I hoped I wasn't coming down with a fever—that it was only fatigue. Or maybe I was just confused. When I closed my eyes I saw numbers—2s and 3s and 4s—all swirling around in my brain together. I wanted it to stop. I stepped off the stage, poured a glass of water from the band's pitcher, and let it cool my throat slowly.

Ted touched my elbow and said, "Band meeting. Right now." The green room, that night, was a book-lined writing room adjacent to the main hall. When we were all inside, Ted didn't waste time. "They're not dancing. And I think it's because we're dragging the beat."

"It's Katy's fault!" Sonia complained. "I'm holding the drumbeat steady, but she's slowing down on her solos."

"Aw, Katy's doin' okay," said Lillian. "I just think nobody's got dancing fever. It's this ladies' convention: there aren't enough men to go around."

"That ain't it," declared Ivy. "Girls'll dance with girls. Why don't we play more swing and see if they get up off their duffs."

Ted held up some paper napkins. "The waiter handed me these—they're requests. Somebody wants to hear 'The Joint Is Jumpin',' and 'Chattanooga Choo Choo,' and 'String of Pearls.' Oh, and Sonia? Helen? You've evidently got some fans out there: they want to hear you do 'My Canary Has Circles Under His Eyes.'"

"We will not!"

"We don't sing that anymore!"

"Can you do *something* they'll remember? Some other number from your old act?"

"All right. But leave the selection up to us."

"Fine. Work it up with the rest of the band, whatever it is, and I'll call for it in the next set. Lillian—you'll blow a fanfare for them."

"Got it. What about those requests, Ted?"

"We'd have to fake 'String of Pearls'—"

"It's an easy progression!" Jack said. "I can write out the chord changes if anybody needs 'em."

"No. I don't want us winging any numbers. I've got arrangements for 'Chattanooga Choo Choo' and 'Joint Is Jumpin'.' They're up in my room. If you're all sure you can read them cold, I'll get them."

"No sweat for me!"

"Easy!"

"Let's *do* it!" Ivy said loudly.

"What else can we do?" Lillian asked.

"Something hot," said Jack. "How about moving 'Eggshells' up from the end and doing it sooner?"

"We could lead off with it, Ted," said Sonia. "I'll give you a good roll to—"

"That's the only roll you'll ever give a man!" Ivy cracked.

"Hey, come back!" Jack rebuked her. "We're in a groove here."

"As long as we're adding songs to the set-list, Ted," said Eileen, "could we close the evening with 'Remember To Forget'?"

"We sure could. Thanks, honey."

The rest of us nodded. We were, as Jack said, "in a groove here," and working together as a team again, for a change.

Ted went to get his lead-sheets and arrangements for the requested songs, but when it was time to start playing again he hadn't returned from his room. So we waited for him, and when he finally showed up, the spotlights made his face look pasty and pale, as though he'd been crying.

I caught his eye. He leaned over to me and whispered, "I'll be fine. But I need to talk to you after we finish the last set." Then, to the others, he called, "Let's give the customers a good show."

We led off with "Walking on Eggshells," and that did, indeed, get people dancing. Our number-one fan, in the blue gown, took one of the men at her table by the hand and led him onto the floor. For the next tune she asked the other man to dance, and alternated between them for the rest of the set, always bringing them right down in front of the band.

She was a good dancer, though she never got into a clinch with either partner. She'd let him lead her into the first few steps, but as soon as she'd done a twirl or two she'd go into a shim-sham, rocking her shoulders in time, and gesturing with outstretched arms for him to do the same. It was like she was in a world of her own. And she didn't make doe-eyes at one fellow or the other, especially, so I guessed that neither of them was a steady boyfriend from Placerville.

Somebody asked Mrs. Parks to dance. I'd expected her to be gauche, but she knew her fox-trot! She stayed right in rhythm,

and still held herself fashionably erect. She didn't look down at her feet, either. I had to remind myself (again!) not to make snap judgments.

"We have a special treat for you now," Ted announced. "Our drummer and our clarinet player are the famous 'Kid Sisters'— Sonia and Helen Bliss. And they will now perform one of the songs they made famous on the vaudeville circuit."

As Sonia stepped down from her drum-set, Helen whispered something in Ivy's ear, and Ivy passed it to Jack, who hid her mouth behind her hand as she leaned over to tell Lillian. By the time the sisters had made little curtsies to the audience, down at the front of the stage, nobody had told me what the tune was.

But then Lillian hit a *ta-daaaa!* and glissed up to a high C. Jack vamped a four-bar intro as Helen struck a pose on one knee, strumming an imaginary ukulele.

I froze. Of all the songs—!

K-k-k-Katy, beautiful Katy,
You're the only g-g-g-girl that I adore....

I looked around. Ivy gave me a little grin when she caught my eye. Lillian smiled and nodded. Ted stepped alongside me and whispered, "What a treat, huh?"

My face flushed. I was sure the sisters had done this out of spite: deliberately picking that song just to annoy me. And Jack and Ivy and Lillian—and Ted! They'd gone along with it. What did *that* mean? I kept my anger bottled up tight, of course. I even put my hands together and pretended to clap as they took their bows.

The mood was broken. I'd really liked the groove we'd gotten into, and now it was all shot to hell. Why did I promise Manny I'd stay on with the band in San Francisco?

The only bright spot for me, in the rest of that show, was the number we ended the night with: Ted's newest composition—a ballad at a walking pace, called "Remember To Forget."

The lyrics are wistful, and the music has a lot of diminished chords, which sound like minor chords, but different. One of my first music teachers used to say that hearing a minor chord was like eating an onion, because it makes you cry. But hearing a diminished chord was like eating a chile pepper: first it makes you cry and then it makes you squirm, but soon you realize that you actually like it and you want another one.

> *You remember everybody's birthday.*
> *You remember where you left your keys.*
> *You remember who drove in the winning run at Ebbets Field,*
> *And every line of Browning's "Sonnets From the Portuguese."*
> *But could you just remember to forget something, please?*
>
> *Remember to forget the night we danced across the sand,*
> *And the days we strolled together holding one another's hand.*
> *Remember to forget how we touched the day we met.*
> *Just remember that we said adieu.*
>
> *Remember to forget the way your singing made me cry,*
> *And that look on Mother's face when you refused her apple pie.*
> *I wouldn't give a thought to all the ice cream cones we bought.*
> *So remember to forget about me, too.*
>
> *We never bribed that Prohibition agent*
> *To let us keep our old bottle of Scotch.*
> *We never bet the rent-check on our best friend's horse,*
> *So we never had to pawn your daddy's watch.*

Remember to forget those suppers lit by candlelight,
And the way the skyline glimmered in a rainstorm,
 late at night.
Standing in our window there, stroking one another's hair—
Just remember I've forgotten about you!

When my violin solo came up I winked at Jack, and we went ahead and broke Ted's First Commandment. We jazzed it, taking off in the best tradition of Joe Venuti (my version, anyway) and Eddie Lang (hers). I let the melody be my starting point, and never strayed too far from it; but I embellished it and jostled it, and goosed it and had a hell of a good time chewing on it. Jack linked her chords together like beads on a chain, with single-string melodic and harmonic riffs that terminated in full chords.

Lillian caught our drift, and when Ted motioned with his baton that we'd play it through once more instrumentally, she started cooking. She worked in long notes. She worked in short notes. She hit high and low, but always with a gentle touch. I swear she was every bit as good as Harry James or Bunny Berigan.

Finally Eileen came back to sing the second bridge and second ending:

We never rode the Ferris wheel together.
We never walked up Broadway in the rain.
We never did get cozy in that upper berth,
So they never threw us off that train.

Remember to forget your reading glasses,
When Winchell says I still love you.
And I wish it weren't so, but I'm feeling awfully low
Rememb'ring to forget I do.

All the dancers snuggled up to one another during the song…all except Miss Jitterbug and the boy she was with for that number. She was stiff-arming him. Maybe he'd gotten too fresh, or maybe she didn't want him to think she was falling for him. Well, there's no flirt like a virgin!

After our last set, we waited for the crowd to thin out, then started boxing up our equipment. Ted and I were loading the music stands into their crates, when I realized that he still didn't look well. He was sweating and squinting, as though he were in pain.

"I've got aspirin," I said. "Want some?"

He looked around, then hustled me off to one side. "When I went to get the music, the desk man waved me over. There was a long-distance call, person-to-person, holding for me."

"From Belinda?"

He nodded. "She's in a motor-court, somewhere outside of Philly. She has a bottle of sleeping pills with her, and she's going to swallow them all if I don't come back."

"Call the police!"

"I don't know where she is. She could be in Pennsylvania, or over the river in Jersey or Delaware."

"Are you sure she really *has* pills? Maybe she's just saying that."

"Keep me company, will you? I don't know what to do."

"We better tell Manny."

"Yeah. Good idea. Let's go upstairs."

The night operator didn't run the elevator any faster than the daytime guy did. In the hall, loaded down with our music books, Ted shifted them onto one arm, fished his room key out of his pocket, and handed it to me.

I opened the door. The light was off.

"Manny? Manny?"

Ted switched the light on.

Manny was half-on and half-off one of the beds, lying on his back with his feet on the floor. Someone must have punched him and knocked him out. His nose and mouth were all bloody, and it had splattered down over his chin and his undershirt.

But between his shirt and his socks he had no other clothes on. He wasn't snoring. And when I got closer I could see he also wasn't breathing.

Ted sat down hard on the chair beside the desk and let the music books tumble onto the floor. "I better call the front desk." He got up slowly, dialed the phone beside the other bed, and said, "Please send the hotel doctor to room five-sixteen."

I touched the side of Manny's neck, but I couldn't feel a pulse. I couldn't avoid glancing at Manny's…exposure. If you like men with lots of body hair, he was your type. There was nothing unusual about his privates, and I didn't see any blood anywhere except around his face and neck.

His toupee was gummed on tight. There were lipstick marks on his cheek, and a smudge of pancake makeup on his undershirt. His socks were snapped into their garters, but his undershorts and tuxedo pants were crumpled on the floor alongside his dress shirt and shoes. And there was something else: it looked like a lipstick but it wasn't. I leaned down. It was a vial of smelling salts.

Manny's wristwatch, his pipe, and his fountain pen were on the nightstand, on top of a telegraph envelope. And so was his money-clip, but it was missing the tens and twenties I'd seen that afternoon.

Ted sat on the edge of the empty bed. "I bet what happened to that bandleader in Florida happened to Manny, too. Some woman was here, but she didn't stay around too long. Look at his money-clip. She probably took what he promised her and helped

herself to a bonus, too, when he dropped dead." He took a deep breath. "After a scare like that, who's to say she didn't deserve a little extra, huh?"

I looked around. The bureau drawers were askew, as though one hand had pushed a drawer shut while the other hand was pulling the next one open. The closet door was open, too, and the suit Manny had been wearing that afternoon was on the floor, its pockets yanked inside-out.

"When could this have happened, Ted? While we were playing?"

"It...he...was like this when I came up."

"What?"

"When I came for the music. He was... I'm sorry, Katy."

"You S.O.B.! You just picked up the music sheets and waltzed away? How could you?"

"I couldn't stop the show."

"You can't do *anything* alone, can you? You always have to have a girlfriend hanging around." I took the chair, set it catty-corner from the bed, and sat down.

"But you're so level-headed, Katy. On the pier, Sunday, I'd have just kept staring down into the water at Lois. But you knew what to do. You asked people what they'd seen—you tried to find out what happened. And then, on the train, when I opened the curtain and saw Suzanne, it was the same thing: I just froze. And tonight! I was so worried about Belinda I couldn't think straight. I must've sat here for ten minutes before I ran back downstairs with the music."

"You went through the drawers. What were you looking for?"

"I didn't do that. Everything was just like you see it! *Cherchez la femme*, I guess."

We heard a knock on the door, and a man said, "It's Doctor Marley. They told me you called."

Ted whispered, "I don't know what the hell is going on any-more. Help me, please, Katy."

Manny had wanted my help, too—and look at him! I leaned back in my chair and tried to sit still for a moment, but that only reminded me that my head was throbbing. I massaged the back of my neck, and rolled my eyes up. "Okay," I whispered back. "When the police come, don't tell them about Suzanne unless they ask you."

Then I opened the door for the doctor.

He took a quick look at Manny, phoned the night manager, and told him to send for the police. "You can wait outside now, miss. I'm going to examine the body."

"No. I want…I have to stay."

Your blood stops flowing when you die, so it puddles in whatever part of your body is closest to the ground. Manny's blood had drained away from his upturned face and chest. It had settled in his back, where he lay on the bed, and in his lower legs, because his feet were on the floor. From the extent to which that had hap-pened, Dr. Marley estimated that he'd died about six hours ago: around seven or eight o'clock.

And that's what he told the plainclothes policeman, Detective Finn, when the night manager brought him into the room. A uni-formed cop kept watch in the hall.

Det. Finn asked Ted and me a lot of questions. Ted didn't say—at least, not while I was there—that he'd already seen Man-ny dead, around ten o'clock.

"Say, Doc. If this guy was—" Det. Finn glanced at me "—overexerting himself, could he have burst a blood vessel?"

"An aneurysm, you mean? Yes. Although bleeding from the nose and mouth is unusual. Normally it would be confined with-in the skull."

"What about this?" He picked up the vial. "The guy could've croaked while he was, uh, *busy*. She tried to revive him with smelling salts, but it didn't work. So she took what she could grab and cut out in a hurry. Could smelling salts make him bleed?" The detective gave it a sniff, said, "Ugh!" and handed it to the doctor.

"They shouldn't." He whiffed it gingerly. "That's not regular smelling salts."

"Hey you—Nywatt! This belong to you?"

"No."

"How about the dead guy?"

"I don't know. I don't think so."

"Any of your girls use them?"

Ted's eyes widened. "You don't think that—"

"Just tell me, will ya!"

"Sonia Bliss does. Her sister might, too."

"Okay, I'll talk to them later."

The night manager moved toward the door. "If you don't need me, I'll—"

"No. Wait a second." Det. Finn motioned him to stay. "Any of *your* girls still around?"

"'My girls'? I don't understand."

"Come off it! There was a convention of appliance dealers here last week, and we happen to know that the, uh, ladies of the neighborhood did a land-office business with the convention-goers. I figure they kick back a percentage to you for, uh, transient accommodations. But I don't wanna take you downtown. Just tell me who was workin' the hotel tonight."

The manager's lips fluttered. "Well, actually, no one was. No. Really! Not tonight. All of our rooms are taken by a ladies' political club...and by this all-girl band."

"You sayin' there weren't enough men around to make it worth a girl's while?"

"Something like that."

"Like hell! You don't want me to pull a raid and put you out of business, do you?"

"No. No. I'll...I'll let people know. Someone's sure to come forward."

"We just want to talk to the girl; find out exactly what happened here." The detective reached an arm around the night manager's shoulder. "This wasn't a murder. Nobody's gonna get arrested. The guy just croaked. The lady thought he fainted, and she tried to revive him. The sooner we find her, the sooner you can all go back to, uh, business as usual. Now, why don't you go downstairs and clear the way for us to take the body out through the laundrymen's door,"

"Yes sir. I'll do that. Thank you." And he hurried out.

The uniformed cop from the hall carried in a stretcher and sheet; then he and the doctor loaded Manny onto it and took him outside.

"Excuse me, Detective Finn," Ted asked. "Are you going to hold us here past dawn? We have to catch a nine-forty-five train to Lake Tahoe in the morning."

"There's another train eastbound, that comes through at eleven-fifteen. I think you better change your reservations so I can talk to everybody in your band. You want their alibis on the official record, don't you?"

"I guess so."

"It's a tough break, Nywatt. But you couldn't have saved him. Nobody could. And don't worry. We won't be tellin' the newspapers until we know just what happened. Nobody likes publicity when a guy dies in a hotel room with a broad that ain't his wife. Know what I mean? Oh—I'm sorry, Miss Green. You must be upset about all this. I'm through with you now. You can leave if you want."

I thanked him, and closed the door behind me. I stood with my back to the door, watching as the cop and the doctor walked the stretcher down the hall to the elevator. Something trickled into my mind: maybe the missing cash from the money-clip was only a distraction. Maybe whoever took it was really looking for something else?

I reached behind my back. The valet-closet came unlatched. I slid my hand inside, pulled out the scrapbook and the hatpin and—clutching them in the sweater I'd wrapped them up in—I headed back to my room.

A Typical Beach Scene along the Shores of Lake Ta...
© FRASHER FOTO

FRIDAY

WE WERE ALL GROUCHY
in the morning. The detectives had, indeed, kept us up
most of the night, which made us miss the early express. Ted
switched us to the later train, but it was a crowded local, again,
and we had to squeeze into just two pairs of seats. The trip might
have been merely uncomfortable, in that way; but I was apparent-
ly being shunned, especially after I said, "I miss Manny. He was
getting to be a really good friend."

Ivy avoided my eyes. Helen, whenever I happened to glance
over at her, was actually glaring at me. I took a seat next to Lillian,
but she got up and sat down beside Sonia. Nobody wanted to be
reminded, I guessed too late. And they probably thought I was a
big baby, from the way I blushed to hear the sisters' song.

Jack headed for the ladies' room and beckoned me to join
her.

As soon as the door shut behind us, I had to ask her: "How
could you play that song, last night?"

"You mean 'K-k-k-Katy'? Helen said it was your favorite song."

"Like hell it is!"

"Well, I'm sorry. We got snookered. But everybody's got a song or a nursery rhyme or something they hate, that makes fun of their name. Mine was 'Jack Sprat could eat no fat.' We're still friends, aren't we?"

"Yes."

She extended her hand, and we shook. Any other woman might have opened her arms for a hug, but Jack wasn't the type...or maybe she didn't want a hug to be misinterpreted as...no! That was what the sisters wanted me to think!

When we got back, Eileen got up; but instead of letting me slide into the row she whispered in my ear: "Don't sit down, Katy. Come to the club car with me."

Half a dozen men were there, smoking, reading newspapers, or looking out the round observation windows at the end of the car. She bought us a couple of ginger ales.

"Ted told me how you helped him, last night," she said right away. "And I just wanted to tell you, privately, that I'll always be grateful. If there's anything I can do for you, just tell me."

"Okay. Tell me: Were you with Ted when he went up to the room? I mean between the sets—when he found Manny."

She squinted. "Are you accusing me? 'Cause I'm going to join the other girls if—"

I tugged her sleeve as she started up, and pulled her down. "No. I just want to know if you saw Manny dead before I did."

She looked out the window, then turned back to me and said, "No. But I think I understand why you're asking. Ted said you'd know what to do, that you...might be able to figure out what happened."

"I can try. Tell me something else: How do you spot all these detectives?"

She half smiled. "Practice makes perfect. They've been following me ever since we got back to California."

"Well, the one you spotted yesterday turned out to be Dr. Gallup!"

"I know, I know. I should have said it was the *other* man: the colored man by the door. But I was always taught not to call attention to people's race. You know, I actually have friends who are—"

"We all do. Tell me about the detectives. Are they always men?"

"Of course."

"But if the agency's really big, they might send a *female* detective to keep you off-balance. There were a lot of women at that convention yesterday; one of them could have been it. Even Mrs. Cavett could be a detective. Or the fat woman on the train the other day—the one who bashed Ivy over the head—she could be—"

"You're dizzy!"

"I *feel* dizzy. Since I ran into Ted I've watched a girl almost drown, and I've seen two people stretched out dead. And everybody looks at me like I'm responsible!"

"*I* don't think you are."

"Thank you."

"We need your help, Katy. Ted says, if anybody can find out what the hell is going on, it's you." She touched my arm, then got up, left a dime on the table for the steward, and went back to our car.

I didn't want to sit with the others. I stayed put and ordered another ginger ale, and stared out the window. I'd expected to see more trees in the Sierra, but the steep hills were badly eroded; not even grass could hang on. The train's vibration set off miniature avalanches as we rumbled past the bare spots.

It seemed unlikely that professional detectives would let themselves be spotted, especially by someone who thought she was being watched. Detectives are clever. I've met a few. A detective knows how to keep out of sight, by not being noticed in the first place. He wears ordinary clothes in plain colors, so he blends in with the crowd. And if you do happen to look in his direction, he'll do something disgusting like spit, or pick his nose, to make you turn away and forget you saw him.

The door opened, and I looked up. Ted came through, glanced around, and flopped down next to me on the banquette, slipping an arm around my shoulder. "Thanks for telling Eileen you'd help us. And I especially want to thank you for sticking by me last night."

"Would you shift over a little, move your arm, and give me some more room?"

"Play along, will you?" he whispered. "Eileen said one of the men reading a newspaper over there—" he tipped his chin "—is the detective. We can distract him by cuddling."

"If he *is* a detective, he's probably a Sacramento plainclothesman, sent by Detective Finn to follow us." I moved a few inches away. I had no wish to be any closer to Ted, and I had plenty of reasons to doubt Eileen's judgment.

Ted ordered a root beer for himself and more ginger ale for me. Then he said, "I got a telegram from Belinda this morning, when I checked us out of the Golden Eagle."

"That's good! It means she hasn't—"

"You better read it." He passed it to me:

TEDDY MAKE THE NYWATT SOUND WITH ME ITS OUR LOVE DUET CAN'T GO ON WITHOUT YOU YOUR BELINDA

"It's the same 'can't go on' again. I'm worried."

"If she's sending you wires, she's still alive. What did Manny's telegram say?"

"Huh?"

"The one that came for him last night, while we were eating. I saw the envelope on his nightstand."

"No. That was the one from Mrs. Cavett, that you read earlier. I still have the one from dinnertime. He was…he never got it."

"Did you read it? Where is it now?"

He shook his head and patted his pocket. I crooked my finger. He opened it with his thumbnail. It was from Santa Cruz:

MED EXAM SAYS ZIMMER DEAD BEFORE HATPIN

PUNCTURE BUT DEATH CAUSE STILL UNCERTAIN

ARRIVING TAHOE FRIDAY GRUMMAN

"Does Sergeant Grumman know about Manny? About last night?"

Ted crumpled up the paper. "He'll find out from the cops in Sacramento. Maybe we should have told them about Suzanne. It's all going to catch up with us, isn't it? I don't know what to do."

I looked out the window. "Manny wasn't having a sexual escapade when he died."

"Come on!"

"I'm not saying he was a saint, or that he never in his life invited a woman up to a hotel room. I just don't think he did it yesterday evening."

"You saw him! His pants were down. The police said—"

"Detective Finn went to the room with a preconceived notion, and he left with it intact. He's looking for a girl who works nights at the hotel. That's why he let us go."

"What makes you think it didn't happen that way? A man needs distraction now and then."

"Give me credit for knowing something about what men need, and how to distract them."

"So what happened—according to you? One of you girls killed Suzanne. Manny figured out who. He called her up to his room to confront her, and she killed him? You're crazy."

"If I am, I'm in the right band. Lillian's dopey. Ivy's punch-drunk. If it were up to Jack, Earl Browder would be in the White House. The Bliss Sisters think Hoover is *still* in the White House. Eileen sees detectives behind every door—"

"Shut up about her, will you?"

"You asked me to help, and I'm helping."

"Not with *that* attitude!"

"Do you want me to just paper everything over so you and Eileen can—"

"Leave her out of it!"

"What if she's the one who—"

"Hey, waiter!" He raised his arm and his voice. "Bring me a Scotch and water, will you?"

"I thought the Third Commandment was—"

"In this band I'm God, and I can break my own commandments! Do you want a real drink?"

"No thanks."

He swallowed half of it as soon as it came, then set it down and leaned back. It cooled him off.

So I asked, "Where did you go when you snuck out of the hotel yesterday? Did you and Eileen have a tryst someplace?"

"No. We went...I wanted us to go talk to her husband."

"Manny told me he's a lobbyist for the Hollywood censors."

"That's right. See, what I was thinking was: Eileen wants to have some kind of film career some day, and I'd like to do some work for the studios, too. So it'd be better all around for us to get on his good side, right?"

"What happened?"

"Well, he was *not* the lunatic I'd been expecting, from what Eileen had told me. And he said he didn't hire any detectives to spy on her. Eileen called him a liar—she insisted that we're being followed."

"Did they reach any kind of decision about their divorce?"

"I didn't stick around after they started yelling at each other. Look, I might as well tell you, Katy, it's *her* money that's producing this tour. She put up the dough for the costumes and the train tickets and everything, so we'd look like a big-time act and get an agency to notice us."

"So it's Eileen who owns half of your band now. And when you sign the contract with Consolidated, she'll get all her money back and still own a third of it. Right?"

"I guess Manny told you what the deal is, huh? You see, her husband pretty much *dared* her to go out on her own, join a band, go on tour, all the time assuming she'd flop. But yesterday, in his office, she was literally laughing in his face. You can imagine how uncomfortable the whole situation was—still is—for me. I've probably squelched any chance of writing for the movies, now."

I looked at him for a long moment; then I said, "Let me see your hotel bill."

"What?"

"Just show me, will you?"

Ted opened his billfold and pulled out the Golden Eagle's typewritten statement. Near the bottom, I spotted what I was looking for and pointed to it. "Nine telephone calls were placed from your room yesterday: three to New York, two to San Francisco, two to Santa Monica, and one to Santa Cruz. And one more to New York this morning."

"The New York calls—they're to Consolidated. And that last one is the one *I* made: to tell them about Manny."

"Are they sending another agent?"

"No. I don't think they trust me now. Manny phoned them about Belinda, like I asked him to, and they wired their man in Philly to look her up." He took a deep breath and let it out. "Apparently, she's not very reliable anymore. The manager at the Deluxe told him that she doesn't always make her piano-bar gig, and when she does show up, she doesn't always play the whole night; she cuts out early. I'm supposed to be their hotshot young bandleader and composer—the one who's ready for the big time. Only now they must think I'm an idiot for trying to stick them with her."

"I'm sorry. You couldn't have known. It's not your fault."

"If she takes those pills, it's my fault! Anyway, I've blown it with the agency."

"You'll work it out with them."

"They told me they want to 're-examine' their commitment to the Ultra Belles. I know what that means: they're gonna sell the band to a smaller agency and drop us. Hey waiter! Another Scotch."

I touched his hand. "Ted, if we figure out what happened to Manny and Suzanne, you'll look like a hero, and you'll keep the act together, too. I bet Manny would have told you what agents always say: bad publicity is better than none at all."

He managed to smile.

"Let me see your hotel bill again. Was it you who called Santa Monica? Is that the number of the hospital?"

"Yeah."

"How's Lois doing? Manny said she had some kind of infection in her throat."

"Still only so-so. She can't even swallow; they've got to feed her with a tube. It'll be another week at least before they let her out."

"I'm sorry." I looked at the bill again. "Two calls to San Francisco. That must've been Manny, doing his credit-checks on Mrs. Cavett's charity ball. And this call to Santa Cruz—that must have been to Sergeant Grumman. But it only lasted a minute, so maybe he wasn't there, and Manny left a message. That could be why the sergeant sent him a telegram later. Now, don't you see why a tryst makes no sense?"

"No."

"Would you have hired a…would you have invited someone up for a *tête-à tête* if you were in the middle of doing business, and your roommate was likely to walk in at any time? The only thing I don't understand is: how could he have been killed when the doctor said: between seven and eight? We were all downstairs in the dining room. Manny must have died much later, or else you'd have given him the telegram when you went back to your room after dinner, to change into your tux."

Ted sat still, then said, "Oh. Well, I didn't go back up. I brought my tux and dress shirt downstairs with me on a hanger, and I changed in the green room. Then I went to the lounge downstairs, and stayed there until it was time to go on. You can ask Eileen. She was with me; she changed into her gown, came down a little after eight, and we were there until showtime at nine."

"Why didn't you go up?"

"Because Manny asked me not to. He wanted to have the room all to himself for an hour or so. He told me he was expecting a visitor."

"Oh."

"I swear, Katy, you think fast, but sometimes you think *too* fast. You're probably the smartest woman I know. But that's why I…I could never love you. You're smarter than me. I can't keep up. I feel like an imbecile when you're around. *And,* I think you

suck up trouble like a vacuum cleaner. This all started when I ran into you on the pier. Jeez, now I wish I hadn't hired you. But I can't afford to fire you until we get paid!"

He stood up, swallowed the rest of his Scotch, and went back to our day-coach where (I was sure) he would go straight to Eileen and tell her everything we'd said.

I stared out the window, feeling as desolate and lonely as those mountain tops where the snow hadn't melted. A long boundary, green on one side, brown on the other, divided the forests from the peaks. I felt like I was stranded up there, above the timberline. An avalanche was coming down on me and I didn't have a single tree to hold on to. I couldn't see anything but an endless blur of snow, like a cold, white shroud.

The train didn't stop at Lake Tahoe, but at a little Hollywood-Western of a town called Truckee, whose main street was lined with plank sidewalks, rails, and hitching posts. The lake itself, according to the map on the station wall, was twelve miles away, downhill; and the state line between California and Nevada ran through the middle of it.

Two wood-paneled Ford station wagons and a delivery truck, with TAHOE TAVERN painted on their doors, took us down the steep, narrow road. As we rounded the umpteenth hairpin turn, I gasped, seeing the lake for the first time. It was bright blue, like a sapphire; small enough for me to make out houses and cabins across the water, but bigger than some of the Finger Lakes back in New York State. And it was cradled gently between mountains that seemed to rise straight up from the shores all around it: the eastern slopes, in Nevada, were dry and craggy. The western slopes, in California, were thickly forested.

The Tahoe Tavern, on the California side, was in a big grove of pine trees. Despite its name, it was a good-sized hotel with

several outbuildings. But like our two previous lodgings, it was a turn-of-the-century relic. This one was in the rustic style, like an Adirondack camp, with unvarnished planks, hand-hewn beams, trees for posts and twigs for railings. From the verandah that faced the lake, a boardwalk ran down to the water and then onto a pier. The pier itself was somewhat of a ruin. Steamships, we were told, used to ply the lake, back when the hotel was new. But everybody drives around it now.

I thought I'd be rooming with Eileen again, but it was Lillian this time. She tossed her suitcase onto the bed by the door, to claim it, then headed straight for the bathroom down the hall. The room was cold; I pulled a sweater out of my traveling bag.

"I think the hot water's off," she said as she came back.

"So's the heat. Maybe the room's jinxed," I said with a laugh.

"If it is, you ought to know. If you hadn't put the hex on those matchsticks—oh! Forget it."

"No. What did you mean?"

"Aw, it was just a gag."

"Were you all drawing straws on the train? To see who'd get stuck rooming with me?"

"I never told you. Okay?" She turned away from me and unlocked her suitcase. "Just forget it."

I walked over and stood behind her, glaring. "What's going on?"

She whirled around. "Nobody wants to room with you, Katy. You take advantage. You got Lois's gig, and then Suzanne's—"

"I had no choice."

"—and now poor Manny's dead.... Oh hell! I don't care anymore. I don't want to think about it." Lillian fished something from her suitcase and held it out toward me. It was a white tube, the size and shape of a lipstick, but with printing on the outside. "Did you ever try these? They're legal! You can buy 'em in a drug

store. You just tell the guy you have a stuffy nose or the flu, and you buy something else, like tissues or cold cream, so they don't think you're only after Little Bennie."

"Who's he?"

"It's called 'Benzedrine.' You take it like this—" she pulled off the cap, pushed the rounded end up to her nose, held one nostril closed with her thumb, and inhaled through the other, deeply. Then she closed her eyes and leaned back, moaning, "I love this stuff. It's a little like cocaine: it helps you—"

"I can see why Spitalny fired you from the Hour of Charm. You must've been high all the time!"

"Bennie doesn't get you high! Like I was saying, it's like cocaine: it helps you concentrate. 'Course, it's like cocaine if you do too much of it, too: you get the heebie-jeebies!"

"I don't scare easily."

"Weren't you scared last night? With Manny dropping dead on you, I mean."

"What?"

"In his room when you…you know. When you were doin' it."

"I never 'did it' with Manny. Where did you get that idea?"

"From Helen. And Sonia. They *saw* you. They said you went out with him; and when you came back, you rode up in the elevator together. And the next thing anybody knows, Manny's dead with his pants down. That's why we all…I mean…didn't you know why we were all looking at you cross-eyed today?"

I turned away and looked out the window. "I thought it was about 'K-k-k-Katy'—because I got so embarrassed over a stupid song. But Manny and I! That beats all. We didn't go 'out,' like on a date. We went down the street for coffee."

"Swear it wasn't you that was doin' it with him?" She waited, so I turned back. She was holding her palm up, facing me, like little girls do.

I felt silly, but I put my palm up flat against hers, and said, "I swear."

Lillian was a queer bird, all right: I never knew which way her head was going to turn. She went over to her suitcase and pulled out a red and pink bathing suit. "Do you think the lake's warm enough for swimming? Let's go for a dip!"

"I'm too cold."

She touched her bosom. "I got extra insulation!" She pulled off her clothes, worked herself into the swimsuit the way you'd push a pillow into a pillowcase, grabbed a towel from the washstand beside the dresser, and slammed the door behind her as she left.

Through the window I saw that Sonia and Helen had also changed into swimming togs, which were not (as my imagination had dressed them) antique bathing costumes. Helen, well-exposed by a dark green swimsuit, had a fine figure. Sonia, in black, did not; and except for her arms—which were strong and well-muscled—she was skinnier than she appeared to be when dressed.

A minute later Lillian had joined them on the beach, and they were all sticking their toes into the water.

I went downstairs to the souvenir shop in the lobby, expecting to buy Indian handicrafts; but all they had were ashtrays and bottle-openers, some birch-bark knickknacks, and chromolithographs of the hotel from its better days.

Picture-postcards were the best deal, at ten for a dollar, so I got them, plus a dime's worth of penny stamps. Just off the lobby there was a small library with a writing desk. I sent a card to Mother in Syracuse, to my brother Tim, who teaches at Hamilton College, to my Gramma in Lithia Springs, to my landlady in New York, and to some friends. I even sent one to Darlene Duncan, care of *Band Star*'s office. But then I was bored again.

I was looking through the bookshelves for something to take to my room and read, when Ivy flopped down in the easy chair alongside mine. Her feet didn't quite reach the floor, but she pinched off her shoes and tucked her legs under her, which put her almost at eye level with me.

"K-k-k-Katy! Hiya, K-k-k-kid! What's up?"

"Do you know how that song makes me feel?"

"It was a gag!" She gave my shoulder a couple of playful taps. "Are you really wounded? Gee, that's too bad!"

"And then to draw straws to see who'd have to room with me! Did you seriously believe that I was so round-heeled that I'd go to Manny's room with him and—"

"I saw Lillian on her way to the lake. She told me you said it wasn't you. Okay. It wasn't you. But you know, in a band like this, you gotta expect us to pull nutty stunts on each other. It breaks the tension. And we've all got tension right now. Or d'you think you're the only one? Look, if it was somebody else, you'd think it was funny, too."

"It's not funny that you're all scared of me."

"I don't know about them, but *I'm* scared of you! You could break my arm any time you felt like, with your Jap wrestling holds."

"Did I hurt you?"

"No. But you're...well, you're strange. You didn't blink when you saw Suzanne. And when you found Manny, you stayed in that room with the body after any sane girl would've run out. We're all tryin' to keep our noses clean, and you keep diggin' a hole for yourself in the dirt, by askin' people very personal questions. Not that I mind; I'm not the blushing type. But I can't figure *your* type. What's in it for you? You're not a cop, are you?"

"No. Of course not."

"Well, you act like one sometimes. And lemme tell you, Katy:

you're not doin' your looks any favor either. Your eyes are goin' bloodshot. I saw you swallow a handful of aspirin yesterday. You're gonna give yourself an ulcer!"

"Excuse me, did... Oh! Miss Green. Hi. Remember me? From yesterday?"

I looked up. It was the young jitterbug again. "Yes. Of course. This is Ivy Powell, our bass player. Ivy, this is... I'm sorry. I've forgotten your name."

"Well gosh, maybe I didn't tell you. I get so goofy sometimes. It's Babs. Well, it's really Barbara Ann. Barbara Ann Fisher. My mom wanted to call me Ann, but my daddy had an aunt who'd just died, and she was a Barbara, so they gave me both names. Everybody just calls me Babs, though."

"You look familiar," Ivy said, squinting up at her.

"Babs was at the gig last night, in Sacramento. She's following us around on our tour."

"What're you? Some kinda private eye?"

"Oh gosh! Me? No!"

"It was a joke, honey."

"Babs is our number-one booster," I explained. "She's starting a fan club for the Ultra Belles, in Placerville."

"You need a fan club. Especially you, Ivy. You're a great bass player; you're as good as Jimmy Blanton any day. That lick you put into 'Walking on Eggshells' last night: it's like what he does on 'Jack the Bear,' and 'Sophisticated Lady.' Only you do it better."

"Hey, thanks."

Babs was laying it on thick. But if she knew Blanton's work in the Ellington band, then she wasn't naïve—at least, not about music.

"Can I buy you both a Coke or something?"

"I'll take one." Ivy swung her legs off the chair.

"Thanks. I'll have one, too."

Babs got between us, grabbed our arms, and practically yanked us into the lounge. She was wearing the white cardigan sweater and pleated skirt that bobby-soxers seem to have adopted like a uniform, although she still wore too much makeup.

And she still wasn't very grown-up in her manners. She called, "Hey, boy!" to the waiter—an Oriental man old enough to be her father—and "Three Cokes, chop-chop!" when he was still about ten feet away. Then, with only enough of a pause to turn toward Ivy, she said, "I know all about the Ultra Belles. See, I went to Philadelphia last year, to visit my grandma, and she took me to see this terrific show called *To the Nines*. I just *loved* it. All those great songs by Ted Nywatt. So when I read in *Band Star* that you were coming to California, I just had to come hear you. Twice!"

"I wasn't in that show you saw in Philly," Ivy said. "Besides, that wasn't a real band: just a bunch of actresses and an orchestra in the pit. *This* band is new, and it's the real thing."

"And I'm new, too," I chipped in. "I just joined up this week. I'm filling in for a girl who...couldn't finish the tour."

"What happened to her?"

"She got water on the brain!" said Ivy. "It sounds like you go gallivantin' all over the country, Babs. Where d'you get your dough? Your pop own a railroad or something?"

They were two of a kind, all right: spontaneous and insensitive, asking personal questions of total strangers. And Ivy had chastised *me* for doing that! Well, Ivy was a boor, but Babs was a boor *and* a chatterbox.

"My father? He imports palm oil from South America."

"Maybe he'd like to hire us for a fancy gig?"

"I'd like to be in a swing band and go out on the road, playing all over the country."

"Naah, you don' wanna do that. It's murder!"

The waiter brought our Cokes. Babs squinted, scrunched up her face, and said, "Velly-velly good. Thank you, s-o-o much!" like Charlie Chan.

I was mortified. I couldn't look at her; I stared out the window.

But she poked me in the ribs. "Can I tell you a secret? I've got a sort of a crush on Mr. Nywatt."

"Yeah?" I sipped my Coke. "Get in line."

"He has a girlfriend already."

"Oh, I thought so, Ivy. Bandleaders always go with the chick-singer, don't they? Only yours has a big wedding ring on. Are she and Mr. Nywatt married?"

"She is, but he isn't."

"I don't get it—oh! You're pulling my leg, Ivy. Come on! Is she really married?"

"Is she ever! Her husband's a big-shot in the movie business."

"Then who's Ted's sweetheart? Is it you?"

Something touched my shin under the table. From the angle, it had to be Ivy's shoe. She smiled and turned toward me just enough so Babs couldn't see her wink. Then she swung around to Babs, head-on, and said, "I wish it was, but it's not me. I do happen to know who Ted's honey-bunch is, though."

"Wow! Who is she?"

"Look out there—" Ivy pointed through the big picture-window. "See the girl in the green swimsuit? That's Helen Bliss. But it's a secret. You won't tell anyone in your fan club, will you?"

"Of course not! A loyal fan never tells the star's secrets. Gosh, she's lucky. Ted's so handsome!" Then she sighed. "What's he like?"

Ivy's eyes rolled up theatrically. "To Helen, Ted is like Orpheus and Cole Porter rolled into one. Of course, Porter's the kind of guy who'd rather go rolling around with Orpheus."

"I don't understand."

"You will when you're older."

"What I meant was: what *does* Ted like? Champagne? Candlelight?"

"Oh. Well, you know that song of his—'Remember To Forget'? We played it last night, for our closing number. Well, it's all about *them*: the horse races, and the Ferris wheel, and how they, you know—*did it*—in an upper berth."

Ivy was laying it on thick. Babs, wide-eyed, was moving her shoulders in tight little circles. She reached up and touched her bangs nervously. I didn't think Ivy ought to be toying with her like that, but I had to hold my breath to keep from laughing.

"Is he happy with her? She looks so old!"

"She's only forty-two."

"So's my mother, almost. Are they're engaged?"

Ivy leaned in. "That's a secret, too. But they're gonna announce it right after our last gig on this tour: tomorrow night, in San Francisco."

"They are? Gee, that's so romantic."

"But if you ask me, it won't last. She's a tramp. Gotta have a new man every week. Come around in a month or so, honey. She'll be through with him like yesterday's paper, and then you can have him."

"But I wasn't—"

"Sure you were! The way you were primpin' with your hair while I was telling you about Ted. You oughta make nice to him. He's a pushover for a cutie-pie like you."

"Really? Cross your heart and hope to die?"

Ivy flicked her eyes toward me, then she folded her arms across her chest and gave Babs a big nod.

From that point on, though, Babs was emboldened to stake out a higher level of presumption on us. We were her new best

friends. She declared that Ted couldn't possibly want her, and proceeded to give us an embarrassingly intimate critique of herself. Her stomach was too large and her breasts were too small; her hair was the wrong color, and at any moment pimples might burst through her skin—which was why, despite a nightly regimen of creams—she had to cover her face so thickly with powder.

Finally, I couldn't stand it any longer. Even though I was still feeling chilly I said, "Hey, look at them all splashing around in the lake! I'm going for a swim. Bye."

Back in my room, I realized that I hadn't taken a book from the library downstairs, after all. But in my bag I still had the *Look* that Suzanne had given me on the train. I plumped my pillows, settled down, and started to read. But it all seemed familiar. There's a name for the feeling you get when you think you've done something or been somewhere before, even if you haven't.

There was an article about South American palm oil. One of the brassiere ads showed you how to measure your breast size; and there was an ad for hair-coloring, and another one for pimple-cream. And I suddenly realized that all of the words in those ads had found their way into what Babs had said.

What a lonely girl she must be! She couldn't sustain a real conversation, or make real friends, so she lived her life through popular magazines. No wonder she devoured every issue of *Band Star*. And I was willing to bet that what she'd said to Ivy about Ellington's bass player she'd probably cribbed from *Down Beat*.

She was like those kids who memorize "The Charge of the Light Brigade" and just *have* to show off by reciting it.

I felt so uncomfortable that, in spite of the chill, I jumped up, changed into my bathing suit, and headed down to the lake.

● ● ●

The Ultra Belles were out on a raft a hundred or so feet from shore. From a wooden tower, where the boardwalk ran down to the beach, a young lifeguard surveyed the girls in his charge. He was wearing a snug bathing suit: one of the new kind that's just shorts—no top—and he swung his binoculars down my way as I stuck my toe in the water.

"Go on, beautiful. It's warmer once you're in it!"

It was cold, all right, but not freezing. I'd swum in colder lakes before. I dove in and did a slow breast-stroke out to the wooden raft, ducking my head under the "lemon-lines" of ropes with small floats that fenced in the shallow area. I hitched myself up onto the wooden raft—it hadn't been whitewashed since at least the previous season—and looked back at the shore.

The lifeguard was smiling, but not at me alone. Lillian was sitting with her back arched, bosom out. Eileen and Jack were letting their legs dangle over the edge of the raft. Sonia was lying on her back. Helen was pulling off her bathing cap, letting the auburn hair she ordinarily wore in a tight bun fall past her shoulders.

Indeed, Helen—remarkably—was the best-looking of us all, at least in the way Atlantic City judges give prizes. She was well-proportioned in the dimensions that men care about. Even Eileen, who was almost twenty years younger, didn't have a shape to match Helen's. I'd laughed at Jack's wisecrack to Manny, about refusing to wear falsies; but it was obvious now that Eileen had no such scruple. She wasn't flat-chested by any measure, but she was certainly not as big as she appeared on stage.

To see Sonia in a swimsuit, however, was to see how far her bones stuck out. My father had told me, long ago, that narcotics take away your appetite; and Sonia was living proof of what her narcotic cough medicine could do.

Lillian's two-tone pink bathing suit had the lighter shade

above, which gave her top more emphasis than it needed. I was thinking that being so conspicuous was probably more of a burden than a treasure for her. "Have you seen Ivy?" she asked.

"I just left her in the lounge with the president of the Ultra Belles' Fan Club."

"We have a fan club?"

"We have one fan." That got a laugh all around. "But don't let her corner you. She's a chatterbox."

"Hey, Eileen!" Lillian called. "Tell Ted to romance her. That'll throw the detectives off your trail!"

"Why are you girls always so casual about sex?" Helen demanded. "I don't get it."

"Did you ever 'get it'?"

"Lillian!" That was Sonia. "Must you be so crude?"

"You're all in such thrall to sex," said Helen. "But it's nowhere near the pleasure it's cracked up to be. For a woman, it's…it's her duty."

I couldn't help saying, "Speak for yourself, Helen."

"I am."

"Well, get off your high horse!" Eileen called over. "If you're an innocent little virgin, Helen, I'm the Duchess of Windsor!"

"I never said I was a virgin. But, well, sex can be dangerous, with all the diseases you could catch. And look what happened to Manny!"

"Yeah!" said Lillian. "I bet every guy dreams of going that way! Dropping dead just as he drops his pants."

Jack chuckled. "It's funny: you never hear of a *girl* dying from it!"

"Girls only die from lo-o-o-ve," Lillian cooed.

Eileen tipped her head toward the shore. "How many of us would it take to kill that lifeguard?"

"There you go again!" Sonia declared.

"Why don't we give him a strip-tease?" said Lillian, wiggling her chest. "Anybody want to skinny-dip?"

"No!" said the rest of us, practically in unison.

"That's for children, Lillian," Helen added. "A grown woman does not go swimming without a bathing suit."

Lillian shook her head. "What is it you don't like about sex anyway? You make it sound so disgusting."

"It's not the sex act itself. Don't get me wrong. A man needs it. It's a healthy release of tension."

"For us, too!" I insisted.

"No. It's different with women. Men have a fundamental need. It keeps them calm. If they don't release themselves, regularly, they go crazy."

"Hey everybody, listen up!" Lillian exclaimed. "We've got an expert here: a regular doctor of sex-ology."

"You stupid cow!" Helen retorted. "Do you think that just because you've got bigger breasts than mine that you're more of a woman?"

"Drop dead!"

"It's not what's on top," Jack chimed in, "it's what's down *there* that counts. Believe me, I know."

"Are you saying you like men, now?"

"I told you before, Helen: if you broadcast that, I'm gonna kill you."

"We saw what you did to Suzanne. You left the door ajar."

Jack pulled her legs out of the water, turned around, and faced the sisters squarely. "D'you think, if we were doin' what you imagine you saw, that we'd have left the door open? I'll tell you what you saw. Suzanne felt a little lump, and she asked me if I thought it was a cyst or something. So I reached over and touched it. It felt like a marble. I don't know what it was. I told her, if she was worried she should have a doctor look at it. That's all. That's

the whole story. You and Sonia have been making it sound like *The Well of Loneliness*."

"I'm sure you took *that* awful book to heart."

"Shut up, Helen!" That was Lillian. "What do you know about sex anyway? At least I was married once."

"Well, so was I: from 1922 to 1931."

Eileen looked up. "Did you get a divorce?"

"No. I'm a widow. He died after two years of wasting away. It was very painful for me. There's a long medical name for the disease he had, and it's rather rare. But Lou Gehrig, of the Yankees—have you seen the newsreels? He has it, too."

"I'm sorry," I said quickly; and the others murmured their own apologies.

There was an awkward silence until Sonia said, "It was very hard for Helen, being left alone like that. She'd quit the stage to nurse him. I'd been performing solo, and she needed a change. So we revived our 'Kid Sisters' act and picked up a couple of bookings. We were on the road in 'thirty-two, when President Hoover asked us to join his campaign. We offered to work for Mr. Landon's campaign, in 'thirty-six, but his people didn't want our help."

"Well, that's why Landon lost," I said, patting her hand and smiling. "He didn't have you girls to sing for him!"

"It's sweet of you to say so, Katy. Thank you." Helen looked out across the lake. "I think I'll excuse myself now, and go back." She pulled her cap on, swung her legs out over the edge of the raft, and slid down into the water.

Lillian leaned over the edge. "I'm sorry. I didn't mean to upset you!"

"She's very sensitive about what happened," Sonia said quietly, as Helen swam away. "He was the only man in her life. Ever. When you all talk about men so casually... Well, it's not your

fault I suppose. And I'm awfully protective of her. Do you think you could perhaps not say anything that might remind her of…those days? Please."

"Okay by me," said Eileen.

I said, "Me, too."

Lillian said, "Sure. And I'll tell Ivy."

Jack held off. "Do you think you and Helen could do something for me in return? You know what I want to hear."

Sonia nodded. "I think so. I'm sorry for what I've been saying, Jack. We were mistaken. It won't happen again."

"Thank you."

The sun was going down; shadows from the pine trees above the lake's western hills reached out to us on the raft, and I was getting cold again. I said I'd see everybody later, and dove off, swimming a fair Australian crawl all the way back to shore, in only two breaths.

By then, Helen had dog-paddled through the shallows and emerged from the water. The lifeguard dismounted from his perch in one bound, and strode over to where she was drying her shoulders. "Hello there, beautiful! It looks like you could use some swimming instruction. I'm a great teacher. Wanna take a lesson?"

She glanced up, shook her head, and—grabbing her robe—ran up the boardwalk and into the hotel.

It took longer than usual to set up for our gig. The ballroom at the Tahoe Tavern was "live": the kind where every note you play seems to bounce off the walls. We had to adjust our positions a couple of times while Ted listened from various spots in the room, so we'd blend just right.

And Helen didn't come to help; she was "indisposed," Sonia told Ted. But we understood. In a band that has to play someplace

different every day, if you skip out once or twice (and don't make a habit of it) you're forgiven. Everybody needs to take a nap sometimes, or finish a book, or go sightseeing, or just be alone with her thoughts.

But Helen didn't show up for the first set either. Ted waited until quarter past nine, then began to fume. Sonia said Helen had dressed early, saying she wanted to walk a while before we went on. We played the first set without her. We hadn't drawn a big crowd, but it was a Friday night, and the people who did come were there to dance and forget their work-week. They clapped wildly, unaware that we were short-handed.

Babs was there, sitting at a small table beside a young man— I was sure I'd seen him before. Sure enough, he was the lifeguard from down at the lake. They danced through most of our numbers, and clapped, hands-over-head, calling for more slow ones, so they could dance close again and again. So it didn't surprise me when I saw them stroll out onto the verandah together, nor when I realized, hours later, that they had never come back. Frankly, I was glad, because it meant that she wouldn't be pestering us with her chatter.

At the break, Ted told Sonia to go find her sister, and when *she* didn't come back on time, things got tricky. We could get by without Helen's clarinet, since Lillian or I could just play additional solos. But Ivy and Jack had to play extra loud, to make up for no drum. Jack helped out by favoring the one-beat and the three-beat instead of the off-beats—the twos and fours. Eventually Lillian and I realized that, if we had to play multiple solos, we might as well improvise, and to hell with Ted's First Commandment! So it was a bare-bones kind of swing sound we pumped out in that set, but we were smiling when it was over.

From the bandstand, across the room, we could see the lake through big picture-windows. A quarter moon was rising over

Nevada. It was peaceful out there. Sonia returned just as we were ready to play the third set, shaking her head. She whispered something in Ted's ear, climbed up onto the stage, and took her place behind the drums.

During the break between the third and fourth sets, however, we all joined the search for Helen. We had about fifteen minutes. Ivy and Lillian went up to check the rooms. Jack and Ted headed down the drive, then split up to trot along the road in both directions, on the theory that Helen had walked away to be alone — that she might have thumbed a ride was unimaginable.

Sonia and I did the same thing, but we took the footpaths beside the lake shore. She went north, where a few home-lights were burning, while I headed south into the darkness. I heard her calling, "Helen?" every few seconds. I called out, too, but only when I came to a cove, a beach, or a dense knot of trees that I couldn't see into. Finally I checked my watch, called, "Helen?" one more time, and turned around.

Back on the bandstand, none of us had found her, and we were worried. It made us tense through our final set. When the crowd had gone, and we were packing up our gear, I felt a cold breeze. The door to the verandah had opened. Someone slipped in and stood in a dark corner. I stared. He stared back, then he walked down to the stage: a tall man with a lantern jaw. It was Sergeant Grumman, of the Santa Cruz police.

"There's only two possibilities," he said, skipping every formality. "Either the Ultra Belles are the unluckiest combo that Manny Blunt ever represented, or one of you girls has committed two murders. Wait a second—there's only six of you." He glanced around. "Where's the other sister?"

"She didn't show up to play tonight," Ted explained. "We've been looking for her during our breaks."

"Did she go off with anybody? A guy, maybe?"

Sonia coughed. "Of course not!"

"Is she a lush, like Miss Zimmer?"

"Certainly not!"

I stepped in and said, "She may have wanted to be by herself for a while. She'd been reminded of a family tragedy."

"Or maybe she's the killer," he shot back, "and when she saw me coming, she ran away."

"No!" Sonia pleaded. "Help me find her, please!"

"I don't have any authority or manpower here. Call the sheriff in Truckee, if you haven't done it already. Now listen—all of you. The Sacramento cops want to talk to you again, since you're heading back through their town in the morning."

"Are we under arrest?" Ted asked.

"Not yet."

Ted checked his watch. "It's ten to three. We have a gig in San Francisco in eighteen hours, and a train to catch in Truckee at eight-thirty in order to make that gig. If they hold us in Sacramento we'll never get to San Francisco in time."

"You'll make it. I'm riding with you, and Detective Finn will get on board when we stop in Sacramento. I want everybody to go to her room now, except you, Mrs. Wheeler. I want to talk to you first, right now. And Miss Green—wait for me in the lobby."

There was a console radio next to a leather settee; I switched it on while I waited. All I could pick up was a station from Reno that was playing cowboy songs—something I wouldn't have cared for ordinarily, except that they had a fiddler who was hitting some really hot swing licks. After about ten minutes, Sgt. Grumman came in, and I switched it off.

"Okay!" was his entire greeting. "I have to tell you: if I thought you killed two people I wouldn't be here alone. I'd have a couple of cops behind me."

"Thank you, I suppose."

"Manny left me a message. He said he trusted you, and to call someone named Darlene Duncan if I wasn't sure. So I did, and she told me how you got her out from under a charge of murder—that guy's body in her car that—"

"I never claimed to be a heroine."

"You never claimed a reward either. Can you help me?"

"I don't know."

"Do you think whoever killed Suzanne killed Manny, too?"

"Yes."

"Tell me what you two talked about yesterday."

I did that, until about four-thirty. Finally I said, "It's all the blood—Manny's blood, Suzanne's blood. That's what bothers me."

He made an outlandish frown. "If you can't stand the sight of blood, why are you—"

"No! I'm *confused* about the blood. I know first-aid; I've helped out in accidents. Manny didn't have a hatpin jammed in his throat; the doctor or the cops would have spotted it. I don't think his nose was broken, either. So where did the blood come from? And I read your telegram. You said the hatpin didn't kill Suzanne. All right. Why did she bleed so much? And why was the hatpin stuck in her throat after she was dead?"

He paced the floor. I gestured toward the place beside me on the settee, but he shook his head and kept pacing.

"The only thing our medical examiner in Santa Cruz knows for sure is that Miss Zimmer had blood in her lungs—enough to drown in it. And that's his theory of how she died. But he hadn't seen anything like it since the War."

"I don't understand."

"That was the last time he saw symptoms like hers. After a gas attack: mustard gas. I was too young to go, but the doc was over

there, in the trenches. He says a gas attack was the worst thing you could get caught in, and both sides used it. It was such a horror that the League of Nations voted to ban it; even the Germans said they'd never make war with it again, and they haven't…yet."

"What's in it?"

"Chlorine, mostly. It works very fast, and it's very painful. It blisters the wet membranes in your nose and throat. If you don't choke right away on fumes, you bleed down your throat and into your lungs, and drown in your own blood."

"Lois—the girl who fell off the pier—d'you know about her?"

"Yeah."

"Check with the hospital in Santa Monica. *Her* throat's all sore and blistered. And what'll you bet that Manny's throat is, too? Where can somebody get mustard gas? Not from hot dog mustard, I'm sure."

"No. And not out of a mustard plaster from the drug store, either. It's dangerous even to make the stuff. You need a factory, or a laboratory anyway. And you have to transport it in a sealed container."

"Could somebody have stolen a gas bomb from an ammunition depot?"

"Uh-uh. We'd know about a theft like that. Every police department in the country gets teletypes from the army to be on the lookout for stolen guns and explosives."

"Suppose they haven't discovered the theft yet? Could it fit in a suitcase?"

"Well, it'd be about two feet long, and weight twenty or thirty pounds."

"We're all strong. Even Sonia's got muscles. We carry our instrument cases, and our baggage, and we wrangle big boxes every day, with all our music stands and equipment. Can you get a search warrant?"

"Not outside of my own jurisdiction. And it's a pretty far-fetched idea to take to a judge anyway. Of course, it's not impossible. Manny was dead a couple of hours before you and Ted found him. The window in his room was open, so the gas could have evaporated."

"I'm deflating my own idea now, but it doesn't work in Lois's case. You couldn't set off a gas bomb out on the pier, with a couple of hundred people around. Nor in Suzanne's case either. The Pullman car's windows don't open. She was in an upper berth with no window anyway. And somebody would have smelled the—"

"Sergeant Grumman!" Ted had run in.

"Yes, Mr. Nywatt?"

"Sorry to interrupt you, but could you come outside? The sheriff and his deputy are here from Truckee. He'd like to meet you. And, uh…they found Helen Bliss."

Torches had been lit along the boardwalk, and people were waving flashlights down at the water's edge. About thirty feet offshore, two men in a rowboat were disentangling Helen from the ropes. They lifted her aboard and rowed her in to where Sonia was sitting on the grass, crying off her makeup and wringing some kind of cloth in her hands.

One of the men from the boat draped his sports jacket around her shoulders, took what she was holding, and shone a flashlight on it. It was a maroon gown—the kind the Ultra Belles wore on stage.

The other man took it and walked halfway up the slope to where we were standing. "This must be her dress. It was down in the bushes. Looks like she left it there when she went skinny-dippin', only she got tangled up in the lemon-lines and drownded."

The torchlight glinted off a big sheriff's-star badge. He was a muscle-bound man in his sixties with a dry, wrinkled face, and his voice had a resonant baritone twang that I thought only cowboys in the movies could have.

"Excuse me, Sheriff," I said, "Helen would *not* have gone skinny-dipping."

"Who're you?"

"I'm in the band."

Sgt. Grumman showed his badge, introduced himself, and said, "Miss Green is a reliable informant, and possibly a witness."

"Glad to make y'r 'quaintance, Sergeant. What were you saying, young lady?"

"Helen told us she would never go swimming naked. And she could barely dog-paddle. People who aren't good swimmers don't usually take midnight dips."

"She could have *walked* in. The water wasn't over her head."

"Then why didn't she walk out? How did she get tangled up?"

The sheriff thought for a moment. "You think she wasn't alone?"

I took a deep breath. "I think you should talk to a girl named Babs. She's a guest here. A fan of the band. She lives in a town called Placerville. She was at our gig in Sacramento, and I know she wanted to see Helen tonight."

"I hear you girls got in trouble in Sac'amenna, too."

"All the more reason to question her now."

"You said she's a guest here?"

"Yes."

"Peterson!"

His deputy hustled over from the lake shore: a younger and taller man whose string-tie was undone. "Yes, sir?"

"Ask the manager where he's got a girl roomin', by the name of—what was it now?"

"Babs—Barbara...something...Barbara Ann Fisher."

"You hear that, Peterson? Go wake 'er up if you hafta, and bring 'er downstairs."

"Yes sir."

"Now, Miss Green, you tell me why we're lookin' for her."

"She's got a crush on Ted. She wanted to know all about his love-life. So we—another girl and I—we had some fun with her. It wasn't very funny, I know, but we told her that Helen was his sweetheart, which she certainly was not."

"And so you think she...what? Took her out for a swim an' drownded 'er?" Now he was squinting down his nose at me. "Who's the other practical joker?"

I wished I didn't have to say, but I had to. "Ivy Powell."

"I'll go talk to 'er. And the youngster. Now, Sergeant, they told me you were up here on business, too."

Sgt. Grumman took a few minutes to explain why he'd come to Lake Tahoe, and when the sheriff heard that, he looked at me and shook his head.

"You gals're havin' a *streak* of bad luck, ain't'cha? C'mon with me, Sergeant. Let's go see the body."

He hadn't included me in his invitation, but I said, "I'll wait here."

"Damn right. You're stayin' put." He started walking toward the shore.

"Don't worry, Miss Green," the sergeant whispered, "I'll tell you if there's anything...you know."

As he followed the sheriff down the slope, the older man jerked his thumb back toward me and said, "She y'r girly-girl, Sergeant?" But I couldn't hear his response.

Why had I been so quick to cast suspicion on Babs? I was

assuming, of course, that she'd believed what Ivy and I told her about Helen. But she'd made such a nuisance of herself! I had a momentary vision of the sheriff bursting into Babs's room and finding her in the sack with the lifeguard; and then another of her, alone in bed, and cross for being awakened. But it was possible that Babs had seen or talked to Helen after the rest of us did, and before—

"Hey, miss!" Peterson, the deputy, was trotting down the boardwalk. "Are you sure you got that name right? The manager says no Barbara Fisher's registered. And he was at the front desk most of yesterday."

"She may have arrived a few hours before we did. There was an earlier train that we didn't take. He must remember her. She's in her early twenties, I guess, though she looks a little younger. She talks a lot. Oh! And we sat in the lounge. Maybe you could ask the waiter."

He took the stairs two at a time.

The sheriff and Sgt. Grumman walked back to where I was standing.

"Miss Green, the sergeant here says you oughta know this, so I'll tell you. But I don't want you tellin' the other girls."

"All right."

"It's stan'ard procedure 'round the lake, to give a body artificial resp'ration when you pull it outa the water. You might-could revive 'em, see? Well, I was pumpin' on the lady's chest while my deputy, Peterson, rowed her back t'shore, and it wasn't any of Lake Tahoe that come outa her mouth."

"Was it blood?"

"It sure was."

We heard loud footsteps. The hotel manager, with Deputy Peterson right behind him, was hurrying over. "I'm sorry, Sheriff," he said. "There's no Barbara Fisher registered. We have

sixteen women staying here, but besides the ladies in the band, only two others checked in yesterday. However, the waiter remembers the girl you described—she was very rude to him. And I know who you mean, now, too. I sold her a ticket to the show last night, and I saw her dancing with our young life-guard."

"What about those other gals, Sheriff? Want me to bring 'em out?"

"No, not yet," replied his boss. "Go see if the sister's recovered enough to ID the body. And if she's through cryin' on your coat, take it back. And tie your tie."

"Yes, sir."

As Peterson walked away, I asked the manager, "What did the two other women look like?"

"One's driving a Buick to California from Salt Lake City, pulling an Airstream trailer, and she's old enough to be my mother. The other woman's the right age, I suppose; but she's nothing like your Miss Fisher: she's uh—" he lowered his voice "—quite a bit overweight."

"Overweight? I'd like to talk to her."

"I'm sorry, miss. But she's gone. A couple of hours ago. While the band was still playing. She rang for the bellboy to bring down her trunk. I asked if there was any trouble, and she said she hadn't expected to be so far away from Reno, and that's where she really wanted to stay. She paid for the night's lodging anyway, so I phoned for a taxi and she left in it."

"She'll be over to Reno by now, but we can find 'er if we hafta," the sheriff said. "Driver'll tell us where he took her."

"Sir, we've got a problem." That, from Deputy Peterson, who'd come back to us. "Miss Bliss says it's her sister, all right; but she doesn't want us to take the body away. I don't want to press her. She could get hysterical."

"You never could figure out women anyhow. I better handle her. You come along, listen, and learn."

They strode down to talk to Sonia. I looked at Sgt. Grumman, shrugged, and said, "I'm confused. Where did Babs go? And why did she lie to us?"

"Why did you lie to *her*?"

SAN FRANCISCO-OAKLAND BAY BRIDGE LO... ...CO, CALIF.

SATURDAY

SHORTLY AFTER DAYBREAK,
the sheriff herded us all into cars and took us up to
Truckee. Sgt. Grumman rode in the truck that carried our
baggage, and if I were he, I'd have searched through our stuff,
without a warrant. For all I know, he probably did.

I hadn't slept much for two nights in a row—none of us had.
I wasn't even sure which station we were being taken to: the train
station or the police station. Lillian started wailing when our car-
avan stopped in front of the sheriff's office. But the deputy
jumped out, ran inside, and returned with a sheaf of mimeo-
graphed papers wrapped with a rubber band.

The three cops held a quick huddle; then they mustered us
out of the cars, and the sheriff spoke for them all. We could go on
to San Francisco and finish our tour, he said, in exchange for put-
ting our signatures on official forms. By signing, each of us would
swear that we wouldn't leave the state of California, or even stray
from the group, without notifying them. The alternative—if

somebody didn't sign—was to sit in the Truckee jail until Monday, when the courthouse opened and the judge showed up. If we did sign, we could go to San Francisco and play the gig. Sgt. Grumman and Dep. Peterson would ride with us all the way to San Francisco; Det. Finn would come aboard in Sacramento.

Ted insisted that if we didn't play the gig tonight, he couldn't guarantee our pay. So we signed.

The *Zephyr* whistled as it pulled into Truckee. It was a new and entirely streamlined diesel train, with shiny aluminum siding that ran all the way along the length of the locomotive and the cars, right down to the wheels.

We were in a Pullman car again—all the accommodations on the *Zephyr* were Pullmans—but it had already gone through its last night of the run; so all eight rows of berths in our car had been turned back into seats. The interior trimmings were brand-new, too: lots of cool chrome and quiet black enamel—a soothing change, after four days of fussy Victorian gingerbread and Wild-West woodcraft. The upholstery was so new that it still smelled like a drygoods shop. And air-conditioning made all the cars virtually soundproof: you could barely hear the wheels and tracks at all. The vestibules between the cars were noisy, of course, but they had canvas tents, like accordion bellows on the tops and sides, that kept the rushing wind down to a steady breeze.

When we'd all sat down, Dep. Peterson checked the timetable against his watch. "The sheriff asked me to make sure you keep your seats; he doesn't want you goin' down to the diner or the club car—"

"You gotta be kidding!" Jack exclaimed. "What're we? School-girls?"

"Excuse me."

"Yes, Sergeant?"

"The sheriff's right to be concerned, but I think we can let them walk around the train. How about this: whenever there's a stop coming up, we'll have a roll call. All of you gather together and let the deputy and me make sure everybody's still on board. You can be here or in another car, I don't care, as long as you're all accounted for."

Peterson nodded. "I think that'd be all right."

"What if we gotta go?" Ivy asked with a grin.

"Go with somebody."

"Two by two, like the Ark!" Eileen got a laugh for that, and it broke the ice.

Ted said, "I guess that's all," and sat down next to her. Without thinking, he put his arm around her shoulder. She startled, looked left and right, and slid away enough that he pulled his arm back.

I motioned Ivy aside and whispered, "Want to come to the ladies' room with me?"

"After you told them what I said to that kid?"

"I'm sorry. I had to. She might have—"

"The hell with you. The other night it was 'I would never tell.' Today it's 'I had to'! Drop dead!"

Jack touched my arm and said, "I'll go with you, Katy. Come on."

The stall in the ladies' room was locked from the inside. We waited in the corridor; the train was rattling only slightly from side to side. It was a very smooth ride.

"If you gotta go real bad, Katy, see if that compartment's empty." Jack pointed to it. "Compartments have a private can."

"Oh, I can wait."

"Suit yourself. I'm gonna go out in the vestibule and grab a smoke. Sure you don't want one? It's good for the nerves." She tapped a Spud out of her pack and struck a match on the

doorframe, stepped out of the car, and let the white smoke drift out one side of her mouth and into the breeze.

The train shuddered a little and I bumped the compartment door. Someone inside must have thought I knocked, because the latch clicked, the door opened, and a heavy-set woman peeped out. "Oh? I thought it was the conductor."

"I'm sorry. Excuse me."

She glared at me and blinked, looked up into the car where the rest of us were sitting, muttered, "Can't a woman have some privacy?" and slammed the door shut.

I would have apologized again, but the ladies' room door opened, and a girl in a silk print dress stepped out. I let her squeeze by, then I went inside.

The lounge was ultra-new, with black countertops and chrome trim. All the towels, seat cushions, wastebaskets, even the little supply cabinet under the vanity, were stenciled with the *Zephyr's* emblem.

I was washing my hands when Jack came in.

"How'd you like to form a band with me, Katy? We can get Lillian to join us. Ivy, too—she won't stay mad for long."

"I guess I could join you. Say—did you see the woman in the compartment?"

"Sorry. I was out in the vestibule. Let's go back, get our instruments out, and play some tunes. What d'you say?"

"Not yet. Remember the woman who beat up Ivy the other day? She had a big stomach and a green coat. Well, this woman did, too."

"Which woman?"

"In the compartment. And it was a big woman who checked into the Tahoe Tavern yesterday—only she left in the middle of the night and went off to Reno, so she could have gotten on this train in Reno, which is the stop before Truckee. And if—"

"Katy! What are you—"

"If it's the same woman, I've got to warn Ivy not to go near her until one of the cops can check her out."

"'The same woman'?" Jack mimicked me. "Katy, everyone in the band thinks you're nuts. Except me. 'Cause I can do something for you."

"What's that?"

"I've got a job for you."

"Playing?"

"Nope. Teaching *ju-jitsu*."

"I'm not looking for a new career."

"We're all gonna change jobs when the war comes, Katy. I made a kind of a 'career choice' and you better make yours if you don't want to go to jail."

"Jail? What are you talking about?"

"Suzanne and Manny! Why'd you kill 'em? Were they Nazi fifth-column? Or saboteurs? You know how to kill people with that *ju-jitsu* stuff. You're like a weapon of war, Katy. Oh, don't worry. I'll keep your secret. I mean: you aren't a homicidal maniac—and you're on *our* side. But there *is* a homicidal maniac loose in the world. He's killed thousands already, and there's more to come. He killed Czechs in 'thirty-eight. He killed Poles in 'thirty-nine. He's killing the French right now, today. It'll be the English next and the Russians after that and to hell with the Nonaggression Pact. The killer's name is Hitler. And if Roosevelt doesn't declare war on that bastard, he's gonna come over and kill us Americans. He'll do it the easy way: in our sleep, like how you killed Suzanne. Or while we've got our pants down, like how you killed Manny."

"Jack! I didn't—"

"But we won't let him kill *us*. Not me—not any of us in my cell of the Party. We're gonna gonna go over and kill him first!"

"I don't see—"

"Listen, Katy. What I'm telling you is a secret, okay? There's a camp, up in the mountains north of here. That's where we're getting ready for the war. You can hide out there."

"But—"

"Lemme finish. You can teach *ju-jitsu* to the beginners, and study commando tactics with the experts. Hell, you already know how to kill people quietly! I swear, Katy, tell me you want to go kill Hitler, and I'll get the Party to send you over there and do it."

"I don't believe this."

"What're you gonna do when the war comes? Get fat behind a desk that used to be some draftee's, while *he* gets to go off and fight? You already know how to fight! And kill! Don't keep it to yourself! Help us win the war."

I took a breath. "Do they teach you to shoot, at camp?"

"Yeah, and not BB-guns either: real rifles. Pistols, too."

"How about making bombs?"

"Ah…there's another camp for that. In the desert. I've never been, but I know some people. Is that…is that what you'd rather—"

"Gas bombs. That's what I want to know about. Especially mustard gas."

"So you like the idea! Great! What d'you figure? Bombs are gonna win the war, in the end?"

"You don't happen to have a gas bomb in your guitar case, do you?"

"If I did, I'd give it to you! What about joinin' my band?"

"The musicians or the assassins?"

She laughed. "Join both! Nobody ever went off to war without a song. And a band might make a good cover for…other activities."

"It's been a good cover for somebody."

"Yeah. *'Somebody.'* Right. I won't tell. Listen, when we get to Frisco I'll call the Party and we'll sneak you out of town."

"No. Wait...uh, wait for me to give you the signal, okay?"

"Sure. Wow! You're swingin' in my groove now, Katy."

"Good. But we've got to play it cool. Let's just go back to our seats, take out our instruments, work up some tunes, like nothing's changed, okay?"

"Thanks, Comrade!"

We did go back and jam, but I didn't play very well. I was distracted, keeping my eye on the compartment at the end of the car. And we put our instruments away as the train pulled into Sacramento.

Detective Finn swung himself aboard even before the porter could set down the little step. He strode into our car, headed straight for the seat across from Ted's, gave us a half wave, and plopped himself down.

Ivy looked at the three cops and said, loudly, "Did somebody turn up the radiator? 'Cause *the heat's on!*"

Det. Finn sneered, and Dep. Peterson kept still, but Sgt. Grumman chuckled and grinned.

As the train started up, Lillian called out, "Ted, I'd like to go down to the club car."

He looked around, said, "Why don't we all go?" and stood up.

Sonia hesitated, but Eileen leaned over, took her arm, and drew her out of the row, saying, "Sonia, you've lived in San Francisco. I'm sure you know all the sights. I want you to tell us everything we should see while we're in town."

"Yeah," Ivy chimed in. "I wanna ride one of those cable cars. Where do they run to, anyway?"

The deputy glanced at the sergeant and the detective. "I'll go along and keep watch."

Det. Finn stood up. "Nobody's going anywhere without me."

Jack made a come-along gesture in my direction, but I inclined my head toward the seat alongside Sgt. Grumman. She looked me straight in the eyes for a long moment, then went out with the others.

There were half a dozen other passengers at the forward end of the car; four were playing cards and two were snoozing. I looked out the window. Thick willows lined the far bank of the Sacramento River. The morning sun cast sidelong shadows of each tree onto the flank of the next, and wherever the river was wide and slow, everything was reflected upside down.

I took the seat across from the sergeant, facing the back of the train, where the compartment was. "Tell me, Sergeant. Do you know anybody who thinks they're being followed all the time?"

"You're asking a cop? Lots of guys think somebody's watching them. The psychoanalysts call them 'paranoiacs.' But you're talking about Eileen Wheeler, right? You think she's nuts because she sees detectives everywhere?"

"Suppose Eileen really is being watched. Suppose we're *all* being watched."

"Watched by whom?"

Just then, the thing I'd been waiting for happened. The compartment opened and the woman stepped out. She pulled her door closed and went straight into the ladies' room. I didn't see her clearly—a veil hung partway down her face. But she wasn't wearing a green coat. She'd changed into a snug tweed suit, maybe only about a size six. And she could fit into such a small outfit because she wasn't fat anymore.

"Did you hear me, Miss Green? I asked you who's following you girls, and you went off in a fog. We've checked with the big detective agencies, and none of their people are—"

"It's not an agency. It's one person who's changing clothes."

"Oh. Well, there are some private dicks who specialize in that. It takes practice. But if he'd been on the train to Santa Cruz, when Miss Zimmer was killed, why didn't he show me his license when I was questioning all the passengers? D'you think he didn't spot the killer and was ashamed to admit it?"

The ladies' room door opened, and the woman in the tweed suit stepped out. She didn't turn my way; she opened the vestibule door and went to the next car.

"Are you listening to me, Miss Green?"

"Come with me to the club car, Sergeant. I'd like you to ask Eileen who she thinks is following her today."

"What for?"

"You could confront whoever she says it is. If it's a detective, you could ask about Suzanne. If it's not a detective, well that's important to know, too, isn't it?"

He sighed. "Okay. What the hell. We've still got—" he checked his watch "—almost an hour before we get to Oakland." He stood up and extended his arm. "Come on."

We walked down to the end of the car together; he opened the vestibule door, but I said, "Oh. I'll be right along. I need to go to the ladies'."

"Meet you in the club car."

As soon as he'd gone I bypassed the ladies' room and leaned against the compartment door, the way I'd done earlier. Only this time I reached behind my back, turned the knob, and let myself in.

The shades were drawn. I let the door click shut behind me as I turned on the light.

A steamer trunk, closed but unlocked, stood beside the door to the toilet. The folding table was set up under the window, and a WPA guidebook to California was open to the chapter on San Francisco. Alongside it was a cosmetics kit the size of an overnight

case, with both its lids opened up, exposing multiple tiers of supplies. Inside one lid was a mirror, and inside the other was a label that read MAX FACTOR & CO.

There were powders and rouges; tubes of spirit-gum; jars of face-putty and cold cream; a packet of cotton balls; hair pieces, false eyebrows and eyelashes; a set of bucked front teeth; and a handful of stretchy rubber chins and noses.

I went over to the trunk and opened the heavy halves of it. The top drawer held lingerie, handkerchiefs, a box of costume jewelry, a suspender belt, and three pairs of silk stockings. Also a flat, brown leather case—too thin for eyeglasses—with four small loops inside. Only one loop had a hatpin through it now: a pin with a small bronze ball on the end.

Two satin evening gowns, one blue and one green, lay in the next drawer below, carefully folded with tissue paper into cardboard boxes. The third drawer held six pairs of shoes wrapped in newspapers, and three vials of smelling salts bound together with a rubber band.

Stuffed into the bottom drawer I found a white cardigan sweater, a straight black wig, a blond wig with dark roots, and an old-fashioned yellow bonnet.

The trunk's hanging rack was curtained; I flipped the cloth over the top and pulled out the hanger bar. Right in front was a sailor's middy blouse and bell-bottom trousers; a pleated skirt was pinned to the next hanger. And from the third hung a tattered dress with a rope for a belt.

I checked the toilet stall. A white blouse and a lime-green coat had been tossed onto the floor. They were about five sizes too large for any woman who could fit into the gowns or the sailor suit. And there was no mistaking the coat now: it had three big cloth-covered buttons, and a dangling thread where Ivy had yanked off the fourth.

You certainly can distract the people you're shadowing by doing something unpleasant. A platinum blonde would ordinarily draw a lot of attention, but one whose hair is badly dyed doesn't get a second look. Ditto for a corpulent woman: a quick glance, and from then on she's ignored. Nobody likes to stare at folks who are down on their luck, especially if they look like they're starving and they're panhandling for dimes. And even if a girl is young and pretty, once she starts making rude remarks or complaining about her pimples and periods, people stop paying attention.

But how did she injure Lois? Or kill Manny? Or Suzanne? Or Helen? There was no gas bomb in her trunk, and nowhere else in the compartment to hide one. She wasn't carrying anything that big when she left for the ladies' room. But then I thought: Why would someone who has a private toilet go into a public stall?

I let myself out of the compartment and looked back toward my seat. None of the Ultra Belles had returned.

It seemed as though the ladies' room floor had just been washed, when I got inside: it smelled a little of ammonia. But the floor wasn't damp or shiny. And except for the few minutes I'd been poking around next door, I'd been facing this end of the car for almost the entire trip. None of the crew had gone in with a mop and bucket.

Yet it smelled like ammonia. Well, no. Not exactly. It was a little like sea water, too. And I'd smelled it before—in the Pullman car, the night Suzanne was killed. I sniffed around the room. It wasn't coming from the stall: the smell was most intense across the room, by the vanity. I squatted down beside a little puddle, to see if it was a leak from the supply cabinet, and opened the little door.

Suddenly I—I was gagging! And coughing! And sneezing! I rolled away, ending up on my side, against the stall door, with my knees against my chest, trying to catch my breath.

My face and my neck were soaking in sweat. My eyes and my nostrils burned. I forced myself to cry and snort, to wash them out. Then I staggered up to the sink, opened the tap, and scooped water onto my face. What dripped down the drain was streaked with red.

I grabbed one of the *Zephyr's* monogrammed towels, pressed it against my nose and mouth, and flung myself toward the frosted window. I snapped open the top section—it stopped halfway down—and I thrust my face out into the warm wind. My lungs ached, and everything from my throat up through my nose felt like it was on fire. But I breathed as deeply as I could stand, and when I coughed again, I coughed red blotches into the towel.

I could taste the blood now, but I'd stopped coughing; and I could feel it trickling down my throat. I looked in the mirror. There was blood all over my upper lip. Scratching shreds of tissue from the box on the vanity, I squeezed them into tight balls and stuffed them in my nostrils. Then I sat down on the upholstered seat and tilted my head way back. I was shivering; I pulled my sweater tightly around my shoulders.

"*Don't do that, Katy!*"

I spun around. Nobody was there. It must've been the noise from the open window, so loud in such a quiet train. Just the *whoosh* and the rumble. But it sounded so clear.

Supposedly some part of your brain works like a guardian angel, to keep you from hurting yourself, to whisper in your ear that you're doing something stupid. What I'd heard—it wasn't my own voice. It was…more like Mother's. And certainly she'd said, "Don't *do* that, Katy!" a thousand times when I was a tomboy. But what had I done now that was so—

It came to me all at once.

When I was about eight years old, Mother was cleaning the house, scrubbing the floor, and I had an idea that would make

her work easier. I picked up the cleaning liquids she was working with and started to pour them into the bucket together. That's when Mother screamed, "Don't do that, Katy! Don't *ever* mix bleach with ammonia!"

I didn't learn the chemistry until years later, in high school, but it's a deadly combination all right. You didn't have to steal a bomb or build a laboratory, or even tote the ingredients around. You could pick them up in any housekeeper's closet or public bathroom.

You'd hold your breath while you mixed the potion—it wouldn't take more than half a minute. And you could carry it in something as small as...as what? Then I remembered. Smelling salts.

What a *tiny* bomb it was! You could wrap it up in a handkerchief and stow it in your purse or your pocket while you were stalking your victims. And when they were *right there*, face to face with you, you'd wait until they exhaled, and then you'd push your little bomb right between their lips.

They'd gag and choke, but no air would get through to their lungs—only that pungent, stinging gas. They'd cough, but that would only make it worse, because it'd come right back up and sear their throats. They'd try taking a deep breath—but that would be their last breath. By then their lungs would be filled with blood, and they couldn't even scream.

I plucked the tissues out of my nostrils and took some tentative breaths through my nose. Then—cautiously—I eased my head upright. My throat hurt, like I'd been screaming. My head ached again. My temples throbbed. I ached all over, down my neck and across my shoulders. But I couldn't wait to let the pain subside.

I opened the door and checked the corridor. No one was around.

I went into the next car, looking at everyone carefully and giving a smile to anyone who happened to look up at me. One young woman caught my attention: she was wearing a gray tweed jacket, but her hair was long, and the woman I'd seen leaving the compartment had hers in a bun. I nodded and muttered, "Hello," when she noticed me, and walked away.

In the following car, I surveyed the rows of seats. A dark head of hair in a bun needed a second look. I stepped quietly past her seat and turned around, snapping my fingers and saying, "Oooh!" as though I'd forgotten something.

She glanced up. I glanced down. She was over sixty; a cane lay beside her on the seat. I said, "Excuse me," and went on.

The diner was practically empty: only a brakeman and a couple of stewards, having coffee and talking about baseball.

I slowed down. "Excuse me. How long before we get to San Francisco?"

"Oakland's the station-stop you want, if you're going to Frisco," said the brakeman. "You can change there for the train that runs over the Bay Bridge. We should be pulling into Oakland in a little over twenty minutes."

"Thank you." I strolled away, past the kitchen, then went through the vestibule into the club car.

The three cops were at a table by themselves, playing pinochle. Ted was sitting on a banquette with one arm around Lillian and the other around Ivy. Eileen was on the opposite banquette, sipping a Coke. Sonia sat next to her with her hands folded. Jack was lounging against one of the service counters, a Spud between her lips.

A woman in an armchair, her back to me, held everyone's attention. She was wielding a cigarette holder like a baton. "The artists worked for over a year," she was saying, "and you *must* go see these murals in the Coit Tower, even though they are the most blatant Socialist propaganda that anyone ever—"

"Murals are art for the common people!" Jack retorted. "And they're not propaganda. They're social realism."

"Don't be silly, dear. As I was saying, these murals—"

"Oh, there you are, Miss Green." Sgt. Grumman half rose from his seat. "Is everything all right? You don't look so good. And—" he lowered his voice and pointed "—you've got a little something red right there, on your face."

"Yes, I know. I had a nosebleed."

"I had to cover for you when we had the roll call, last stop. Don't put me on the spot again. D'you want me to ask about—"

"No. Not anymore. Thank you."

Ted took his left arm off Lillian's shoulder, opened his hand in a welcoming gesture, and said, "Isn't this a coincidence, Katy? Mrs. Cavett got on the train in Sacramento. She's been telling us some great things to see when we get to Frisco. She really knows the place. You can ask her anything."

"May I?" I looked right at her.

"Certainly, Miss Green." The powder was thick on her face, and she'd penciled in her eyebrows darkly. I squatted down right in front of her veil. "Must you get so close, dear? Do you have a question?"

"Yeah. Have you lost a lot of weight recently?"

"I beg your pardon?"

"Katy!" said Ted.

Ivy whispered, "Are you high? Did you take a whiff of something?"

"It was *something*, all right."

Lillian grinned. "Ooohh! Got any more?"

I leaned in closer to Mrs. Cavett. "Do hot dogs taste better out of the garbage can?"

"What?"

"I want my quarter back!"

She stood up. "I'm sorry, Mr. Nywatt. This woman is crazy. I don't think I want to hire the Ultra Belles for my party after all. I'm going back to my compartment."

"No, wait! I'm sure—oh, damn!" Ted had half risen, but he'd gotten Ivy's hair stuck in his watchband, so he had to settle back and disentangle it.

"Perhaps if you were to replace Miss Green in the band I might reconsider. Call me when you get to the City." She took her purse from beside her chair, and walked out in a hurry.

The chorus chimed right in: "Katy, what the hell—?" "How could you—?" "You've got some nerve!" "You just cost us a—"

But I wheeled around, said, "I've got to catch her," and took off.

"Damn right you do!" Ted yelled after me, still snagged.

"You better apologize!" That was Eileen.

Ivy chuckled, then she bellowed, "Catfight!"

"Hell, no." Jack elbowed Ivy in the ribs. "Katy's gonna *kill* her."

As I dashed past the card players I heard Det. Finn ask, "What was that all about?"

Dep. Peterson snorted. "Who knows, with *women?*"

She wasn't in the diner. I smiled at the brakeman and the stewards as I ran through.

In the next car I turned my head from side to side, checking every row, in case she'd hidden herself by simply dropping down into a seat and letting me run right by.

Through a window I saw the blue-green water of San Francisco Bay. There might be a stop before Oakland. If she got off, even if she left her trunk behind, she could wash her face and buy another outfit, and no one would ever recognize her again. They wouldn't find her home on Pacific Heights either.

I paused for a moment to catch my breath, between cars. The canvas tarps were flapping, and the breeze was cooled by the Bay. I'd been singing to myself while I ran, and panting to the rhythm of the train: "You *can*not make*an ome*lette without *break*ing something *dear* I'm*walking*on *eggshells —*"

A hand grabbed hold of me, tugging me backward. She'd been hiding beside the door!

I smelled something familiar, and painfully sharp! The vial was in her fist. She lunged at me with it, underhand, like a knife.

I pushed it away, got hold of her arm, and twisted it until she was off-balance. But the momentum drew her chest in too close to mine. She squeezed her hand back up toward my face. I shook myself hard and wriggled free, spun around, and clenched my right fist.

I struck her on the chin. The rubber was resilient, and the powder over it was slick, so my fist slipped. Instead of disabling her it only knocked her head to one side. She continued turning in place, which yanked the hand with the vial out of my grip. And she went all the way around, giving her outstretched hand added momentum. It connected with the side of my head.

I backed off, stunned. There was no use yelling for help. No one would hear me over the noise.

She came at me again, grabbed my sweater, and pulled me to the metal deck. I rolled over, so I was on top of her, but she wriggled violently. That, plus the two-way movement of the coupling between the cars right underneath us, made me lose my balance again, and she leaped on top of me.

She pushed the vial against my mouth. I clenched my jaw tight and blew out through pursed lips, hoping I could take a full breath in time. I raised my knees behind her back and then sprung my legs out, lofting myself an inch off the deck.

It was enough. It forced her to catch her balance, and that was all I needed to roll over onto one side and catch my breath. She had to pull her leg free, and I escaped out from under it.

She took a second to realize that I was standing up. She sprang to her feet. We glared at each other like cats on a fence.

She took a step toward me, expecting me to do the same: to fight in close again. But *ju-jitsu* teaches you to do the *un*expected. She'd stepped forward, so I hopped back and—meeting no resistance—she just kept going. She tried to slide her foot out in front of her, but it was too late. She pitched forward and fell.

I dropped down on top of her back, my knees on her shoulders. She was cheek-down, against the steel floor. Her right hand slipped into the gap between the cars, and a moment later the train clanged them together, pinching it tight. She tried to yank it free, but we both heard the bones break, and she shrieked.

I grabbed her wrist and pulled it out of the gap, brought her arm around, and held it against her back. I looked down. The glass vial and her fingers were crushed together.

She might have been too hurt to move, but I couldn't take the chance. I twisted her left arm behind her back, too, so I could hold both of her wrists down with my right hand, and touch her face with my left.

She moaned and wriggled, but I slid my fingers under the edge of the wig and yanked it off her head, revealing short chestnut-brown hair in a tight net snood underneath.

Her makeup was blotchy now, and streaked by tears and sweat. I pulled at her cheek, and the bridge of her nose, until the edges came loose. I peeled off the rubber pad that reshaped her chin, and the putty that had given her a beak.

The door to the car behind us opened. Sgt. Grumman and Dep. Peterson stood looking down at us...at *her*, really. She snorted, blinked back tears, and lifted her head to look up.

Ted elbowed his way in between the cops and stared.

She was cute again: even with her hair awry, streaks of grime and powder across her face, and crumbs of putty clinging to her button nose.

Finally she smiled, panted, until she'd caught her breath.

"Hello, Ted."

His mouth moved wordlessly for a second, before he found his voice.

"Belinda?"

They held the train in Oakland while we waited for yet another police officer to board, evaluate the situation, and escort us all off. Then they crowded us into the stationmaster's office—all except Sonia, who was lying down on a couch in the ladies' lounge.

Belinda Beale sat on the floor, handcuffed to the leg of a big oak desk. She was awake, but not entirely. Sgt. Grumman had wrapped a bandage around her broken hand, and made a sling for her arm with a towel from the bathroom. He'd also given her a shot of morphine from the stationmaster's first-aid kit.

Each of the four cops phoned his headquarters. Dep. Peterson and the Oakland cop listened to their superiors' instructions, while Det. Finn spent his nickel barking out orders. When it was Sgt. Grumman's turn to call, though, he not only brought his staff up to date, he told them to contact the press—which ensured that the first and most extensively covered trial would be the one held in *his* jurisdiction.

Manny had said that Sgt. Grumman was ambitious but honest, and nothing I'd seen of him made that out to be a bad combination. He'd kept on top of his case, followed all the leads he'd developed, and he'd even done the human thing for Belinda, who maybe didn't deserve it. He was entitled to whatever glory the whole mess brought him.

He said something to her, but she was nodding, eyes closed, and may not have heard. So he asked me what happened.

"Belinda's been on stage practically all her life," I told him. "But it takes more than makeup to fool people *off* the stage. There's a technique called 'the Method' that actors can learn, where they put their own feelings into a part; it becomes more realistic that way. She was in a lot of those WPA Living Theater plays, like *Street Scene*, where the situations and characters are drawn from real life."

"But how'd she dream up that gas bomb?"

"I'm guessing, but she probably got the idea while she was cleaning somebody's house."

"Stupid accident!" Belinda was suddenly awake, and straining against the handcuff. "My voice was shot for weeks. Couldn't work."

Sgt. Grumman leaned in toward her. "What was the hatpin for, if you—"

"To throw you cops a curve ball, of course! If you knew how I killed 'em, you be that much closer to catching me!"

"Why'd you do it?"

"Ask *him* over there."

Ted blinked. "Me?"

"You never came to see me after I got hurt, Ted! You got a whole new band, and a whole new girlfriend. That Joan Barber! I came to your gigs at the Franklin, in a putty face, all puffed up with pillows, and stared at her from the back of the room, night after night, for weeks, until she was all nervous and missing her cues."

I stepped closer to her. "Did you throw her out the window, too?"

"Sure I did! But I made her crazy first, so Ted'd think she did it herself!"

"I told you she wasn't a cokie!" Lillian exclaimed.

Ivy jumped up. "I just got it. The pillows! That was *you* on the train! No wonder—"

"I should've killed you, too, you little twerp. If Ted hadn't—"

"Are you saying all this is *my* fault?" he demanded.

"You had to go out with *another* one of the girls in your band. And I had to know *who*. I read that you were going on tour. I had enough saved up, so I got out to California ahead of you…and…and on the pier…she was…" Her head drooped, but a second later she shook it and blinked. "Where's that song you were gonna write for me, Ted? That's not us in 'Remember To Forget.' We didn't go to the races. We didn't take an upper berth together. Who was she?"

"It's nobody, Belinda. No one girl. Or it's everybody, maybe. Some of it's true. Most of it's just made up, to fit the rhyme-scheme."

"If you could write a song for your precious Katy Green, you could write one for me!"

"I did write a song for you, Belinda. It's 'Walking on Egg-shells.'"

"You son of a bitch!"

We heard cars screech to a stop outside, and six men—two with cameras—trotted through the station door. The Oakland cop pushed them back. Flashbulbs went off anyway.

"You don't have to say anything to the reporters, Miss Beale." Sgt. Grumman held her by the shoulders.

"Then get me out of here. Take me to jail. Throw me in the Bay. I don't care."

He disconnected the end of the handcuff that had secured her to the desk, attached it to his wrist, and took her good arm to help her stand up.

Ted stepped closer. "I'll come see you, Belinda. I'll call you from—"

"You said you'd call, last time. But you never did!" She rolled her mouth around and puffed a wad of spit in his face. Then she yanked at the handcuff and pulled Sgt. Grumman toward the door. The other cops followed them out.

Ted stared dumbly, letting it drip, before he pulled the pocket-square out of his jacket and dabbed it away. Then he made a half smile. "Lucky for us, Katy, you figured out it was her."

"I should have caught on sooner. I'm sorry. One of the telegrams she sent you said something about the Nywatt Sound. But Manny coined that phrase on the train to Santa Cruz, and Eileen announced it on stage that night, while Belinda was dressed as Mrs. Cavett."

"But she called me, long-distance."

"She called you from a pay-phone in the lobby and pretended to be an operator. The only long-distance calls she made were from California to Philadelphia, to the Western Union office there, so the wires she sent you would come from there."

"Why did she kill Manny?"

"She was dressed as Babs, in Sacramento, and she heard one of the good-government ladies from San Francisco say she'd never heard of the garden club, and that the hospital had already held a fund-raiser. Manny would have found that out soon enough. So she probably called his room right away and gave him Babs's fan-club palaver. That's why he told you he was expecting a visitor, Ted. When she got there, I don't think he knew what hit him. Afterward, she pulled down his pants and messed up the room, to confuse everybody, and then came down to the ballroom to watch the show and dance."

"Well, I don't know how to thank you. What do you think, Eileen? Can we do something for Katy? Eileen? You don't look well."

She took his arm. "I don't feel well. Let's see what time the next train to L.A. comes through."

He lifted her fingers off. "You can't run out on the gig tonight."

"Do I have to sing?"

"Only if you want to get paid."

"Hey! I want to get paid!" Ivy chirped.

Lillian blinked. "Are we playing tonight? What did he say?"

"We have a contract," Ted announced, "and we're short-handed again. I could sit in on trombone. Who's coming with me?"

"I want my dough," said Ivy.

"What about Sonia?" I asked.

"She's a trouper."

Ted shook his head. "I'll phone the union for a sub. What about the rest of you?"

Lillian shrugged. "Count me in."

"Me, too," said Jack.

"Katy? Are you coming?"

"I signed on for the the tour; I'm not quitting now. But I think Eileen owes everybody an apology, first."

"I don't know what you're talking about. Apologize for what?"

"For telling us that detectives were following you. If you didn't want anybody to see you with Ted, you could've just kept to yourself, or played solitaire, and nobody'd know anything. But you kept pushing the rest of us into Ted's arms, and that's pretty risky, considering what a ladies'-man he is. Some of us can give as good as we get."

"Well, we *were* being followed, weren't we? I just thought it was a detective, that's all. I never met Belinda. I practically never heard her name."

"But you put the picture-puzzle together—last Sunday, I think, when Lois was hurt. Somebody had followed her out onto

the pier, waited until she was alone, and tried to kill her. It was so much like what happened to Joan Barber that it started you thinking: suppose somebody was trying to kill Ted's girlfriends? You probably thought it was Suzanne, because she'd been making a play for Ted. But then she was killed, so maybe it was some girlfriend from Ted's past. But Ted hadn't spotted her, meaning she could be in disguise. You couldn't risk exposing yourself as Ted's girlfriend, or she might kill you, too. But you didn't have to make up a story about detectives. Why didn't you just call the cops?"

"I'm calling them right now. You're out of your mind! Hey, officer! Lock this one up, too."

I glanced at Dep. Peterson; he was shaking his head. Det. Finn was standing still, looking at her—not me.

"You didn't call the cops," I went on, "because you're jealous, Eileen—just like Belinda. You waited, while she tracked the band across California, like a lioness following a herd of antelope, picking off the weak ones first. As long as there was some girl standing between her and Ted—and it wasn't you—then she'd go for *that* one, and you'd be safe for a while longer. You let her do your dirty work, Eileen, didn't you? Well? Say something."

"You'll never work in my band again. Let's go, Ted. Get a sub for Katy, too, or get one for me, 'cause if she's playing, I'm not singing."

He shrugged. "Katy, why don't you just apologize?"

"She owes *me* an apology. And you. And everyone else."

"Fire her, Ted!"

"You always say you want my advice, Ted. So quit being a bandleader and let Eileen go off to Reno. That'll give her husband a break, too, so maybe he'll use his connections to help you get work in Hollywood. I know you, Ted: you want to write songs full-time; you don't want to run a band. Come Monday, the rest of us'll be down at the union local anyway, looking for a new gig.

Let us put together our own version of the Ultra Belles: Jack and
Ivy and Lillian and me. Sonia, too, if she wants. An all-girl band
is *our* profession, not yours. What I'm saying is: Abdicate, your
majesty—and take your duchess with you."

Eileen glared. "You sneaky bitch! Blaming me for what hap-
pened is your way of getting Ted back, isn't it? Ted—tell the Red-
caps to leave her bags right here."

"I don't know, Eileen. We've got to play the gig tonight, to get
our money. I owe Katy for playing two instruments—"

"Is that all? I can cover her fee with what I've got in my bag."
She snapped open her purse, pulled out three hundred-dollar
bills, and flung them down onto my shoes. "Besides, now that
Consolidated's out of the picture, I still own half the band. And I
say she's out. Where's the Redcap? We'll take a couple of taxis.
Come on, Ted. The rest of you, too. We're going over to the City."

She seized Ted's hand and pulled him behind her. Flash-
bulbs popped as soon as they opened the double doors. Eileen
shifted their hands, so the photos would look like *he* was escorting
her, and they went out the main entrance.

Jack stepped up alongside me. "You need a vacation, Katy."

"I can afford one, now."

"I know where you can go: the mountains. Or maybe the
desert?"

"I'm sorry, Jack. I was only stringing you along about that. I'll
keep it a secret."

"I don't know what you two are talking about," Lillian
declared, "but listen, Katy: how about meeting us after the show
tonight? It's the last gig, and we've got to play it, so we can get
our money. We'll go out for a drink. Or…something stronger."

Ivy shook her head. "No, no, Lillian. After what Katy's been
through, she needs to get some sleep. Look at her eyes—they're
all bloodshot."

"Yeah," Jack added. "You rest up, Katy. We'll get together to-morrow, in the City. There's a YW on Page Street. We'll meet you there. We better get Sonia and take off, now."

I waved good-bye as they left, and rubbed my eyes. My head was sore, my shoulders ached. My clothes were all disheveled. It would be an hour or more before I got any sleep.

Flashbulbs went off again outside the front entrance. Sgt. Grumman came back inside and pulled the double doors shut behind him. "One of the local cops is giving me a ride into San Francisco, Katy. That's where I catch the train back down to Santa Cruz."

"Where's Belinda?"

"They're keeping her overnight in Oakland. I'll come up again tomorrow with a warrant, and a couple of policewomen to escort her back. I'd like to bring a stenographer along, and take a statement from you. Where can I find you?"

I wouldn't mind seeing him again, when I felt better—and looked better. "Uh, at the YW on Page Street. Do you suppose I could hitch a ride over there with you now?"

"Sure."

The Oakland cop tossed my bags into the trunk for me, and gave me the whole back seat to stretch out on. His heavy black Dodge reeked of cigarettes and stale coffee. I was exhausted. I could have taken a nap then and there, but I heard somebody singing "Yours Till Dawn." The car had a police radio in the dash-board, but it wasn't playing music. Finally I realized: the song was in my head. I squeezed myself small, on the faded brown leather, hoping the tune would go away or come to an end.

We drove over a trestle bridge and into a tunnel, right through an island in the middle of the Bay. When daylight came back, I looked out the window and up along the huge suspension cables, to the top of the towers on the silvery Bay Bridge.

Then we crossed over the shoreline of the City, and I smelled coffee—not from the stains on the car seat: I mean real coffee. Beans. Roasting! I took a long, loud sniff of it. The cop turned and smiled, and pointed out the window to a big factory down below us, on the waterfront.

And then I saw the San Francisco skyline for the first time, and suddenly I wasn't sleepy anymore.

A *different* song was playing in my head, and I didn't want it to stop, because now the lyrics cut both ways. The way Eileen was going to run Ted's life for him, *he'd* be the one who'd be walking on eggshells.

AFTERWORD

In *Too Dead To Swing*, practically all aspects of everyday life in 1940 are rendered accurately. But small errors or inconsistencies of detail are inevitable, e.g., that trains in the story do not adhere to contemporary railroad timetables. Hannah wrote her novels after the war, while she was living in Hawaii. I doubt that she traveled to California to do research; so either she drew upon her memory of trains and schedules or (more likely) she invented them to accommodate the action.

When I adapted *Too Dead To Swing* as an audio-play script, I chose to overlook such minor flaws. But I did take some liberties with Hannah's draft in both the script and the novel. I altered some of her characters' names, to make them sound more euphonious. I shifted the order of some scenes, to enhance the narrative flow. And during the recording sessions, the leading actors were entitled to suggest alternative readings of their speeches; and I incorporated those emendations if they enhanced a character's development or made a scene more dramatic.

I feel that, in all of these things, Hannah would have concurred...if she were a real person. For I also have to say here that Hannah—like Katy—is my own creation, and that I am the true author.

Writers take pen-names for a variety of reasons, and this is one of them: When a story is told in the first-person female, there is a general expectation that it is written by a woman. So I wrote the Katy Green mysteries under the name of Hannah Dobryn, and—to help establish the 1940s setting—I invented a plausible life-story for her as well. My wife, Kathy Frankovic, who helped to produce the audio-play of *Too Dead To Swing*, continues to encourage "Hannah" to write—for which I am profoundly grateful.

Thanks are due also to my editor, Meredith Phillips, at Perseverance Press. It was she who listened to the audio-play, contacted me to ask if the book rights were available, and then championed it to the publishers, John and Susan Daniel. Meredith scrupulously corrected the manuscript's spelling and grammar, and adjusted its punctuation, to conform to modern usage without sacrificing the period flavor of the language. I am also indebted to art director Eric Larson for his book design work, and his ability to reproduce the vintage postcards and other illustrations that enhance the story's verisimilitude.

To all of you go my sincere thanks—and Hannah's.

HAL GLATZER

Saul Feldman

ABOUT THE AUTHOR

Hal Glatzer is an innovator in mystery fiction, beginning twenty-five years ago with his multimedia pastiche, *Kamehameha County*. His thriller about computer hackers, identity theft, and on-line pornography, *The Trapdoor*, was published in 1986—ten years before those topics were front-page news. And in 1992 he posted one of the first eBooks to download on the Worldwide Web: *Massively Parallel Murder*.

A swing guitarist and Art Deco enthusiast, Glatzer wrote the songs as well as the story for *Too Dead To Swing* and produced it as an award-winning audio-play in 2000. Visit the Web site at www.toodeadtoswing.com for further background and information on ordering. Glatzer lives in San Francisco with his wife.

MORE MYSTERIES
💀 FROM PERSEVERANCE PRESS 💀
For the New Golden Age

Available now—

Open Season on Lawyers, A Novel of Suspense
by Taffy Cannon
ISBN 1-880284-51-0
Somebody is killing the sleazy attorneys of Los Angeles. LAPD Detective
Joanna Davis matches wits with a killer who tailors each murder to a specific
abuse of legal practice. They call him The Atterminator—and he likes it.

The Tumbleweed Murders, A Claire Sharples Botanical Mystery
by Rebecca Rothenberg, completed by Taffy Cannon
ISBN 1-880284-43-X
Microbiologist Sharples explores the musical, geological, and agricultural his-
tory of California's Central Valley, as she links a mysterious disappearance a
generation earlier to a newly discovered skeleton and a recent death.

Keepers, A Port Silva Mystery
by Janet LaPierre
ISBN 1-880284-44-8
Patience and Verity Mackellar, a Port Silva mother-and-daughter private inves-
tigative team, unravel a baffling missing-persons case and find a reclusive reli-
gious community hidden on northern California's Lost Coast.

Blind Side, A Connor Westphal Mystery
by Penny Warner
ISBN 1-880284-42-1
The deaf journalist's new Gold Country case involves the celebrated Calaveras
County Jumping Frog Jubilee. Connor and a blind friend must make their dis-
abilities work for them to figure out why frogs—and people—are dying.

The Kidnapping of Rosie Dawn, A Joe Barley Mystery
by Eric Wright
Barry Award, *Best Paperback Original 2000*
Edgar, Ellis, and Anthony Award nominee
ISBN 1-880284-40-5
A Toronto academic sleuth is on an odd odyssey, to rescue student/exotic danc-
er Rosie Dawn—and find out who wants her out of the way, and why. One part
crime caper, one part academic satire, and one part love story compose this new
series entry.

Guns and Roses, An Irish Eyes Travel Mystery
by Taffy Cannon
Agatha and Macavity Award nominee, *Best Novel 2000*
ISBN 1-880284-34-0
Ex-cop Roxanne Prescott turns to a more genteel occupation in this new series, leading a History and Gardens of Virginia tour. But by the time the group reaches Colonial Williamsburg, strange misadventures and annoying pranks have escalated into murder.

Royal Flush, A Jake Samson & Rosie Vicente Mystery
by Shelley Singer
ISBN 1-880284-33-2
Jake and Rosie infiltrate a dangerous far-right group, to save a good kid who's in over his head. The laid-back California private eyes will need a scorecard to tell the ringers in the gang from the real racist megalomaniacs.

Baby Mine, A Port Silva Mystery
by Janet LaPierre
ISBN 1-880284-32-4
The web of small-town relationships in the coastal California village is fraying, stressed by current economic and political forces. Police chief Vince Gutierrez and his schoolteacher wife, Meg Halloran, must help their town recover.

Forthcoming—

Another Fine Mess, A Bridget Montrose Mystery
by Lora Roberts
Bridget Montrose wrote a surprise bestseller, but now her publisher wants another one. A writers' retreat seems the perfect opportunity to work in the rarefied company of other authors...except that one of them has a different ending in mind.

Flashover, A Novel of Suspense
by Nancy Baker Jacobs
A serial arsonist is killing young mothers in the Bay Area. Now Susan Kim Delancey, California's newly appointed chief arson investigator, is in a race against time to catch the murderer and find the dead women's missing babies — before more lives end in flames.

**Available from your local bookstore or from
Perseverance Press/John Daniel & Co. at (800) 662-8351
or www.danielpublishing.com/perseverance.**